CHARLES LAMB

His Life Recorded by his
Contemporaries

Compiled by

EDMUND BLUNDEN

LONDON, 1934
PUBLISHED BY LEONARD AND VIRGINIA WOOLF AT
THE HOGARTH PRESS, 52 TAVISTOCK SQUARE, W.C.1

PUBLISHER'S NOTE

This is the first volume in a new series of biographies which proceeds on a system different from the usual. The life of each biographer will be presented entirely through the eyes of his contemporaries, from contemporary descriptions by those who knew or saw him, and from contemporary documents.

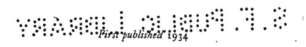

First published 1934

MADE AND PRINTED IN GREAT BRITAIN BY THE
GARDEN CITY PRESS LTD., LETCHWORTH, HERTS

CONTENTS

1818–25

ELIA AND HIS ADMIRERS

1825–34

THE SUPERANNUATED MAN

1834-5
" PROSE ELEGIES "

PREFACE

THE subject of the present volume was induced to write his own Autobiography, which has been frequently reprinted and is the best preliminary to the accounts now collected :

[In William Upcott's Collection.]

CHARLES LAMB born in the Inner Temple 10th Feb. 1775 educated in Christ's Hospital afterwards a clerk in the Accountants Office East India House pensioned off from that service 1825 after thirty-three years' service, is now a Gentleman at large, can remember few specialities in his life worth noting except that he once caught a swallow flying (*teste suâ manu*); below the middle stature, cast of face slightly Jewish, with no Judaic tinge in his complexional religion; stammers abominably and is therefore more apt to discharge his occasional conversation in a quaint aphorism or a poor quibble than in set and edifying speeches; has consequently been libelled as a person always aiming at wit, which, as he told a dull fellow that charged him with it, is at least as good as aiming at dulness; a small eater but not drinker; confesses a partiality for the production of the juniper-berry, was a fierce smoker of Tobacco, but may be resembled to a volcano burnt out, emitting only now and then a casual puff. Has been guilty of obtruding upon the Public a Tale in Prose, called *Rosamund Gray*, a Dramatic Sketch named *John Woodvil*, a Farewell Ode to Tobacco, with sundry other Poems and light prose matter, collected in Two slight crown Octavos and pompously christened his Works, tho' in fact they were his Recreations and his true works may be found on the shelves of Leadenhall Street, filling some hundred Folios. He is also the true Elia whose Essays are extant in a little volume published a year or two since; and rather better known from that name without a

meaning, than from any thing he has done, or can hope to
do in his own. He was also the first to draw the Public
attention to the old English Dramatists, in a work called
*Specimens of English Dramatic Writers who lived about the time
of Shakspeare*, published about fifteen years since. In short,
all his merits and demerits to set forth would take to the
end of Mr. Upcott's book and then not be told truly.

He died 18 , much lamented.[1]
 Witness his hand,

10th Apr. 1827. CHARLES LAMB.

[1] *To any body*. Please to fill up these blanks. [*Dec. 27th*, 1834.]

By this unassuming sketch we may perceive that Lamb
was not over pleased with the fact that Elia, his temporary
self, had usurped the place of Charles Lamb irrevocably in
the mind of the public; and also, that he regarded his
pioneer appreciations of the Elizabethan drama as an
achievement—which was no pretentious feeling. What
should be added? The real answer is the biography, the
correspondence and the works of Lamb; the observations
and tributes of those who knew him. With Lamb himself,
according to a profusion of evidence, there passed from the
world a wealth of even " glorious life " apart from and, it
may be, hardly reflected in his extant writings.

It would seem that in early years Lamb was not watched
and portrayed with the same eagerness as in his prime and
his decline. He was at the outset the companion of men
whose genius and purpose did not allow them much time
for estimating *him*. He withdrew from direct literary
ambition into his clerkship, occasionally contributing some-
thing to current poetical or critical action, but even then
retiring with cheerful haste from the possibilities of becoming
An Author, " complete in box." The eminence of Coleridge,
Wordsworth, Southey, was not for him. Nevertheless, his
personality and the original acuteness of his published and
private opinions attracted to him, midway through his life,
a great many friends who understood that he was worthy
of their best discussion and careful chronicling. Upon the

publication of *Elia*, Lamb became a celebrity, and allusions
to him multiplied. Visitors from Scotland (Carlyle among
them!) and America endured long journeys in their desire
to speak with this singular creator of beautiful illusion, this
seer of humanities—to carry away some new instances of his
wit-melancholy and his judgment on books and men. Many
brought him their manuscripts; he was as a father to those
aspiring authors Hood, Forster, Moxon, Procter, Thomas
Westwood and others. Lamb's friendship was of a kind
which did not make it easy for everyone who knew him well
to say much about him in print while he lived. After his
death, his younger contemporaries did much to perpetuate
him in their verse and prose.

It has always been considered one of the many excellences
of Mr. E. V. Lucas's *Life of Lamb* that he brought together
and introduced into his narrative so many descriptions and
notices of Lamb by contemporaries. After Mr. Lucas, the
difficulty is to discover anything that he did not draw upon
(still more, anything of which he was not aware even if he
did not make use of it!). The present plan, however, permits
a new arrangement of materials, and a compilation of some
new materials, or parts of those well known which have been
sacrificed to the needs of biographical composition. I believe
that even the learned devotees of Lamb—the members of
" The Elian " themselves—will receive a fresh pleasure and a
mild surprise at the sight of the numerous and various friends
of their old friend, combining thus to tell his life story. To
venture a bad but timely pun, these contemporaries here

quasi cursores Vitai Lambada *tradunt.*

Some of them have written in such a manner as to require
the severities of an editor; omissions were inevitable,
and lengthy passages have been split up in order that
information might go to its chronological billet. In general,
my business has been to avoid interference, and to preserve
what Lamb's friends wrote as they wrote it. I have not
attempted to include all the poems addressed to Lamb in
his own period, but some chose themselves. It cannot be

helped that such a work as this is composed rather of personal impression, sketch and anecdote than of episode and "moving accident"; Lamb's life, so far as we can see it, after the original tragedy, was not one of marked incidents, and we may not see any more than even his intimate friends what passed in his mind when (how often!) the problem of Mary's insanity and his own spectres arose and assailed him.

<div align="right">E. B.</div>

NOTE

The compiler's thanks are due to several friends for their assistance in tracing some of the passages given: to Mr. Fred Edgcumbe of Keats House, Hampstead, who pointed out the items in the Potter Collection of newspaper cuttings; to Mr. H. C. Brooke-Taylor for the glimpse of Lamb with Taylor and Hessey's porter (now first available); to Miss A. Hayashi, indefatigable among old periodicals; to Mr. Basil Anderson, through whose liberality the use of many of Mrs. G. A. Anderson's annotated Lamb books was again possible.

It is certain that records and impressions of Lamb exist which have escaped the present survey, either in uncommon print or in manuscript, and the compiler would be grateful to any correspondent who cares to communicate anything of the sort to him for the benefit of any later editions. (Some well-known writers on Lamb have been sparingly quoted because of their verbiage.)

At p. 56, some description of Lamb's labours on his Elizabethan Dramatists (1808) would have been desirable. It may be noted that Lamb took the notice of his book in the "Annual Review" to be Coleridge's. "No editor had ever a mind more congenial to his office than Mr. Lamb possesses. There are no beauties which escape him, he understands them as well as feels them, but sometimes he enters so fully into the spirit of his author, that the feeling seems to overpower his judgment. . . . Yet our dramatic writers have never been commented on with such kindred power; the remarks are even more original than the text."

ADMISSION TO CHRIST'S HOSPITAL
1782

30th March, 1781

To the Right Honourable, Right Worſhipful, and Wor-
ſhipful the Governors of CHRIST's-HOSPITAL, LONDON

The humble Petition of *John Lamb*
 of the *Inner Temple, London, Scrivener*

Humbly Sheweth,

THAT the Petitioner *has a Wife and Three Child*ⁿ*; and
he finds it difficult to maintain and educate his Family
without ſome Aſsist*ᶜᵉ

∽∽∽∽∽∽∽∽∽∽∽∽∽∽

Therefore *He* humbly befeeches your Worſhips, in your
uſual Pity and Charity to diſtreſſed Men, poor Widows,
and Fatherleſs Children, to grant the Admiſſion
of *one* of *his* ∽∽∽∽ Child*ren* into CHRIST's-
HOSPITAL, named *Charles Lamb* ∽∽∽∽∽∽
of the Age of *Seven* years *and upwards* ∽∽∽∽
there to be Educated and brought up among other poor
Children.

Adm. Comm. 17*th July*, 1782.[1]

Cloathed 9*th Octbʳ*. And *He* shall ever pray, &c.

[1] Mr. G. A. T. Allan discovered recently that Lamb's brother John had
preceded him as a Bluecoat boy. John Lamb's subsequent career may be
summed up in the words of the *Gentleman's Magazine*: " October 26th, 1821.
In his 58th year, John Lamb, esq., Accountant to the South Sea Company,
in which establishment he served upwards of 40 years."—*B.*

DISCHARGE FROM CHRIST'S HOSPITAL
1789

Nov^r 23. Charles Lamb is this day discharged from this Hospital for ever by Elizabeth Lamb his Mother[1] living in the Temple, who is to provide a Master for him.

<div align="right">

Eliz. Lamb.

</div>

[1] Mr. Allan kindly informs me that, among the Hospital records, "there is an entry in the Apprentice Book shewing the payment of '£10—cloaths included' on his apprenticeship to his father."

1782-1800:
YOUTH AND POETRY

SCHOOL-DAYS OF LAMB

1782-9

[*C. V. Le Grice, in Talfourd's* Memorials, 1837.]

One of his school-fellows, of whose genial qualities he has made affectionate mention in his *Recollections of Christ's Hospital*, Charles V. Le Grice, now of Trereife, near Penzance, has supplied me with some particulars of his school-days, for which friends of a later date will be grateful. " Lamb," says Mr. Le Grice, " was an amiable, gentle boy, very sensible and keenly observing, indulged by his school-fellows and by his master on account of his infirmity of speech. His countenance was mild; his complexion clear brown with an expression which might lead you to think that he was of Jewish descent. His eyes were not each of the same colour, one was hazel, the other had specks of grey in the iris, mingled as we see red spots in the blood-stone. His step was plantigrade, which made his walk slow and peculiar, adding to the staid appearance of his figure. I never heard his name mentioned without the addition of Charles, although, as there was no other boy of the name of Lamb, the addition was unnecessary; but there was an implied kindness in it, and it was a proof that his gentle manners excited that kindness.

" His delicate frame and his difficulty of utterance, which was increased by agitation, unfitted him for joining in any boisterous sport. The description which he gives, in his *Recollections of Christ's Hospital*, of the habits and feelings of the school-boy, is a true one in general, but is more particularly a delineation of himself—the feelings were all in his own heart—the portrait was his own: ' While others were all fire and play, he stole along with all the self concentration of a young monk.' These habits and feelings were awakened and cherished in him by peculiar circumstances; he had been

born and bred in the Inner Temple; and his parents continued to reside there while he was at school, so that he passed from cloister to cloister, and this was all the change his young mind ever knew. On every half-holiday (and there were two in the week) in ten minutes he was in the gardens, on the terrace, or at the fountain of the Temple; here was his home, here his recreation; and the influence they had on his infant mind is vividly shown in his description of the old Benchers. He says, ' I was born and passed the first seven years of my life in the Temple;' he might have added, that here he passed a great portion of the second seven years of his life, a portion which mixed itself with all his habits and enjoyments, and gave a bias to the whole. Here he found a happy home, affectionate parents, and a sister who watched over him to the latest hour of his existence (God be with her!) with the tenderest solicitude; and here he had access to the library of Mr. Salt, one of the Benchers, to whose memory his pen has given in return for this and greater favours—I do not think it extravagant to say—immortality. To use his own language, ' Here he was tumbled into a spacious closet of good old English reading, where he browsed at will upon that fair and wholesome pasturage.' He applied these words to his sister; but there is no doubt they ' browsed ' together; they had walked hand in hand from a time ' extending beyond the period of their memory.' "

MR. GUY

[*C. V. Le Grice*, ibid.]

" In the first year of his clerkship," says Mr. Le Grice, in the communication with which he favoured me, " Lamb spent the evening of the 5th November [1792] with some of his former school-fellows, who, being amused with the particularly large and flapping brim of his round hat, pinned it up on the sides in the form of a cocked-hat. Lamb made no alteration in it, but walked home in his usual sauntering gait towards the Temple. As he was going down Ludgate Hill, some gay young men, who seemed not to have past the London Tavern without resting, exclaimed ' The veritable

Guy!—no man of straw!' and with this exclamation they took him up, making a chair with their arms, carried him, seated him on a post in St. Paul's Churchyard, and there left him. This story Lamb told so seriously, that the truth of it was never doubted. He wore his three-cornered hat many evenings, and retained the name of Guy ever after. Like Nym, he quietly sympathized in the fun, and seemed to say, ' that was the humour of it.' A clergyman of the city lately wrote to me, ' I have no recollection of Lamb. There was a gentleman called Guy, to whom you once introduced me, and with whom I have occasionally interchanged nods for more than thirty years; but how is it that I never met Mr. Lamb ? If I was ever introduced to him, I wonder that we never came in contact during my residence for ten years in Edmonton.' Imagine this gentleman's surprise when I informed him that his nods to Mr. Guy had been constantly reciprocated by Mr. Lamb! "

BLUECOAT SCHOOL GLIMPSES

1789 *and after*

[*Leigh Hunt,* " *Lord Byron, &c.*," 1828.]

I

Lamb's visits to the school, after he left it, I remember well, with his fine intelligent face. Little did I think I should have the pleasure of sitting with it in after-times as an old friend, and seeing it care-worn and still finer.

II

I was fifteen when I put off my band and blue skirts for a coat and neckcloth. I was then first Deputy Grecian; and had the honour of going out of the school in the same rank, at the same age, and for the same reason, as my friend Charles Lamb. The reason was, that I hesitated in my speech . . . it was understood that a Grecian was bound to deliver a public speech before he left school, and to go into the Church afterwards; and as I could do neither of these things, a Grecian I could not be. So I put on my coat and waistcoat, and, what was stranger, my hat. . . .

COLERIDGE SEEKS POETICAL ASSISTANCE

1794

[*S. T. Coleridge to Southey, December* 1794; *from* Letters, *ed. E. H. Coleridge*, 1895.]

It[1] is a lovely sonnet. Lamb likes it with tears in his eyes. His sister has lately been very unwell, confined to her bed, dangerously. She is all his comfort, he hers. They dote on each other. Her mind is elegantly stored; her heart feeling. Her illness preyed a good deal on his spirits, though he bore it with an apparent equanimity, as beseemed him who, like me, is a Unitarian Christian, and an advocate for the automatism of man.

I was writing a poem,[2] which when finished you shall see, and wished him to describe the character and doctrines of Jesus Christ for me; but his low spirits prevented him. The poem is in blank verse on the Nativity. I sent him these careless lines, which flowed from my pen extemporaneously:

TO C. LAMB

Thus far my sterile brain hath framed the song
Elaborate and swelling: but the heart
Not owns it. From thy spirit-breathing power
I ask not now, my friend! the aiding verse,
Tedious to thee, and from thy anxious thought
Of dissonant mood. In fancy (well I know)
Thou creepest round a dear-loved Sister's bed
With noiseless step, and watchest the faint look,
Soothing each pang with fond solicitude,
And tenderest tones medicinal of love.
I too a Sister had, an only Sister—
She loved me dearly, and I doted on her!
On her soft bosom I reposed my cares
And gained for every wound a healing scar.
To her I pour'd forth all my puny sorrows,
(As a sick Patient in his Nurse's arms),

[1] One by Southey dedicating Poems to Edith Southey.—*B.*
[2] " Religious Musings."—*B.*

That shrink ashamed from even Friendship's eye.
O! I have woke at midnight and have wept
Because she was not! Cheerily, dear Charles!
Thou thy best friend shalt cherish many a year:
Such high presages feel I of warm hope!
For not uninterested the dear Maid
I've view'd—her Soul affectionate yet wise,
Her polish'd wit as mild as lambent glories
That play around a holy infant's head.
He knows (the Spirit who in secret sees,
Of whose omniscient and all-spreading Love
Aught to implore were impotence of mind)
That my mute thoughts are sad before his throne,
Prepar'd, when he his healing ray vouchsafes,
To pour forth thanksgiving with lifted heart,
And praise Him Gracious with a Brother's Joy!

EARLY FRIENDSHIPS

1794-5

[Robert Southey, Letter to E. Moxon, February 2nd, 1836.]

Coleridge introduced me to Lamb in the winter of 1794-5.
. . . When I saw the family (one evening only, and at that
time) they were lodging somewhere near Lincoln's Inn, on
the western side (I forget the street[1]), and were evidently in
uncomfortable circumstances. The father and mother were
both living; and I have some dim recollection of the latter's
invalid appearance. The father's senses had failed him before
that time. He published some poems in quarto. Lamb
showed me once an imperfect copy: the " Sparrow's Wed-
ding " was the title of the longest piece, and this was the
author's favourite; he liked, in his dotage, to hear Charles
read it.

[Lamb's] most familiar friend, when I first saw him,
was White,[2] who held some office at Christ's Hospital, and

[1] Little Queen Street, High Holborn.—*B.*
[2] James White had been discharged from Christ's Hospital in 1790 by his
Aunt Sarah, " living at Mr. Coventry's " (one of Lamb's Old Benchers), to be
" trained in the Business of the Counting House of this Hospital."—*B.*

continued intimate with him as long as he lived. You know
what Elia says of him. He and Lamb were joint authors of
the *Original Letters of Falstaff*.[1] Lamb, I believe, first appeared
as an author[2] in the second edition of Coleridge's *Poems*
(Bristol, 1797), and, secondly, in the little volume of *Blank
Verse*, with Lloyd (1798). Lamb, Lloyd, and White were
inseparable in 1798; the two latter at one time lodged
together, though no two men could be imagined more unlike
each other. Lloyd had no drollery in his nature; White
seemed to have nothing else. You will easily understand how
Lamb could sympathise with both.

Lloyd, who used to form sudden friendships, was all but a
stranger to me, when unexpectedly he brought Lamb down
to visit me at a little village (Burton) near Christ Church, in
Hampshire, where I was lodging in a very humble cottage.
This was in the summer of 1797, and then, or in the following
year, my correspondence with Lamb began. I saw more of
him in 1802 than at any other time, for I was then six
months resident in London. His visit to this country was
before I came to it; it must have been either in that or the
following year: it was to Lloyd and to Coleridge.

Cottle has a good likeness of Lamb, in chalk, taken by an
artist named Robert Hancock, about the year 1798. It looks
older than Lamb was at that time; but he was old-
looking.[3]

Coleridge introduced him to Godwin, shortly after the
first number of the *Anti-Jacobin Magazine and Review* was
published, with a caricature of Gillray's, in which Coleridge
and I were introduced with asses' heads, and Lloyd and
Lamb as toad and frog. Lamb got warmed up with what-
ever was on the table, became disputatious, and said things
to Godwin which made him quietly say, " Pray, Mr. Lamb,
are you toad or frog ? " Mrs. Coleridge will remember the
scene, which was to her sufficiently uncomfortable. But the
next morning S. T. C. called on Lamb, and found Godwin
breakfasting with him, from which time their intimacy
began.

[1] Lamb never says as much. His own copy bore the inscription " From the
Author, James White." But see subsequent entry.—B.

[2] i.e. with his name on a title-page. Some of his Sonnets were in the first
edition of S. T. C.'s *Poems*, 1796.—B.

[3] This impressive portrait is now at the N.P.G.—B.

I have heard Coleridge say that, in a fit of derangement,
Lamb fancied himself to be Young Norval. He told me this
in relation to one of his poems.[1]

DEATH OF LAMB'S MOTHER
1796

[*From " Domestic Occurrences " in the* Gentleman's Magazine *for September* 1796.]

Friday, September 23rd. This afternoon the coroner's jury sat
on the body of a lady in the neighbourhood of Holborn, who
died in consequence of a wound from her daughter, the pre-
ceding day. While the family were preparing for dinner, the
young lady, in a fit of insanity, seized a case knife lying on the
table and in a menacing manner pursued a little girl, her
apprentice, round the room. On the eager calls of her help-
less infirm mother, to forbear, she renounced her first object
and, with loud shrieks, approached her parent. The child,
by her cries, quickly brought up the landlord of the house,
but too late: the dreadful scene presented to him the mother
lifeless on a chair, pierced to the heart; her daughter yet
wildly standing over her with the fatal knife; and the vener-
able old man, her father, weeping by her side, himself bleed-
ing at the forehead from the effects of a blow he received
from one of the forks she had been madly hurling about the
room. For a few days prior to this, the family had discovered
some symptoms of lunacy in her, which had so much in-
creased on the Wednesday evening that her brother, early
the next morning, went in quest of Dr. Pitcairn: had that
gentleman been providentially met with, the fatal catas-
trophe had, probably, been prevented. She had once before,
in the earlier part of her life, been deranged, from the
harassing fatigues of too much business. As her carriage
towards her mother had been ever affectionate in the extreme
it is believed that to her increased attentiveness to her, as her

[1] In Coleridge's *Poems*, 1797, appeared " The Tomb of Douglas: see the
Tragedy of that Name," by Lamb. There was method in this " derange-
ment."—*B.*

infirmities called for it, is to be ascribed the loss of her reason at this time. The jury, without hesitation, brought in their verdict—lunacy.

COLERIDGE MINISTERS
September 28th, 1796

[*Gillman's* Life of Coleridge, 1838.]

Your letter,[1] my friend, struck me with a mighty horror. It rushed upon me and stupified my feelings. You bid me write you a religious letter. I am not a man who would attempt to insult the greatness of your anguish by any other consolation. Heaven knows that in the easiest fortunes there is much dissatisfaction and weariness of spirit; much that calls for the exercise of patience and resignation; but in storms like these, that shake the dwelling and make the heart tremble, there is no middle way between despair and the yielding up of the whole spirit unto the guidance of faith. And surely it is a matter of joy that your faith in Jesus has been preserved; the Comforter that should relieve you is not far from you. But as you are a Christian, in the name of that Saviour who was filled with bitterness and made drunken with wormwood, I conjure you to have recourse in frequent prayer to " his God and your God "; the God of mercies, and the father of all comfort. Your poor father is, I hope, almost senseless of the calamity; the unconscious instrument of Divine Providence knows it not, and your mother is in heaven. It is sweet to be roused from a frightful dream by the song of birds and the gladsome rays of the morning. Ah, how infinitely more sweet to be awakened from the blackness and amazement of a sudden horror by the glories of God manifest and the hallelujahs of angels.

As to what regards yourself, I approve altogether of your abandoning what you justly call vanities.[2] I look upon you

[1] Lamb gave Coleridge " the outlines " of the disaster on September 27th, and asked him to " write,—as religious a letter as possible—but no mention of what is gone and done with."—*B.*

[2] " Mention nothing of poetry. I have destroyed every vestige of past vanities of that kind." C. L. See however p. 240.—*B.*

as a man called by sorrow and anguish and a strange desolation of hopes into quietness, and a soul set apart and made peculiar to God! We cannot arrive at any portion of heavenly bliss without in some measure imitating Christ; and they arrive at the largest inheritance who imitate the most difficult parts of his character, and, bowed down and crushed underfoot, cry in fullness of faith, " Father, Thy will be done."

I wish above measure to have you for a little while here; no visitants shall blow on the nakedness of your feelings; you shall be quiet, and your spirit may be healed. I see no possible objection, unless your father's helplessness prevent you, and unless you are necessary to him. If this be not the case, I charge you write me that you will come.

I charge you, my dearest friend, not to dare to encourage gloom or despair. You are a temporary sharer in human miseries that you may be an eternal partaker of the Divine nature. I charge you, if by any means it be possible, come to me.[1]

<div align="center">I remain your affectionate</div>

<div align="right">S. T. COLERIDGE.</div>

CHARLES AND MARY, AFTER THE TRAGEDY
1796

[*S. T. Coleridge to B. Flower, of Cambridge, December* 1796; *from* Unpublished Letters of Coleridge, *ed. E. L. Griggs.*]

The young lady, who in a fit of frenzy killed her own mother, was the sister of my dearest friend, and herself dear to me as an only sister. She is recovered, and is acquainted with what she has done, and is very calm. She was a truly pious young woman; and her brother, whose soul is almost wrapped up in her, hath had his heart purified by this horror of desolation, and prostrates his spirit at the throne of God in believing silence. The terrors of the Almighty are the whirlwind, the earthquake, and the fire that precede the still small voice of his love.

1 " I charge you, don't think of coming to see me." C. L.—*B.*

THE FALSTAFF LETTERS
1796
[Gentleman's Magazine, *January* 1797.]

I. A REVIEW

Original Letters, &c. of Sir John Falstaff and his Friends. . . . The late imposture[1] is now so completely detected and abandoned, and the author withdrawn to a distance from the public eye; it is too much to ask 3s. and 6d. for the short-lived amusement of an indifferent imitation of the epistolary correspondence of *Fastolfe*, especially when so many genuine letters of his remain unedited.

II. AUTHORSHIP

[*J. M. Gutch to W. C. Hazlitt, April 2nd,* 1852.]

These letters were the production of my old schoolfellow James White, with incidental hints and corrections by another schoolfellow, Charles Lamb.

A VETERAN'S ENCOURAGEMENT
1797
[*George Dyer, footnote to his* Poet's Fate, *2nd ed.* 1797.]

In connection with [Southey and Coleridge], I cannot forbear mentioning those of three young men, who have given early proofs, that they can strike the true chords of poesy; W. WORDSWORTH, author of *Descriptive Sketches in Verse*; C. LLOYD, author of a volume of very elegant sonnets; and CHARLES LAMB, author of some tender sonnets in COLERIDGE's *Poems*, of a fine poem in CHARLES LLOYD's *Poems*, and of sonnets in an excellent publication, entitled the *Monthly Magazine*.[2]

[1] The Shakespeare forgeries of W. H. Ireland.—*B.*

[2] G. D.'s phrase of "the true chords" amused Lamb, *vide* Lamb's letter to Coleridge, August 14th, 1800. He, however, must be gratefully remembered as a public friend of Lamb's verse at this time; the opposition was busy in the *Anti-Jacobin, e.g.* July 9th, 1798

> . . . Still blasphemous and blackguard, praise Lepaux!
> And ye five other wandering Bards, that move
> In sweet accord of harmony and love,
> C—dge and S—th—y, L—d, and L—be and Co.
> Tune all your mystic harps to praise Lepaux!—*B.*

ACQUAINTANCE WITH THE DEMOCRATS

c. 1797

[*John Britton*, Autobiography, 1850, i, 147.]

I often joined Thelwall's[1] private dinner and evening parties, where I met Godwin, Holcroft, Dr. Wolcot, Major Cartwright, Kenney, Robinson, Lamb, Quin, Cline, Taylor, and many other eminent authors as well as artists.

COLERIDGE, LAMB AND LLOYD

1798

[*S. T. Coleridge*, Letters, *ed. E. H. Coleridge*, 1895.]

Dear Lamb,—Lloyd has informed me through Miss Wordsworth that you intend no longer to correspond with me. This has given me little pain; not that I do not love and esteem you, but on the contrary because I am confident that your intentions are pure. You are performing what you deem a duty, and humanly speaking have that merit which can be derived from the performance of a painful duty.

Painful, for you would not without struggles abandon me in behalf of a man[2] who, wholly ignorant of all but your name, became attached to you in consequence of my attachment, caught his from my enthusiasm, and learned to love you at my fireside, when often while I have been sitting and talking of your sorrows and afflictions I have stopped my conversations and lifted up wet eyes and prayed for you. No! I am confident that although you do not think as a wise man, you feel as a good man.

[1] Citizen John Thelwall; mentioned agreeably by Lamb in a letter to Coleridge, February 1797.—In " A letter to the Anti-Jacobin Reviewers," 1799, C. Lloyd announced, " The person you have thus leagued in a partnership of infamy with me is Mr. Charles Lamb, a man who, so far from being a democrat, would be the first person to assent to the opinions contained in the foregoing pages: he is a man too much occupied with real and painful duties—duties of high personal self-denial—to trouble himself about speculative matters. Whenever he has thrown his ideas together, it has been from the irresistible impulse of the moment, never from any intention to propagate a system, much less any ' of folly and wickedness.' "—But Lamb himself in *Elia* here and there lets it appear that he was something of a politician in his early days, and not unmoved by the theories associated with the French Revolution.—*B.*

[2] Charles Lloyd. His novel "Edmund Oliver," 1798, founded on Coleridge's experiences, was inscribed "To his friend Charles Lamb."—*B.*

From you I have received little pain, because for you I suffer little alarm. I cannot say this for your friend. ...

I have been unfortunate in my connections. Both you and Lloyd became acquainted with me when your minds were far from being in a composed or natural state, and you clothed my image with a suit of notions and feelings which could belong to nothing human. You are restored to comparative saneness, and are merely wondering what is become of the Coleridge with whom you were so passionately in love; *Charles Lloyd's* mind has only changed his disease, and he is now arraying his ci-devant Angel in a flaming San Benito— the whole ground of the garment a dark brimstone and plenty of little devils flourished out in black. Oh, me! Lamb, " even in laughter the heart is sad ! "

CHARLES AND MARY REUNITED
1799
[*T. N. Talfourd*, Final Memorials, 1848.]

His sister still remained in confinement in the asylum to which she had been consigned on her mother's death— perfectly sensible and calm,—and he was passionately desirous of obtaining her liberty. The surviving members of the family, especially his brother John, who enjoyed a fair income in the South Sea House, opposed her discharge;— and painful doubts were suggested by the authorities of the parish, where the terrible occurrence happened, whether they were not bound to institute proceedings, which must have placed her for life at the disposition of the Crown, especially as no medical assurance could be given against the probable recurrence of dangerous frenzy. But Charles came to her deliverance; he satisfied all the parties who had power to oppose her release, by his solemn engagement that he would take her under his care for life; and he kept his word. Whether any communication with the Home Secretary occurred before her release, I have been unable to ascertain; it was the impression of Mr. Lloyd, from whom my own knowledge of the circumstances, which the letters do not ascertain, was derived, that a communication took place, on which a similar pledge was given; at all events,

the result was, that she left the asylum[1] and took up her abode for life with her brother Charles. For her sake, at the same time, he abandoned all thoughts of love and marriage.

A COMPLAINT

1799

[S. T. Coleridge to R. Southey, October 15th, 1799.]

I have great affection for Lamb, but I have likewise a perfect Lloyd-and-Lambophobia! Independent of the irritation attending an epistolary controversy with them, their *prose* comes so damn'd dear! Lloyd especially writes with a woman's fluency in a large rambling hand, most dull though profuse of feeling. I received from them in last quarter letters so many, that with the postage I might have bought Birch's *Milton*.[2]

[1] After the death of their father, in April 1799. It seems desirable here to remind the reader that the insanity of Mary remained a guarded private history not only through Lamb's life but until her death. That event, wrote Talfourd in July 1848, prefacing the "Final Memorials," "has released Lamb's biographer from a difficulty which has hitherto prevented a due appreciation of some of his noblest qualities. . . . While his frailties have received an ample share of that indulgence which he extended to all human weaknesses, their chief exciting cause has been hidden." The publication of Mary's tragedy in the *British Quarterly Review* settled any doubts that Talfourd still felt, and in Chapter II of "Final Memorials" he told the story at length.—*B*.

[2] Coleridge seems to have destroyed the evidence, for no letters from Lamb to him during this period are known.—*B*.

1800-18

CLERKSHIP, FRIENDSHIP, AND OCCASIONAL AUTHORSHIP

c

"NOW AND THEN *IRRADIATES*"
1800

[*S. T. Coleridge to Godwin, May 21st,* 1800; *from* Unpublished Letters, *ed. E. L. Griggs.*]

My poor Lamb! How cruelly afflictions crowd upon him! I am glad that you think of him as I think; he has an affectionate heart, a mind *sui generis*; his taste acts so as to appear like the unmechanic simplicity of an instinct—in brief he is worth an hundred men of *mere* talents. Conversation with the latter tribe is like the use of leaden bells—one warms by exercise—Lamb every now and then *irradiates*, and the beam, though single and fine as a hair, is yet rich with colours, and I both see and feel it.

JOHN WOODVIL
1800

[*John Rickman to R. Southey, December 30th,* 1800.]

I have a very pleasant neighbour[1] opposite, C. Lamb. He laughs as much as I wish, and makes even *puns*, without remorse of conscience. He has lately completed a dramatic piece,[2] rather tragic (without murder). The language entirely of the last century, and farther back: from Shakespeare, Beaumont, and Fletcher. He demurs on printing it. I wish him to *set it forth* under some fictitious name of that age—Shirley (perhaps) who was burnt out at the great fire of London. Lamb is peculiarly happy in his heroine, and altogether I have not seen a play with so much humour, moral feeling and correct sentiment, since the world was young.

[1] " I have made an acquisition latterly of a *pleasant hand*, one Rickman." C. L. to Manning, Nov. 3rd, 1800.—*B.*
[2] The early version of *John Woodvil.*—*B.*

G. Dyer is miserable about his unfortunate preface. I am quite vexed at his obstinacy. Lamb calls him, *Cancellarius Magnus*, The Lord High *Canceller*.

G. DYER
1802

[*R. Southey to Rickman, February* 17*th,* 1802.]

Of the other George I have more doleful tidings. Mary Lamb and her brother have succeeded in talking him into love with Miss Benjay[1] or Bungey or Bungay; but they have got him into a quagmire and cannot get him out again, for they have failed in the attempt to talk Miss Bungay or Bungey or Benjey into love with him. This is a cruel business, for he has taken the injection, and it may probably soon break out into sonnets and elegies. . . .

MORNING POST ENGAGEMENT
1802

[*John Rickman, Dublin Castle, to R. Southey, January* 5*th,* 1802.]

. . . I am a little out of intelligence from London (save from the Cockpit); last I heard of G. Dyer, who printeth, but hath not begun his *Vita Authoris*[2] schemed for him by Lamb's ingenuity. Lamb also printeth,[3] to better purpose; he has pruned Margaret, he says, into my shape and conception of things. I hope carefully, since certainly I know not much of the drama; nothing beyond instinct.

I receive the *Morning Post* and search it diligently; he owneth certain theatrical reports, and I find jokes besides. I think they will have an interest in paying him very handsomely. When daily papers run against one another in peace,

[1] Elizabeth O. Benger (1778-1827). "An ardour for knowledge disclosed itself in her early childhood, and never left her." Biographer of Tobin, Klopstock, Mary Queen of Scots, and others.—*B.*

[2] Dyer is understood to have written these memoirs; but where are they ?—*B.*

[3] *John Woodvil, a Tragedy.* G. and J. Robinson, 1802.—*B.*

in times of no intelligence, where can such an aid be found
as Lamb ? I have heard wit from him in an evening to feed
a paper for a week.

JOHN WOODVIL
1802

[R. Southey to Rickman, February 17th, 1802.]

. . . You have received " John Woodville." I retain my
first opinion. It is delightful poetry badly put together. An
exquisite picture in a clumsy frame. Margaret is a noble
girl. The other characters not so well conceived. A better
imitation of old language I have never seen, but was the
language of the serving men ever the language of nature ?
Lamb has copied the old writers, I expect that they did not
copy existing characters. Those quaint turns of words and
quainter contortions of thought never could be produced by
ignorant men. The main interest of the play (the discovery)
is too foolish. The effect produced too improbable. Withal
so beautiful is the serious dialogue that it more than redeems
the story. Most I like the concluding scene.

"THE CAUSE IS DISTRESSING"
1803

[John Rickman to Southey, March 30th, 1803.]

. . . Yesterday evening or rather afternoon, C. Lamb
came in somewhat abruptly, and at sitting down, shed some
tears. The cause is distressing; inasmuch as his sister is
again seized with an unhappy derangement; and has been
therefore compelled to go into custody, away from home,
but as she has usually recovered in about two or three
months, we may hope the best. Poor Lamb recovered
himself pretty well towards night, and slept at my house:
he dines with me to-day, and then hopes that he will be
steadied. He desires me to thank you for the wish you
expressed of his spending some time with you in his next
vacation. Write to him just to amuse him, he feels dreary,
and would like a letter from any friend. I believe Coleridge
is going to chum with him some time for company's sake.

MARY LAMB'S INSANITY
1803

[S. T. Coleridge to his wife, April 4th, 1803.]

I had purposed not to speak of Mary Lamb, but I had better write it than tell it. The Thursday before last she met at Rickman's a Mr. Babb, an old friend and admirer of her mother. The next day she smiled in an ominous way; on Sunday she told her brother that she was getting bad, with great agony. On Tuesday morning she laid hold of me with violent agitation and talked wildly about George Dyer. I told Charles there was not a moment to lose; and I did not lose a moment, but went for a hackney-coach and took her to the private madhouse at Hogsden. She was quite calm, and said it was the best to do so. But she wept bitterly two or three times, yet all in a calm way. Charles is cut to the heart.

G. DYER
1803

[J. Rickman to Southey, December 4th, 1803.]

. . . Geo. I. is relapsed into the full enjoyment of petty patronage and blind benevolence. He went to Lamb the other day, and put 1/6 into his hand, explaining that he had prevailed on somebody to buy the unfortunate Jno. Woodville at that half price (he Geo. I. not having been desired to have anything to do with the sale of the book). Lamb pocketed the 1/6 with due complacency, and G. D. concluded his exploit with saying, how little he could now do for those he wished to serve!

DE QUINCEY GETS LAMB OFF HIS OFFICE SEAT
c. 1804

[T. de Quincey, London Reminiscences.]

I walked into one of the two open doorways of the railing, and stood close by the high stool of him who occupied the first place within the little aisle. I touched his arm by way

of recalling him from his lofty Leadenhall speculations to this sublunary world; and presenting my letter, asked if that gentleman (pointing to the address) was really a citizen of the present room; for I had been repeatedly misled by the directions given me into wrong rooms. The gentleman smiled; it was a smile not to be forgotten. This was Lamb. And here occurred a very, very little incident—one of those which pass so fugitively that they are gone whizzing away into Lethe almost before your attention can have arrested them; but it was an·incident which, to me who happened to notice it, served to express the courtesy and delicate consideration of Lamb's manners. The seat upon which he sat was a very high one; so absurdly high, by the way, that I can imagine no possible use or sense in such an altitude, unless it were to restrain the occupant from playing truant at the fire, by opposing Alpine difficulties to his descent. Whatever might be the original purpose of this aspiring seat, one serious dilemma arose from it, and this it was which gave the occasion to Lamb's act of courtesy. . . . Between two extremes Lamb had to choose—between appearing ridiculous for a moment by going through a ridiculous evolution, stepping down by steps and stages analogous to dismounting from horseback—an evolution which no man could execute with grace; or, on the other hand, appearing lofty and assuming in a degree which his truly humble nature (for he was the humblest of men in the pretensions which he put forward for himself) must have shrunk from with horror. Nobody who knew Lamb can doubt how the problem was solved; he began to dismount instantly; and, as it happened that the very first round· of his descent obliged him to turn his back upon me as if for a sudden purpose of flight, he had an excuse for laughing, which he did heartily, saying at the same time something to this effect, that I must not judge from first appearances; that he should revolve upon me; that he was not going to fly; and other facetiae, which challenged a general laugh from the clerical brotherhood. When he had reached the basis of *terra firma* on which I was standing, naturally, as a mode of thanking for his courtesy, I presented my hand, which in a general case I should certainly not have done; for I cherished in an ultra-English degree the English custom (a wise

custom) of bowing in frigid silence on a first introduction
to a stranger; but to a man of literary talent, and one who
had just practised so much kindness in my favour, at so
probable a hazard to himself of being laughed at for his
pains, I could not maintain that frosty reserve. Lamb took
my hand; did not absolutely reject it; but rather repelled
my advance by his manner. This, however, long afterwards,
I found was only a habit derived from his too great sensitive-
ness to the variety of people's feelings, which run through a
gamut so infinite of degrees and modes as to make it unsafe
for any man who respects himself to be too hasty in his
allowances of familiarity.

MR. H—— DAMNED

(*Drury Lane, December* 10*th*, 1806)

[*William Hazlitt*, London Magazine.]

We often make life unhappy in wishing things to have
turned out otherwise than they did, merely because that is
possible to the imagination which is impossible in fact. I
remember when L——'s farce was damned (for damned it
was, that's certain) I used to dream every night for a month
after (and then I vowed I would plague myself no more
about it) that it was revived at one of the minor or pro-
vincial theatres with great success, that such and such
retrenchments and alterations had been made in it, and
that it was thought it might do at the other house. I had
heard indeed (this was told in confidence to L——) that
Gentleman Lewis[1] was present on the night of its performance,
and said, that if he had had it, he would have made it, by
a few judicious curtailments, "the most popular little thing
that had been brought out for some time." How often did I
conjure up in recollection the full *diapason* of applause at the
end of the Prologue, and hear my ingenious friend in the
first row of the pit roar with laughter at his own wit! Then
I dwelt with forced complacency on some part in which it
had been doing well: then we would consider (in concert)

[1] William T. Lewis, twenty years acting-manager of Covent Garden Theatre.
In *Authentic Memoirs of the Green-Room*, 1801, the actors are all designated Mr.—
except " W. T. Lewis, Esq."—*B.*

whether the long, tedious opera of the *Travellers*, which preceded it, had not tired people beforehand, so that they had not spirits left for the quaint and sparkling "wit skirmishes" of the dialogue, and we all agreed it might have gone down after a Tragedy, except L—— himself, who swore he had no hopes of it from the beginning, and that he knew the name of the hero when it came to be discovered could not be got over.—*Mr. H——*, thou wert damned!

Bright shone the morning on the play-bills that announced thy appearance, and the streets were filled with the buzz of persons asking one another if they would go to see *Mr. H——*, and answering that they would certainly: but before night the gaiety, not of the author, but of his friends and the town was eclipsed, for thou wert damned! Hadst thou been anonymous, thou haply mightst have lived. But thou didst come to an untimely end for thy tricks, and for want of a better name to pass them off!

CRABB ROBINSON SEES *MR. H——*
1806

[Crabb Robinson.]

By this time I had become acquainted with Charles Lamb and his sister, for I went with them to the first performance of *Mr. H——* at Covent Garden, which took place in the month of December. The prologue was very well received. Indeed it could not fail, being one of the very best in our language. But on the disclosure of the name, the squeamishness of the vulgar taste in the pit showed itself by hisses; and I recollect that Lamb joined, and was probably the loudest hisser in the house. The damning of this play belongs to the literary history of the day, as its author to the literary magnates of his age.

I was introduced to the Lambs by Mrs. Clarkson. And I had heard of them also from W. Hazlitt, who was intimate with them. They were then living in a garret in Inner Temple Lane. In that humble apartment I spent many happy hours and saw a greater number of excellent persons

than I had ever seen collected together into one room. Talfourd, in his *Final Memorials*, has happily characterized this circle.

TALES FROM SHAKESPEARE
1806

[*Mary Lamb, Letter to Sarah Stoddart, June 2nd, 1806.*]

Charles has written *Macbeth, Othello, King Lear*, and has begun *Hamlet*; you would like to see us, as we often sit writing on one table (but not on one cushion sitting), like Hermia and Helena in the *Midsummer Night's Dream*; or, rather, like an old literary Darby and Joan: I taking snuff, and he groaning all the while, and saying he can make nothing of it, which he always says till he has finished, and then he finds out he has made something of it.

OF PERSONS ONE WOULD WISH TO HAVE SEEN
" Come like shadows—so depart "
[*At Mitre Court Buildings, c.* 1806]

[*William Hazlitt*, " *Literary Remains,*" *from* New Monthly Magazine, *January* 1826. *The ascriptions of the remarks are a little puzzling. In the* New Monthly, *H— (perhaps Hazlitt) makes the last.*]

Lamb it was, I think, who suggested this subject, as well as the defence of Guy Faux, which I urged him to execute. As, however, he would undertake neither, I suppose I must do both—a task for which he would have been much fitter, no less from the temerity than the felicity of his pen—

> " Never so sure our rapture to create
> As when it touched the brink of all we hate."

Compared with him I shall, I fear, make but a commonplace piece of business of it; but I should be loth the idea was entirely lost, and besides I may avail myself of some hints of his in the progress of it. I am sometimes, I suspect, a better reporter of the ideas of other people than expounder of my own. I pursue the one too far into paradox or mys-

ticism; the others I am not bound to follow farther than I like, or than seems fair and reasonable.

On the question being started, A[yrton] said, "I suppose the two first persons you would choose to see would be the two greatest names in English literature, Sir Isaac Newton and Mr. Locke?" In this A[yrton], as usual, reckoned without his host. Every one burst out a laughing at the expression of Lamb's face, in which impatience was restrained by courtesy. "Yes, the greatest names," he stammered out hastily, "but they were not persons—not persons."—"Not persons?" said A[yrton], looking wise and foolish at the same time, afraid his triumph might be premature. "That is," rejoined Lamb, "not characters, you know. By Mr. Locke and Sir Isaac Newton, you mean the *Essay on the Human Understanding*, and the *Principia*, which we have to this day. Beyond their contents there is nothing personally interesting in the men. But what we want to see anyone *bodily* for, is when there is something peculiar, striking in the individuals, more than we can learn from their writings, and yet are curious to know. I dare say Locke and Newton were very like Kneller's portraits of them. But who could paint Shakspeare?"— "Ay," retorted A[yrton], "there it is; then I suppose you would prefer seeing him and Milton instead?"—"No," said Lamb, "neither. I have seen so much of Shakspeare on the stage and on book-stalls, in frontispieces and on mantel-pieces, that I am quite tired of the everlasting repetition: and as to Milton's face, the impressions that have come down to us of it I do not like; it is too starched and puritanical; and I should be afraid of losing some of the manna of his poetry in the leaven of his countenance and the precisian's band and gown."—"I shall guess no more," said A[yrton]. "Who is it, then, you would like to see ' in his habit as he lived,' if you had your choice of the whole range of English literature?" Lamb then named Sir Thomas Browne and Fulke Greville, the friend of Sir Philip Sidney, as the two worthies whom he should feel the greatest pleasure to encounter on the floor of his apartment in their nightgown and slippers, and to exchange friendly greeting with them. At this A[yrton] laughed outright, and conceived Lamb was jesting with him; but as no one followed

his example, he thought there might be something in it, and
waited for an explanation in a state of whimsical suspense.
Lamb then (as well as I can remember a conversation that
passed twenty years ago—how time slips!) went on as follows.
" The reason why I pitch upon these two authors is, that
their writings are riddles, and they themselves the most
mysterious of personages. They resemble the soothsayers of
old, who dealt in dark hints and doubtful oracles; and I
should like to ask them the meaning of what no mortal but
themselves, I should suppose, can fathom. There is Dr.
Johnson, I have no curiosity, no strange uncertainty about
him: he and Boswell together have pretty well let me into
the secret of what passed through his mind. He and other
writers like him are sufficiently explicit: my friends, whose
repose I should be tempted to disturb (were it in my power),
are implicit, inextricable, inscrutable.

" When I look at that obscure but gorgeous prose-
composition the *Urn-Burial*, I seem to myself to look into
a deep abyss, at the bottom of which are hid pearls and
rich treasure; or it is like a stately labyrinth of doubt and
withering speculation, and I would invoke the spirit of the
author to lead me through it. Besides, who would not be
curious to see the lineaments of a man who, having himself
been twice married, wished that mankind were propagated
like trees! As to Fulke Greville, he is like nothing but one
of his own *Prologues spoken by the ghost of an old king of
Ormus*, a truly formidable and inviting personage: his
style is apocalyptical, cabalistical, a knot worthy of such an
apparition to untie; and for the unravelling a passage or
two, I would stand the brunt of an encounter with so
portentous a commentator!" "I am afraid in that case,"
said A[yrton], " that if the mystery were once cleared up,
the merit might be lost ";—and turning to me, whispered a
friendly apprehension, that while Lamb continued to admire
these old crabbed authors, he would never become a
popular writer. Dr. Donne was mentioned as a writer of the
same period, with a very interesting countenance, whose
history was singular, and whose meaning was often quite as
uncomeatable, without a personal citation from the dead, as
that of any of his contemporaries. The volume was pro-
.duced; and while some one was expatiating on the exquisite

simplicity and beauty of the portrait prefixed to the old edition, A[yrton] got hold of the poetry, and exclaiming, " What have we here ? " read the following:

> " Here lies a She-Sun, and a He-Moon there,
> She gives the best light to his sphere,
> Or each is both and all, and so
> They unto one another nothing owe."

There was no resisting this till Lamb seizing the volume turned to the beautiful ' Lines to his Mistress,' dissuading her from accompanying him abroad, and read them with suffused features and a faltering tongue.

> " By our first strange and fatal interview,
> By all desires which thereof did ensue,
> &c."

Someone then inquired of Lamb if we could not see from the window the Temple walk in which Chaucer used to take his exercise; and on his name being put to the vote, I was pleased to find that there was a general sensation in his favour in all but A[yrton], who said something about the ruggedness of the metre, and even objected to the quaintness of the orthography. I was vexed at this superficial gloss, pertinaciously reducing everything to its own trite level, and asked " if he did not think it would be worth while to scan the eye that had first greeted the Muse in that dim twilight and early dawn of English literature; to see the head, round which the visions of fancy must have played like gleams of inspiration or a sudden glory; to watch those lips that ' lisped in numbers, for the numbers came '—as by a miracle, or as if the dumb should speak ? Nor was it alone that he had been the first to tune his native tongue (however imperfectly to modern ears); but he was himself a noble, manly charac- ter, standing before his age and striving to advance it; a pleasant humourist withal, who has not only handed down to us the living manners of his time, but had, no doubt, store of curious and quaint devices, and would make as hearty a companion as Mine Host of the Tabard. His interview with Petrarch is fraught with interest. Yet I would rather have seen Chaucer in company with the author of *The Decameron*, and have heard them exchange their best stories

together,—' The Squire's Tale ' against ' The Story of the
Falcon,' ' The Wife of Bath's Prologue ' against ' The
Adventures of Friar Albert.' How fine to see the high
mysterious brow which learning then wore, relieved by the
gay, familiar tone of men of the world, and by the courtesies
of genius! Surely, the thoughts and feelings which passed
through the minds of these great revivers of learning, these
Cadmuses who sowed the teeth of letters, must have stamped
an expression on their features, as different from the moderns
as their books, and well worth the perusal. Dante," I con-
tinued, " is as interesting a person as his own Ugolino, one
whose lineaments curiosity would as eagerly devour in order
to penetrate his spirit, and the only one of the Italian poets
I should care much to see. There is a fine portrait of
Ariosto by no less a hand than Titian's; light, Moorish,
spirited, but not answering our idea. The same artist's
large colossal profile of Peter Aretine is the only likeness of
the kind that has the effect of conversing with ' the mighty
dead,' and this is truly spectral, ghastly, necromantic."
Lamb put it to me if I should like to see Spenser as well as
Chaucer; and I answered without hesitation, " No; for that
his beauties were ideal, visionary, not palpable, or personal,
and therefore connected with less curiosity about the man.
His poetry was the essence of romance, a very halo round the
bright orb of fancy; and the bringing in the individual
might dissolve the charm. No tones of voice could come up to
the mellifluous cadence of his verse; no form but of a winged
angel could vie with the airy shapes he has described. He
was (to our apprehensions) rather ' a creature of the element,
that lived in the rainbow and played in the plighted clouds,'
than an ordinary mortal. Or if he did appear, I should wish
it to be as a mere vision, like one of his own pageants, and
that he should pass by unquestioned, like a dream or sound—

—' *That* was Arion crown'd:
So went he playing on the wat'ry plain! ' "

Captain Burney muttered something about Columbus,
and Martin Burney hinted at the Wandering Jew; but the
last was set aside as spurious, and the first made over to the
New World.

" I should like," said Mrs. Reynolds, " to have seen Pope

talking with Patty Blount; and I *have* seen Goldsmith."
Everyone turned round to look at Mrs. Reynolds, as if by so
doing they too could get a sight of Goldsmith.

"Where," asked a harsh croaking voice, "was Dr.
Johnson in the years 1745-6 ? He did not write anything
that we know of, nor is there any account of him in Boswell
during those two years. Was he in Scotland with the
Pretender ? He seems to have passed through the scenes in
the Highlands in company with Boswell many years after
' with lack-lustre eye,' yet as if they were familiar to him, or
associated in his mind with interests that he durst not
explain. If so, it would be an additional reason for my
liking him; and I would give something to have seen him
seated in the tent with the youthful Majesty of Britain, and
penning the Proclamation to all true subjects and adherents
of the legitimate Government."

"I thought," said A[yrton], turning short round upon
Lamb, "that you of the Lake School did not like Pope?"—
"Not like Pope! My dear sir, you must be under a mistake—
I can read him over and over for ever!"—"Why certainly,
the *Essay on Man* must be allowed to be a masterpiece."—"It
may be so, but I seldom look into it."—"Oh! then it's his
Satires you admire?"—"No, not his *Satires*, but his friendly
Epistles and his compliments."—"Compliments! I did not
know he ever made any."—"The finest," said Lamb, "that
were ever paid by the wit of man. Each of them is worth
an estate for life—nay, is an immortality. There is that
superb one to Lord Cornbury:

> ' Despise low joys, low gains;
> Disdain whatever Cornbury disdains;
> Be virtuous, and be happy for your pains.'

Was there ever more artful insinuation of idolatrous praise ?
And then that noble apotheosis of his friend Lord Mansfield
(however little deserved), when, speaking of the House of
Lords, he adds:

> ' Conspicuous scene! another yet is nigh,
> (More silent far) where kings and poets lie;
> Where Murray (long enough his country's pride)
> ·Shall be no more than Tully or than Hyde!'

And with what a fine turn of indignant flattery he addresses Lord Bolingbroke:

> ' Why rail they then, if but one wreath of mine,
> Oh! all-accomplished St. John, deck thy shrine ? '

Or turn," continued Lamb, with a slight hectic on his cheek and his eye glistening, " to his list of early friends:

> ' But why then publish ? Granville the polite,
> And knowing Walsh would tell me I could write,
> Well-natured Garth inflamed with early praise,
> And Congreve loved and Swift endured my lays:
> The courtly Talbot, Somers, Sheffield read,
> Ev'n mitred Rochester would nod the head;
> And St. John's self (great Dryden's friend before)
> Received with open arms one poet more.
> Happy my studies, if by these approved!
> Happier their author, if by these beloved!
> From these the world will judge of men and books,
> Not from the Burnets, Oldmixons, and Cookes.' "

Here his voice totally failed him, and throwing down the book, he said, " Do you think I would not wish to have been friends with such a man as this ? "

" What say you to Dryden ? "—" He rather made a show of himself, and courted popularity in that lowest temple of Fame, a coffee-house, so as in some measure to vulgarize one's idea of him. Pope, on the contrary, reached the very *beau ideal* of what a poet's life should be; and his fame while living seemed to be an emanation from that which was to circle his name after death. He was so far enviable (and one would feel proud to have witnessed the rare spectacle in him) that he was almost the only poet and man of genius who met his reward on this side of the tomb, who realized in friends, fortune, the esteem of the world, the most sanguine hopes of a youthful ambition, and who found that sort of patronage from the great during his lifetime which they would be thought anxious to bestow upon him after his death. Read Gay's verses to him on his supposed return from Greece, after his translation of Homer was finished, and say if you would not gladly join the bright procession that welcomed him home, or see it once more land at

Whitehall-stairs."—"Still," said Mrs. Reynolds, "I would rather have seen him talking with Patty Blount, or riding by in a coronet-coach with Lady Mary Wortley Montagu!"

Erasmus Phillips, who was deep in a game of piquet at the other end of the room, whispered to Martin Burney to ask if Junius would not be a fit person to invoke from the dead. "Yes," said Lamb, "provided he would agree to lay aside his mask."

We were now at a stand for a short time, when Fielding was mentioned as a candidate: only one, however, seconded the proposition. "Richardson?"—"By all means, but only to look at him through the glass-door of his backshop, hard at work upon one of his novels (the most extraordinary contrast that was ever presented between an author and his works), but not to let him come behind his counter lest he should want you to turn customer, nor to go upstairs with him, lest he should offer to read the first manuscript of *Sir Charles Grandison*, which was originally written in eight-and-twenty volumes octavo, or get out the letters of his female correspondents, to prove that Joseph Andrews was low."

There was but one statesman in the whole of English history that any one expressed the least desire to see—Oliver Cromwell, with his fine, frank, rough, pimply face, and wily policy;—and one enthusiast, John Bunyan, the immortal author of the *Pilgrim's Progress*. It seemed that if he came into the room, dreams would follow him, and that each person would nod under his golden cloud, "nigh sphered in Heaven," a canopy as strange and stately as any in Homer.

Of all persons near our own time, Garrick's name was received with the greatest enthusiasm, who was proposed by Barron Field. He presently superseded both Hogarth and Handel, who had been talked of, but then it was on condition that he should act in tragedy and comedy, in the play and the farce, *Lear* and *Wildair* and *Abel Drugger*. What a *sight* for *sore eyes* that would be! Who would not part with a year's income at least, almost with a year of his natural life, to be present at it? Besides, as he could not act alone, and recitations are unsatisfactory things, what a troop he must bring with him—the silver-tongued Barry, and Quin, and Shuter and Weston, and Mrs. Clive and Mrs. Pritchard, of

D

whom I have heard my father speak as so great a favourite when he was young! This would indeed be a revival of the dead, the restoring; and so much the more desirable, as such is the lurking scepticism mingled with our overstrained admiration of past excellence, that though we have the speeches of Burke, the portraits of Reynolds, the writings of Goldsmith, and the conversation of Johnson, to show what people could do at that period, and to confirm the universal testimony to the merits of Garrick; yet, as it was before our time, we have our misgivings, as if he was probably after all little better than a Bartlemy-fair actor, dressed out to play Macbeth in a scarlet coat and laced cocked-hat. For one, I should like to have seen and heard with my own eyes and ears. Certainly, by all accounts, if any one was ever moved by the true histrionic *œstus*, it was Garrick. When he followed the Ghost in *Hamlet*, he did not drop the sword, as most actors do, behind the scenes, but kept the point raised the whole way round, so fully was he possessed with the idea, or so anxious not to lose sight of his part for a moment. Once at a splendid dinner-party at Lord ——'s, they suddenly missed Garrick, and could not imagine what was become of him, till they were drawn to the window by the convulsive screams and peals of laughter of a young negro boy, who was rolling on the ground in an ecstacy of delight to see Garrick mimicking a turkey-cock in the court-yard, with his coat-tail stuck out behind, and in a seeming flutter of feathered rage and pride. Of our party only two persons present had seen the British Roscius; and they seemed as willing as the rest to renew their acquaintance with their old favourite.

We were interrupted in the hey-day and mid-career of this fanciful speculation, by a grumbler in a corner, who declared it was a shame to make all this rout about a mere player and farce-writer, to the neglect and exclusion of fine old dramatists, the contemporaries and rivals of Shakspeare. Lamb said he had anticipated this objection when he had named the author of *Mustapha and Alaham*, and out of caprice insisted upon keeping him to represent the set, in preference to the wild hare-brained enthusiast Kit Marlowe; to the sexton of St. Ann's, Webster, with his melancholy yew-trees and death's-heads; to Decker, who was but a garrulous proser; to the voluminous Heywood; and even to Beau-

mont and Fletcher, whom we might offend by complimenting the wrong author on their joint productions. Lord Brook, on the contrary, stood quite by himself, or in Cowley's words, was " a vast species alone." Someone hinted at the circumstance of his being a lord, which rather startled Lamb, but he said a *ghost* would perhaps dispense with strict etiquette, on being regularly addressed by his title. Ben Jonson divided our suffrages pretty equally. Some were afraid he would begin to traduce Shakspeare, who was not present to defend himself. " If he grows disagreeable," it was whispered aloud, " there is Godwin can match him." At length, his romantic visit to Drummond of Hawthornden was mentioned, and turned the scale in his favour.

Lamb inquired if there was any one that was hanged that I would choose to mention ? And I answered, Eugene Aram.[1] The name of the " Admirable Crichton " was suddenly started as a splendid example of waste talents, so different from the generality of his countrymen. This choice was mightily approved by a North-Briton present, who declared himself descended from that prodigy of learning and accomplishment, and said he had family plate in his possession as vouchers for the fact, with the initials A. C.— *Admirable Crichton !* Hunt laughed or rather roared as heartily at this as I should think he has done for many years.

The last-named Mitre-courtier[2] then wished to know whether there were any metaphysicians to whom one might be tempted to apply the wizard spell ? I replied, there were only six in modern times deserving the name—Hobbes, Berkeley, Butler, Hartley, Hume, Leibnitz; and perhaps Jonathan Edwards, a Massachusets man. As to the French, who talked fluently of having *created* this science, there was not a tittle in any of their writings, that was not to be found literally in the authors I had mentioned. (Horne Tooke, who might have a claim to come under the head of Grammar, was still living.) None of these names seemed to excite much interest, and I did not plead for the reappearance of those who might be thought best fitted by the abstracted nature of their studies for their present spiritual and disembodied state, and who, even while on this living stage,

[1] See *Newgate Calendar* for 1758.
[2] Lamb at this time occupied chambers in Mitre Court, Fleet Street.

were nearly divested of common flesh and blood. As A[yrton] with an uneasy fidgetted face was about to put some question about Mr. Locke and Dugald Stewart, he was prevented by Martin Burney who observed, " If J—— was here, he would undoubtedly be for having up those profound and redoubted scholiasts, Thomas Aquinas and Duns Scotus." I said this might be fair enough in him who had read or fancied he had read the original works, but I did not see how we could have any right to call up these authors to give an account of themselves in person, till we had looked into their writings.

By this time it should seem that some rumour of our whimsical deliberation had got wind, and had disturbed the *irritabile genus* in their shadowy abodes, for we received messages from several candidates that we had just been thinking of. Gray declined our invitation, though he had not yet been asked: Gay offered to come and bring in his hand the Duchess of Bolton, the original Polly: Steele and Addison left their cards as Captain Sentry and Sir Roger de Coverley: Swift came in and sat down without speaking a word, and quitted the room as abruptly: Otway and Chatterton were seen lingering on the opposite side of the Styx, but could not muster enough between them to pay Charon his fare: Thomson fell asleep in the boat, and was rowed back again—and Burns sent a low fellow, one John Barleycorn, an old companion of his who had conducted him to the other world, to say that he had during his lifetime been drawn out of his retirement as a show, only to be made an exciseman of, and that he would rather remain where he was. He desired, however, to shake hands by his representative—the hand, thus held out, was in a burning fever, and shook prodigiously.

The room was hung round with several portraits of eminent painters. While we were debating whether we should demand speech with these masters of mute eloquence whose features were so familiar to us, it seemed that all at once they glided from their frames, and seated themselves at some little distance from us. There was Leonardo with his majestic beard and watchful eye, having a bust of Archimedes before him; next him was Raphael's graceful head turned round to the Fornarina; and on his other side was Lucretia Borgia,

with calm golden locks; Michael Angelo had placed the
model of St. Peter's on the table before him; Correggio had
an angel at his side; Titian was seated with his Mistress
between himself and Giorgione; Guido was accompanied by
his own Aurora, who took a dice-box from him; Claude
held a mirror in his hand; Rubens patted a beautiful
panther (led in by a satyr) on the head; Vandyke appeared
as his own Paris, and Rembrandt was hid under furs, gold
chains, and jewels, which Sir Joshua eyed closely, holding
his hand so as to shade his forehead. Not a word was spoken;
and as we rose to do them homage, they still presented the
same surface to view. Not being *bona-fide* representations of
living people, we got rid of the splendid apparitions by signs
and dumb show. As soon as they had melted into thin air,
there was a loud noise at the outer door, and we found it was
Giotto, Cimabue, and Ghirlandaio, who had been raised
from the dead by their earnest desire to see their illustrious
successors—

> " Whose names on earth
> In Fame's eternal records live for aye! "

Finding them gone, they had no ambition to be seen after
them, and mournfully withdrew. " Egad! " said Lamb,
" those are the very fellows I should like to have had some
talk with, to know how they could see to paint when all was
dark around them ? "
 " But shall we have nothing to say," interrogated G. J.——,
" to the Legend of Good Women ? "—" Name, name, Mr.
J——," cried H—— in a boisterous tone of friendly exulta-
tion, " name as many as you please, without reserve or fear
of molestation! " J—— was perplexed between so many
amiable recollections, that the name of the lady of his choice
expired in a pensive whiff of his pipe; and Lamb impatiently
declared for the Duchess of Newcastle. Mrs. Hutchinson
was no sooner mentioned, than she carried the day from the
Duchess. We were the less solicitous on this subject of filling
up the posthumous lists of Good Women, as there was
already one[1] in the room as good, as sensible, and in all re-
spects as exemplary, as the best of them could be for their
lives! " I should like vastly to have seen Ninon de L'Enclos,"

[1] Mary Lamb.—*B.*

said that incomparable person; and this immediately put
us in mind that we had neglected to pay honour due to our
friends on the other side of the Channel: Voltaire, the
patriarch of levity, and Rousseau, the father of sentiment,
Montaigne and Rabelais (great in wisdom and in wit),
Molière and that illustrious group that are collected round
him (in the print of that subject) to hear him read his comedy
of the *Tartuffe* at the house of Ninon; Racine, La Fontaine,
Rochefoucault, St. Evremont, &c.

"There is one person," said a shrill, querulous voice, "I
would rather see than all these—Don Quixote!"

"Come, come!" said H——; "I thought we should
have no heroes, real or fabulous. What say you, Mr. Lamb?
Are you eking out your shadowy list with such names as
Alexander, Julius Caesar, Tamerlane, or Ghengis Khan?"
—"Excuse me," said Lamb; "on the subject of characters
in active life, plotters and disturbers of the world, I have a
crotchet of my own, which I beg leave to reserve."—"No,
no! come, out with your worthies!"—"What do you think
of Guy Fawkes and Judas Iscariot?" H—— turned an eye
upon him like a wild Indian, but cordial and full of smothered
glee. "Your most exquisite reason!" was echoed on all
sides; and Ayrton thought that Lamb had now fairly en-
tangled himself. "Why, I cannot but think," retorted he
of the wistful countenance, "that Guy Fawkes, that poor,
fluttering annual scare-crow of straw and rags, is an ill-used
gentleman. I would give something to see him sitting pale
and emaciated, surrounded by his matches and his barrels
of gunpowder, and expecting the moment that was to trans-
port him to Paradise for his heroic self-devotion; but if I
say any more, there is that fellow Godwin will make some-
thing of it. And as to Judas Iscariot, my reason is different.
I would fain see the face of him who, having dipped his
hand in the same dish with the Son of Man, could afterwards
betray him. I have no conception of such a thing (not
even Leonardo's very fine one) that gave me the least idea of
it." "You have said enough, Mr. Lamb, to justify your
choice."

"Oh! ever right, Menenius,—ever right!"

"There is only one other person I can ever think of after
this," continued Lamb; but without mentioning a name

that once put on a semblance of mortality. " If Shakspeare was to come into the room, we should all rise up to meet him; but if that person was to come into it, we should all fall down and try to kiss the hem of his garment! "

As a lady present seemed now to get uneasy at the turn the conversation had taken, we rose up to go. The morning broke with that dim, dubious light by which Giotto, Cimabue and Ghirlandaio must have seen to paint their earliest works; and we parted to meet again and renew similar topics at night, the next night, and the night after that, till that night overspread Europe which saw no dawn. The same event, in truth, broke up our little Congress that broke up the great one. But that was to meet again: our deliberations have never been resumed.

MRS. LEICESTER'S SCHOOL
published 1807

[W. S. Landor to Crabb Robinson, April 1831.]

It is now several days since I read the book you recommended to me, *Mrs. Leicester's School*; and I feel as if I owed a debt in deferring to thank you for many hours of exquisite delight. Never have I read anything in prose so many times over, within so short a space of time, as The Father's Wedding-day. Most people, I understand, prefer the first tale—in truth a very admirable one—but others could have written it. Show me the man or woman, modern or ancient, who could have written this one sentence: " When I was dressed in my new frock, I wished poor mamma was alive to see how fine I was on papa's wedding-day; and I ran to my favourite station at her bedroom door." How natural, in a little girl, is this incongruity—this impossibility! Richardson would have given his *Clarissa* and Rousseau his *Heloïse*, to have imagined it. A fresh source of the pathetic bursts out before us, and not a bitter one. If your Germans can show us anything comparable to what I have transcribed, I would almost undergo a year's gurgle of their language for it. The story is admirable throughout,—incomparable, inimitable.

ADVENTURES OF ULYSSES

1808

[Godwin to Lamb, March 10th, 1808.]

Dear Lamb,—I address you with all humility, because I know you to be *tenax propositi*. Hear me, I entreat you, with patience.

It is strange with what different feelings an author and a bookseller looks at the same manuscript. I know this by experience: I was an author, I am a bookseller. The author thinks what will conduce to his honour: the bookseller what will cause his commodities to sell.

You, or some other wise man, I have heard to say, It is children that read children's books, when they are read, but it is parents that choose them. The critical thought of the tradesmen puts itself therefore into the place of the parent, and what the parent will condemn.

We live in squeamish days. Amid the beauties of your manuscript, of which no man can think more highly than I do, what will the squeamish say to such expressions as these,—" devoured their limbs, yet warm and trembling, lapping the blood," p. 10 ? Or to the giant's vomit, p. 14; or to the minute and shocking description of the extinguishing the giant's eye in the page following ? You, I dare say, have no formed plan of excluding the female sex from among your readers, and I, as a bookseller, must consider that if you have, you exclude one half of the human species.

Nothing is more easy than to modify these things if you please, and nothing, I think, is more indispensable.

Give me, as soon as possible, your thoughts on the matter.

I should also like a preface. Half our customers know not Homer, or know him only as you and I know the lost authors of antiquity. What can be more proper than to mention one or two of those obvious recommendations of his works, which must lead every human creature to desire a nearer acquaintance.—Believe me, ever faithfully yours,

W. GODWIN.

A SPEAKING PANTOMIME
1808

[Mary Lamb, letter to Sarah Stoddart, December 10th, 1808.]

The Skeffington is quite out now, my brother having got drunk with claret and Tom Sheridan. This visit, and the occasion of it, is a profound secret, and therefore I tell it to nobody but you and Mrs. Reynolds. Through the medium of Wroughton, there came an invitation and proposal from T. S., that C. L. should write some scenes in a speaking Pantomime, the other parts of which Tom now, and his father formerly, have manufactured between them. So, in the Christmas holydays, my brother and his two great associates, we expect, will be all three damned together, that is, I mean, if Charles's share, which is done and sent in, is accepted.

AT WINTERSLOW
1809

[W. Hazlitt, London Magazine, September 1820.]

L—— once came down into the country to see us. He was "like the most capricious poet Ovid among the Goths." The country people thought him an oddity, and did not understand his jokes. It would be strange if they had; for he did not make any while he staid. But when we crossed the country to Oxford, then he spoke a little. He and the old colleges were hail-fellow-well-met; and in the quadrangles, he "walked gowned."

LAMB AND BLAKE'S CATALOGUE
1810

[Crabb Robinson, 1827.]

When, in 1810, I gave Lamb a copy of the Catalogue of the paintings exhibited in Carnaby Street, he was delighted, especially with the description of a painting afterwards

engraved, and connected with which there was a circum-
stance which, unexplained, might reflect discredit on a
most excellent and amiable man. It was after the friends of
Blake had circulated a subscription paper for an engraving
of his " Canterbury Pilgrims," that Stothard was made a
party to an engraving of a painting of the same subject, by
himself. But Flaxman considered this as not done wilfully.
Stothard's work is well known; Blake's is known by very
few. Lamb preferred the latter greatly, and declared that
Blake's description was the finest criticism he had ever read
of Chaucer's poem.

HAZLITT AND TOBACCO
1811

[*S.T.C. to Rickman, October* 1811.]

Re the subject of dining with Lamb I had a long conversa-
tion with him yester-evening—and only blame myself, that
having long felt the deepest convictions of the vital impor-
tance of his not being visited till after 8 o'clock and then, too,
rarely except on his open nights, I should yet have been led
to take my friend M[organ] there, at dinner, at his proposal,
out of a foolish delicacy in telling him the plain truth, that it
must not be done. I am right glad, that something effective
is now done—tho' permit me to say to you in confidence,
that as long as Hazlitt remains in town I dare not expect any
amendment in Lamb's health, unless luckily H. should grow
moody and take offence at being desired not to come till
8 o'clock. It is seldom indeed, that I am with Lamb more
than once in the week—and when at Hammersmith[1], most
often not once in a fortnight, and yet I see what harm has
been done even by me—what then if Hazlitt—as probably he
will—is with him 5 evenings in the seven ? Were it possible
to wean C. L. from the pipe, other things would follow with
comparative ease, for till he gets a pipe, I have regularly
observed that he is contented with porter—and that the
unconquerable appetite for spirit comes in with the tobacco
—the oil of which, especially in the gluttonous manner in

[1] Coleridge was living with J. J. Morgan there.—*B.*

which he *volcanizes* it, acts as an instant poison on his stomach or lungs.—Believe me, dear Sir,

<div style="text-align:center">Yours with affectionate Esteem,
S. T. COLERIDGE.</div>

LAMB IN 1811

<div style="text-align:center">[Crabb Robinson.]</div>

<div style="text-align:center">I</div>

January 8th. Spent part of the evening with Charles Lamb (unwell) and his sister. He had just read the *Curse of Kehama*, which he said he liked better than any of Southey's long poems. The descriptions he thought beautiful, particularly the finding of Kailyal by Ereenia. He liked the opening, and part of the description of hell; but, after all, he was not made happier by reading the poem. There is too much trick in it. The three statues and the vacant space for Kehama resemble a pantomime scene; and the love is ill managed. On the whole, however, Charles Lamb thinks the poem infinitely superior to *Thalaba.*

We spoke of Wordsworth and Coleridge. To my surprise, Lamb asserted the latter to be the greater man. He preferred the *Ancient Mariner* to anything Wordsworth had written. He thought the latter too apt to force his own individual feelings on the reader, instead of, like Shakespeare, entering fully into the feelings of others. This, I observed, is very much owing to the lyrical character of Wordsworth's poems. And Lamb concluded by expressing high admiration of Wordsworth, and especially of the *Sonnets.* He also spoke of *Hart-leap Well* as exquisite.

Some one, speaking of Shakespeare, mentioned his anachronism in which Hector speaks of Aristotle. " That's what Johnson referred to," said Lamb, " when he wrote,—

<div style="text-align:center">" And panting Time toils after him in vain! "</div>

<div style="text-align:center">II</div>

March 16th. C. Lamb stepped in to announce Dr. Tuthill's defeat as candidate for the post of physician to St. Luke's Hospital.[1] He accompanied me and Mrs. Collier to Covent

[1] Lamb was a benefactor of that Asylum.—*B.*

Garden. *Cato* was acted. . . . *Bluebeard* followed, to the delight
of a crowded audience. C. L. was seemingly very merry—
his sister's illness I dare say leaves him in no other state than
outward affliction or violent and false spirits which he works
himself into to subdue his real feeling.

III

June 13*th*. After tea a call on C. Lamb. His brother with
him. A chat on puns. Evanson, in his *Dissonance of the
Gospels*, thinks Luke most worthy of credence. P—— said
that Evanson was a lukewarm Christian. I related this to
C. Lamb. But, to him, a mere play of words was nothing
without a spice of the ridiculous. He was reading with a
friend a book of Eastern travels, and the friend observed of
the Mantochu Tartars, that they must be cannibals. This
Lamb thought better. The large room in the accountant's
office at the East India House is divided into boxes or com-
partments, in each of which sit six clerks, Charles Lamb him-
self in one. They are called compounds. The meaning of
the word was asked one day, and Lamb said it was " a collec-
tion of simples."

IV

May 15*th*. A very pleasant call on Charles and Mary
Lamb. Read his version of the story of Prince Dorus, the
long-nosed king. Gossipped about writing. Urged him to
try his hand at a metrical Umarbeitung (working up) of
" Reynard the Fox." He believed, he said, in the excellence
of the work, but he was sure such a version as I suggested
would not succeed now. The sense of humour, he main-
tained, is utterly extinct. No satire that is not personal will
succeed.

V

July 21*st*. A call on C. Lamb. L. had met with an accident
(H. Wadd[1] had nearly put out his eye by throwing a pen
full of ink into it).

[1] Extract from " East India Register," 1810 : "*Account.-General's Department :
Clerks*— . . . C. Lamb, John Mathie, H. Dodwell, H. Rouse, H. Wadd. . . .
This last-named worthy figures in Lamb's epigram :

What Wadd knows, God knows,
But God knows what Wadd knows.—*B.*

VI

August 3rd. Bathed for the first time in Peerless Pool,[1] originally perilous pool; but it deserves neither title. In the evening at Charles Lamb's. He was serious, and therefore very interesting. I accidentally made use of the expression " poor Coleridge! " Lamb corrected me, not angrily, but as if really pained. " He is," he said, " a fine fellow, in spite of all his faults and weaknesses. Call him Coleridge; I hate ' poor,' as applied to such a man. I can't bear to hear such a man pitied." He then quoted an expression to the same effect by (I think) Ben Jonson, of Bacon.

VII

December 5th. While Coleridge was commenting on Lancaster's[2] mode of punishing boys, Lamb whispered: " It is a pity he did not leave this till he got to ' Henry VI,' for then he might say he could not help taking part against the Lancastrians." Afterwards, when Coleridge was running from topic to topic, Lamb said, " This is not much amiss. He promised a lecture on the Nurse in *Romeo and Juliet,* and in its place he has given us one in the manner of the Nurse."

VIII

December 10th. Miss Lamb dined with us. In the evening Charles Lamb, Manning, and Mrs. Fenwick; a pleasant evening. Lamb spoke well about Shakespeare. I had objected to Coleridge's assertion, that Shakespeare, as it were, identified himself with everything except the vicious, and I observed that if Shakespeare's becoming a character is to be determined by the truth and vivacity of his delineation, he had become some of the vicious characters as well as the virtuous. Lamb justified Coleridge's remark, by saying that Shakespeare never gives characters wholly odious and detestable. I adduced the King in *Hamlet* as altogether mean; and he allowed this to be the worst of Shakespeare's characters. He has not another like it. I cited Lady Macbeth. " I think this one of Shakespeare's worst characters," said Lamb. " It is also inconsistent with

[1] Where Lamb, I believe, would have bathed as a Bluecoat boy.—*B.*

[2] Joseph Lancaster, the educational reformer. See *Coleridge's Shakespearean Criticism,* ed. T. M. Raysor, 1930, ii 111.—*B.*

itself. Her sleep-walking does not suit so hardened a being."
. . . I then referred to the Bastard in *Lear*, but Lamb con-
sidered his character as the result of provocation on account
of his illegitimacy. Lamb mentioned Iago and Richard III
as admirable illustrations of the skill with which Shakespeare
could make his worst characters interesting. I noticed King
John and Lewis, as if Shakespeare meant, like a Jacobin, to
show how base kings are. Lamb did not remark on this, but
said *King John* is one of the plays I like least." He praised
Richard II.

<div align="center">IX</div>

December 15th. On coming away Mrs. Godwin took me
into another room and very angrily reproached me with not
bearing anything from G. while I would take anything
from C. Lamb.

C. Lamb says rude things, but always in so playful a style
that you are sure he means nothing by what he says. Mrs. G.
also spoke of the persecution she has to bear from the Lambs,
Mrs. Holcroft, etc. But I would hear nothing on that
subject.

<div align="center">

LAMB IN 1812

[Crabb Robinson.]

I
</div>

January 17th. At 10, went to Barron Field's [at No. 4.
Hare Court, Temple]. C. Lamb, and Leigh Hunt and Mrs.
Hills there. Lamb and Hunt, I found, had had a contest
about Coleridge. H. had spoken of him as a bad writer,
L. as of the first man he ever knew. The dispute was revived
by me, but nothing remarkable was said. C. L. who soon
became tipsy, in his droll extravagant way abused everyone
who denied the transcendency, while H. dryly denied the
excellency of his writings and expressed his regret that he
did not know him personally. H. took L's. speeches in good
part, evidently by his manner showed his respect for his
talents while C. L. to make his freedom endurable praised
Hunt's remarks on Fuseli (a praise H. seemed to relish). I
spoke about Hazlitt's lectures in terms of great praise, but

C. L. would not join me and I fear I did not succeed in my object. I left C. L. getting very drunk, and I understand the party remained up till late. I staid only till 12.

II

April 12th. A call on the Aikins. The whole family full of their praises of Charles Lamb. The Doctor termed him a brilliant writer. The union of so much eloquence with so much wit shows great powers of mind. Miss Aikin was not less warm in her praise. She asked why he did not write more. I mentioned, as one cause, the bad character given him by the reviewers. She exclaimed against the reviewers. I then spoke of the *Annual Review* (Arthur Aikin, the editor, was present), as having hurt him much by its notice of *John Woodvil.* She exclaimed, " Oh! that Tommy; that such a fellow should criticize such a man as Lamb."

III

June 6th. Lent *Peter Bell* to Charles Lamb. To my surprise, he does not like it. He complains of the slowness of the narrative, as if that were not the art of the poet. He says Wordsworth has great thoughts, but has left them out here. In the perplexity arising from the diverse judgments of those to whom I am accustomed to look up, I have no resource but in the determination to disregard all opinions, and trust to the simple impression made on my own mind.

A HIT
1812

[*Lady C. Bury,* Diary Illustrative of the Times of George IV, 1838.]

November 10th. I send you some verses which I read in *The Examiner.* I think them very witty, although very abominable. Believe me, most truly yours, M. G. Lewis. [Lamb's *The Triumph of The Whale* is transcribed.[1]] Who is there that

[1] The piece was thought to be Byron's, and is included in the Paris edition of his *Poems,* 1829. It probably paved the way of *The Examiner* proprietors to their imprisonment (see p. 64).—*B.*

may not be caricatured, when the most avowedly graceful man of his time, or perhaps of any time, can thus be personally ridiculed ?

SEVENTEEN KINDS OF E's
1813

[Crabb Robinson.]

December 30th. After dinner a rubber at Lamb's; then went with Lamb and Burney to Rickman's. Hazlitt there. Cards, as usual, were our amusement. Lamb was in a pleasant mood. Rickman produced one of Chatterton's forgeries. In one manuscript there were seventeen different kinds of e's. " Oh," said Lamb, " that must have been written by one of the

ν " Mob of gentlemen who write with ease."[1]

VISITS TO LEIGH HUNT IN PRISON
1814

[Leigh Hunt (writing as " Harry Brown ") in The Examiner, *August 25th, 1816.]*

TO C. L.

O thou, whom old Homer would call, were he living,
Home-lover, thought-feeder, abundant-joke-giving;
Whose charity springs from deep-knowledge, nor swerves
Into mere self-reflections, or scornful reserves;
In short, who were made for two centuries ago,
When Shakspeare drew men, and to write was to know;
You'll not be surprised that I can't walk the streets,
Without thinking of you and your visiting feats,
When you call to remembrance how you and one more,
When I wanted it most, used to knock at my door.
For when the sad winds told us rain would come down,

[1] Pope's *Satires and Epistles of Horace Imitated, Bk II. Ep. I.*—B.

Or snow upon snow fairly clogg'd up the town,
And dun yellow fogs brooded over its white,
So that scarcely a being was seen towards night,
Then, then said the lady yclept near and dear,
" Now mind what I tell you,—the L.'s will be here."
So I pok'd up the flame, and she got out the tea,
And down we both sat, as prepar'd as could be;
And there, sure as fate, came the knock of you two,[1]
Then the lantern, the laugh, and the " Well, how d'ye
 do!"
Then your palms tow'rds the fire, and your face turn'd to
 me,
And shawls and great coats being—where they should
 be,—
And due " never saws " being paid to the weather,
We cherish'd our knees, and sate sipping together,
And leaving the world to the fogs and the fighters,
Discuss'd the pretensions of all sorts of writers;
Of Shakspeare's coevals, all spirits divine;
Of Chapman, whose *Homer's* a fine rough old wine;
• Of Marvell, wit, patriot, and poet, who knew
To give, both at once, Charles and Cromwell their due;
Of Spenser, who wraps you, wherever you are,
In a bow'r of seclusion beneath a sweet star;
Of Richardson too, who afflicts us so long,
We begin to suspect him of nerves over strong;
In short, of all those who give full-measur'd page,
Not forgetting Sir Thomas, my ancestor sage,
Who delighted (so happy were all his digestions)
In puzzling his head with impossible questions,
But *now*, Charles—you never (so blissful you deem me)
Come lounging, with twirl of umbrella, to see me.
In vain have we hop'd to be set at our ease
By the rains, which you know used to bring L—— and
 pease;
In vain we look out like the children in Thomson,
And say, in our innocence, " Surely he'll come soon."

[1] " But what return can I make to the L.'s, who came to comfort me in all
weathers, hail or sunshine, in daylight or in darkness, even in the dreadful
frost and snow of the beginning of 1814 ? I am always afraid of talking about
them, lest my tropical experiment " [qy. *temperament*] " should seem to render
me too florid." L. H.

E

LAMB IN 1814

[Crabb Robinson.]

I

May 28th. After dinner with the Colliers accompanied Charles and Miss Lamb to Dr. Aikin's. The visit was highly agreeable to all parties. Lamb was quite on his good behaviour. He kept within bounds and yet was very pleasant. He related a droll history of a clerk in the India House suspected of living on human flesh, and he introduced the whimsical conceit that among cannibals a man who would not join in the common diet would be called a Misanthropist. Lamb abused Gray's poetry, but the Aikins did not take up the assertion, and the Doctor's favourite opinion of the unimprovability of mankind met with no opposition from the L.'s. Miss A. admired both the wit and the fine face of Lamb, and he was pleased with the family, particularly the old lady. I believe they will renew their visit.

II

June 29th. Called on Lamb in the evening. Found him as delighted as a child with a garret he had appropriated and adorned with all the copper-plate engravings he could collect, having rifled every book he possesses for the purpose. It was pleasant to observe his innocent delight. Schiller says all great men have a childlikeness in their nature.

III

July 3rd. A day of great pleasure. Charles Lamb and I walked to Enfield by Southgate, after an early breakfast in his chambers. We were most hospitably received by Anthony Robinson and his wife. After tea, Lamb and I returned. The whole day most delightfully fine, and the scenery very agreeable. Lamb cared for the walk more than the scenery, for the enjoyment of which he seems to have no great susceptibility. His great delight, even in preference to a country walk, is a stroll in London. The shops and the busy streets, such as Thames Street, Bankside, &c., are his great favourites. He, for the same reason, has no great relish for landscape painting. But his relish for historic painting is

exquisite. Lamb's peculiarities are very interesting. We had not much conversation—he hummed tunes, I repeated Wordsworth's " Daffodils," of which I am become very fond. Lamb praised T. Warton's " Sonnet in Dugdale " as of first-rate excellence.[1] It is a good thought, but I find nothing exquisite in it. He praised Prior's courtly poems—his " Down Hall "—his fine application of the names of Marlborough, so as to be offensive in the ears of Boileau.

IV

November 21st. In the evening I stepped over to Lamb, and sat with him from ten to eleven. He was very chatty and pleasant. Pictures and poetry were the subjects of our talk. He thinks no description in *The Excursion* so good as the history of the country parson who had been a courtier. In this I agree with him. But he dislikes *The Magdalen*, which he says would be as good in prose, in which I do not agree with him.

LAMB'S STUDY

1814

[*Mary Lamb, letter to Barbara Betham, November 2nd, 1814.*]

We still live in Temple-lane, but I am now sitting in a room you never saw; soon after you left us we were distressed by the cries of a cat, which seemed to proceed from the garrets adjoining to ours, and only separated from ours by the locked door on the farther side of my brother's bedroom, which you know was the little room at the top of the kitchen stairs. We had the lock forced and let poor puss out from behind a panel of the wainscot, and she lived with us from that time, for we were in gratitude bound to keep her, as she had introduced us to four untenanted, unowned rooms, and by degrees we have taken possession of these unclaimed apartments—first putting up lines to dry our clothes, then moving my brother's bed into one of these, more commodious than his own room. And last winter, my brother being unable to pursue a work he had begun, owing to the kind interruptions of friends who were more at leisure than

[1] This Sonnet was " written in a Blank Leaf of Dugdale's *Monasticon.*"

himself, I persuaded him that he might write at his ease in
one of these rooms, as he could not then hear the door knock,
or hear himself denied to be at home, which was sure to
make him call out and convict the poor maid in a fib. Here,
I said, he might be almost really not at home. So I put in
an old grate, and made him a fire in the largest of these
garrets, and carried in one table and one chair, and bid him
write away, and consider himself as much alone as if he
were in some lodging on the midst of Salisbury Plain, or
any other wide unfrequented place where he could expect
few visitors to break in upon his solitude. I left him quite
delighted with his new acquisition, but in a few hours he
came down again with a sadly dismal face. He could do
nothing, he said, with those bare whitewashed walls before
his eyes. He could not write in that dull unfurnished prison.

The next day, before he came home from his office, I had
gathered up various bits of old carpeting to cover the floor;
and, to a little break the blank look of the bare walls, I hung
up a few old prints that used to ornament the kitchen, and
after dinner, with great boast of what an improvement I
had made, I took Charles once more into his new study. A
week of busy labours followed, in which I think you would
not have disliked to have been our assistant. My brother
and I almost covered the walls with prints, for which pur-
pose he cut out every print from every book in his old library,
coming in every now and then to ask my leave to strip a
fresh poor author—which he might not do, you know, with-
out my permission, as I am elder sister. There was such
pasting, such consultation where their portraits, and where
a series of pictures from Ovid, Milton, and Shakespeare
would show to most advantage, and in what obscure corner
authors of humbler note might be allowed to tell their stories.
All the books gave up their stories but one—a translation
from Ariosto—a delicious set of four-and-twenty prints,
and for which I had marked out a conspicuous place; when
lo! we found at the moment the scissors were going to work
that a part of the poem was printed at the back of every
picture. What a cruel disappointment! To conclude this
long story about nothing, the poor despised garret is now
called the print room, and is become our most favourite
sitting-room.

A LONELY EVENING
1815

[*Crabb Robinson.*]

January 23rd. I then went to Lamb; he was glad to see me. He complained of his solitary evenings and that he was harassed by the business of his office, which, with the affliction his sister's illness caused him, renders his life wretched. He is indeed unhappy. I will try to be frequent in my visits for they relieve his spirits.

TRIBUTE TO LAMB AS A POET
1815

[*T. N. Talfourd, in* The Pamphleteer, 1815.]

Mr. Lamb has also written a tragedy, in which, as it was never intended for the stage, he has been able to follow, without restraint, the leading of his own genius. This simple production is, therefore, wholly unincumbered with the artificial splendor and the pompous decorations with which *Remorse*[1] was rendered palateable to the multitude, and appears in the chaste beauty which is beyond the reach of art. It contains no striking situation, no wonderful incident, no intricacy of plot—and, therefore, it has "no form nor comeliness," that ordinary readers should admire it. Those, however, who love our old dramatists for their gentler qualities, will be delighted with *John Woodvil*: they will find that the author has searched, with a fondness amounting to devotion, for those lovely springs of fresh inspiration at which they drank in the spirit of the creation in which they breathed. Of all living poets, he possesses most the faculty of delighting, he awakens the pulses of joy with more vivid touches, and by the mere force of natural imagery excites a keen shivering rapture, which, though far more serene, is scarcely less powerful than the greetings of happy lovers. There is a

[1] I do not know why Talfourd fell out with Coleridge's play, which indeed was praised elsewhere for its spectacular elements.—*B.*

venerableness, a scriptural sanctity about his little narratives, which enables us to contemplate them with a feeling somewhat similar to that with which we should gaze on an exquisite picture, dug from a buried city, in the freshness of its ancient colouring. They seem more like newly discovered narratives of holy writ, and fragments of patriarchal history, than the productions of the present generation. And yet the mind of the writer, caring little for the bustle of life, but seeking pure gratification in all that is cheerful and redeeming, amiable in its very jests and tender even in sportiveness, is clearly revealed in their sentiments. His singular qualities might disarm the most malicious criticism—for who, but the most profligate among those who sting to display their dexterity, could dare to wound one, whose sole aim seems to render us better by making us happier ? His very pathetic, touching, as it is, has not the slightest tinge of agony. The very tears he draws from us are those which it is a luxury to shed. The soft " music of humanity not harsh nor grating," seems to echo alike from the scenes of infancy or the green bed of friendship; from the cradle or the grave; in the same gentle and mellow notes which make the Soul forget its distresses and listen delighted.

TALFOURD'S RECOLLECTIONS

c. 1815

[*Memorials*, 1837.]

Methinks I see him before me now, as he appeared then, and as he continued, with scarcely any perceptible alteration to me, during the twenty years of intimacy which followed, and were closed by his death. A light frame, so fragile, that it seemed as if a breath would overthrow it, clad in clerk-like black, was surmounted by a head of form and expression the most noble and sweet. His black hair curled crisply about an expanded forehead; his eyes, softly brown, twinkled with varying expression, though the prevalent feeling was sad; and the nose slightly curved, and delicately carved at the nostril, with the lower outline of the face

regularly oval, completed a head which was finely placed on
the shoulders, and gave importance, and even dignity, to a
diminutive and shadowy stem. Who shall describe his
countenance—catch its quivering sweetness—and fix it for
ever in words ? There are none, alas! to answer the vain
desire of friendship. Deep thought, striving with humour;
the lines of suffering wreathed into cordial mirth; and a
smile of painful sweetness, present an image to the mind it
can as little describe as lose. His personal appearance and
manner are not unfitly characterized by what he himself
says in one of his letters to Manning of Braham—" a com-
pound of the Jew, the gentleman, and the angel."

The years[1] which Lamb passed in his chambers in Inner
Temple-lane were, perhaps, the happiest of his life. His
salary was considerably augmented, his fame as an author
was rapidly extending; he resided near the spot which he
best loved; and was surrounded by a motley group of
attached friends, some of them men of rarest parts, and all
strongly attached to him and to his sister. Here the glory
of his Wednesday nights shone forth in its greatest lustre.
If you did not meet there the favourites of fortune; authors
whose works bore the highest price in Paternoster-row,
and who glittered in the circles of fashion; you might find
those who had thought most deeply; felt most keenly; and
were destined to produce the most lasting influences on the
literature and manners of the age. There Hazlitt, sometimes
kindling into fierce passion at any mention of the great
reverses of his idol Napoleon, at other times bashfully enun-
ciated the finest criticisms on art; or dwelt with genial
iteration on a passage in Chaucer; or, fresh from the theatre,
expatiated on some new instance of energy in Kean, or reluct-
antly conceded a greatness to Kemble; or detected some
popular fallacy with the fairest and the subtlest reasoning.
There Godwin, as he played his quiet rubber, or benignantly
joined in the gossip of the day, sat an object of curiosity and
wonder to the stranger, who had been at one time shocked
or charmed with his high speculation, and at another awe
struck by the force and graphic power of his novels. There
Coleridge sometimes, though rarely, took his seat;—and then
the genial hubbub of voices was still ; critics, philosophers,

[1] 1809-17.

and poets, were contented to listen; and toil-worn lawyers,
clerks from the India House, and members of the Stock·
Exchange, grew romantic while he spoke. Lamb used to
say that he was inferior then to what he had been in his
youth; but I can scarcely believe it.

THURSDAY EVENINGS

c. 1815

[*W. Hazlitt*, " *On the Conversation of Authors*," London Magazine,
September· 1820.]

But when a set of adepts, of *illuminati*, get about a question,
it is worth while to hear them talk. They may snarl and
quarrel over it, like dogs; but they pick it bare to the bone,
they masticate it thoroughly.

This was the case at L——'s formerly—where we used
to have many lively skirmishes at their Thursday evening
parties. I doubt whether the small-coal man's musical
parties could exceed them. Oh! for the pen of John Buncle
to consecrate a *petit souvenir* to their memory! There was
L—— himself, the most delightful, the most provoking, the
most witty and sensible of men. He always made the best
pun, and the best remark, in the course of the evening. His
serious conversation, like his serious writing is his best. No
one ever stammered out such fine, piquant, deep, eloquent
things in half a dozen half sentences, as he does. His jests
scald like tears: and he probes a question with a play upon
words. What a keen, laughing, hair-brained vein of home-
felt truth! What choice venom! How often did we cut into
the haunch of letters, while we·discussed the haunch of
mutton on the table. How we skimmed the cream of criticism!
How we got into the heart of controversy! How we picked
out the marrow of authors! "And, in our flowing cups,
many a good name and true was freshly remembered."
Recollect (most sage and critical reader) that in all this I
was but a guest! Need I go over the names ? They were
but the old everlasting set—Milton and Shakspeare, Pope
and Dryden, Steele and Addison, Swift and Gay, Fielding,

Smollett, Sterne, Richardson, Hogarth's prints, Claude's landscapes, the Cartoons at Hampton-court, and all those things, that, having once been, must ever be. The Scotch Novels had not then been heard of: so we said nothing about them. In general, we were hard upon the moderns. The author of the *Rambler* was only tolerated in Boswell's *Life* of him; and it was as much as any one could do to edge in a word for Junius. L—— could not bear *Gil Blas*. This was a fault. I remember the greatest triumph I ever had was persuading him after some years' difficulty, that Fielding was better than Smollett. One one occasion, he was for making out a list of persons famous in history that one would wish to see again—at the head of whom were Pontius Pilate, Sir Thomas Browne, and Dr. Faustus—but we black-balled most of his list! But with what a gusto would he describe his favourite authors Donne, or Sir Philip Sidney, and call their most crabbed passages *delicious*! He tried them on his palate as epicures taste olives, and his observations had a smack in them, like a roughness on the tongue. With what discrimination he hinted a defect in what he admired most—as in saying that the display of the sumptuous banquet in *Paradise Regained* was not in true keeping, as the simplest fare was all that was necessary to tempt the extremity of hunger—and stating that Adam and Eve in *Paradise Lost* were too much like married people. He has furnished many a text for C—— to preach upon. There was no fuss or cant about him: nor were his sweets or his sours ever diluted with one particle of affectation. I cannot say that the party at L——'s were all of one description. There were honorary members, lay-brothers. Wit and good fellowship was the motto inscribed over the door. . . .

Those days are over! An event, the name of which I wish never to mention, broke up our party, like a bomb-shell thrown into the room: and now we seldom meet—

Like angels' visits, short and far between.

There is no longer the same set of persons, nor of associations. L—— does not live where he did. By shifting his abode, his notions seem less fixed. He does not wear his old snuff-coloured coat and breeches. It looks like an alteration in his style.

AT CAMBRIDGE
1815

[Mary Lamb in a letter.]

Last Saturday was the grand feast day of the India House
Clerks. I think you must have heard Charles talk of his
yearly turtle feast. He has been lately much wearied with
work, and, glad to get rid of all connected with it, he *used*
Saturday, the feast day being a holiday, *borrowed* the Mon-
day following, and we set off on the outside of the Cambridge
Coach from Fetter Lane at eight o'clock and were driven
into Cambridge in great triumph by Hell Fire Dick five
minutes before three. . . .

In my life I never spent so many pleasant hours together
as I did at Cambridge. We were walking the whole time—
out of one College into another. If you ask me which I like
best I must make the children's traditionary unoffending
reply to all curious enquirers, " Both." I liked them all
best. . . .

On the Sunday we met with a pleasant thing. We had
been congratulating each other that we had come alone to
enjoy, as the miser his feat, all our sights greedily to ourselves,
but having seen all we began to grow flat and wish for this
and tother body with us, when we were accosted by a young
gownsman whose face we knew but where or how we had
seen him we could not tell, and were obliged to ask his
name: he proved to be a young man we had twice seen at
Alsager's. He turned out a very pleasant fellow—shewed us
the insides of places—we took him to our Inn to dinner, and
drank tea with him in such a delicious college room, and
then again he supped with us. We made our meals as short
as possible, to lose no time, and walked our young conductor
almost off his legs. Even when the fried eels were ready
for supper and coming up, having a message from a man who
we had bribed for the purpose, that then we might see Oliver
Cromwell,[1] who was *not at home* when we called to see him,
we sallied out again and made him a visit by candlelight—
and so ended our sights. When we were setting out in the
morning our new friend came to bid us good bye and rode

[1] Cooper's portrait of Cromwell at Sidney Sussex.

with us as far as Trumpington. I never saw a creature so happy as he was the whole time he was with us, he said we had put him in such good spirits that [he] should certainly pass an examination well that he is to go through in six weeks in order to qualify himself to obtain a fellowship.

Returning home down old Fetter Lane I could hardly keep from crying to think it was all over. With what pleasure [Charles] shewed me Jesus College where Coleridge was— the barbe[rs shop] where Manning was—the house where Lloyd lived—Franklin's rooms (a young schoolfellow with whom Charles was the first time he went to Cambridge), I peeped in at his window, the room looked quite deserted— old chairs standing about in disorder that seemed to have stood there ever since they had sate in them. I write sad nonsense these things, but I wish you had heard Charles talk his nonsense over and over again about his visit to Franklin and how he then first felt himself commencing gentleman and had eggs for his breakfast. Charles Lamb commencing gentleman!

TALFOURD, ROBINSON, LAMB
1815
[Crabb Robinson.]

November 24th. I called on Lamb, and chatted an hour with him. Talfourd stepped in, and we had a pleasant conversation. Lamb has a very exclusive taste, and spoke with equal contempt of Voltaire's *Tales* and *Gil Blas*.[1] He may be right in thinking the latter belongs to a low class of compositions, but he ought not to deny that it has excellence of its kind.

A PRINT FROM LEONARDO
1816
[Crabb Robinson.]

July 13th. An unsettled morning. My print of Leonardo da Vinci's " Vierge aux Rochers " was brought home framed. I took it to Miss Lamb as a present. She was much

[1] Cf. Hazlitt's statement, p. 73.

pleased with it, and so was Lamb, and I lost much of the
morning in chatting with Miss Lamb. I dined at the
Colliers'. After dinner I went to Lamb's and took tea with
him. White[1] of the India House was there. We played three
rubbers of whist. Lamb was in great good humour, delighted
like a child with his present; but I am to change the frame
for him, as all his other frames are black. How Lamb
confirms the remark of the childlikeness of genius!

A MISSING VOLUME

1816

[*S. T. Coleridge, letter to J. H. Frere, July 16th*, 1816: Unpublished
Letters of S. T. C., *ed. E. L. Griggs*, 1932, *vol. ii.*]

Likewise, some 10 years ago Poor Charles Lamb took it
into his head that he had lent me a Volume of Dodsley's
Old Plays.[2] I thought him in joke at first; but hearing, that
he talked it off whenever he was tipsy (an effect, which 3
glasses of wine will produce at any time) I begged him to let
me have the other volumes and I would send him a new set.
This he refused with oaths, said he would never speak to me
again if I attempted it. At length however, I was lucky
enough to procure the odd volume from Southey, and gave
it to Lamb. His wild speeches (half joke, half dream) had it
seems been caught up by Robinson, who had talked (and
O ye Gods! how he does talk!) at the Westminster Library,
and elsewhere. Yesterday I had an opportunity of cross-
questioning him. Robinson, I have borrowed more Books
from you, than from all my acquaintance collectively:
because I could not procure German Books elsewhere.
Have I ever lost one? No.—Have I ever retained your
Books beyond the given time without obtaining your
permission? No.—Then you ought in justice to do your

[1] E. White, junior to Lamb in his department; an amateur artist.—*B.*

[2] Lamb continued to think that he had "lent" this volume to "Comberbatch,
matchless in his depredations." Discussing "slight vacuums" in his book-
shelves, in "The Two Races of Men" (*London Magazine*, December 1820), he
maintained, "Just below, Dodsley's dramas want their fourth volume, where
Vittoria Corombona is." The odd volume that Coleridge procured from
Southey seems not to have been *the same*; bookmen will catch the note.—*B.*

best to contradict the calumny, which your knowledge of poor Charles Lamb's Character ought to have prevented you from helping to spread. `

AMICABLE SOCIETY OF BLUES

1817

[*From* The Records of the Amicable Society of Blues, *by H. A. Roberts*, 1924.]

Minutes:

14 January, 1817. . . . Read a Work of C. Lamb's on Christ's Hospital—Resolved that C. Lamb be invited to Dine at the ensuing Meeting.

11 February, 1817—Present Henry Woodthorpe Senr member, Chairman, Messrs. Sparks, Nixson, Hill, Jackson, Deane, Few, Pinkey, Kennett, Steel, Bun, Blenkinsopp, Williams Secy—Visitors, C. Lamb[1] and Mr. Charles Cole—No. 15.—

Read a Correspondence between C. Lamb and Henry Woodthorpe Junr President. . . .

TROUBLE IN THE LAKE DISTRICT

1817

[*M. R. Mitford, September* 13th, 1817.]

The best estimate I ever met with of Wordsworth's powers is in Coleridge's very out-of-the-way, but very amusing *Biographia Literaria*. It is in the highest degree

[1] It is believed that this was the dinner of which Lamb wrote to Mrs. Wordsworth thus on February 18th, 1818: " I am always in pain, lest the gift of utterance should suddenly fail the orator in the middle, as it did me at the dinner given in honour of me at the London Tavern. ' Gentlemen,' said I, and there I stopped, the rest of my feelings were under the necessity of supplying." The correspondence mentioned has gone astray, but may be expected to come to light one day. The Woodthorpes, father and son, were Town Clerks of London. The Work which the Amicables read will have been what Leigh Hunt notes thus in his *Feast of the Poets*, 1814: " a very interesting account [of Christ's Hospital] in some late numbers of the *Gentleman's Magazine* by my friend Charles Lamb . . . of whose powers of wit and observation I should delight to say more, if he had not confined those chief talents of his to the fireside."—*B.*

flattering but it admits that he may have faults; and Mr. Lamb, who knows them both well, says he is sure Mr. Wordsworth will never speak to Mr. Coleridge again.

AFFAIR OF THE STAMP-CONTROLLER
1817

[*B. R. Haydon*, Autobiography, 1853, i, 353-7.]

In December Wordsworth was in town, and as Keats wished to know him, I made up a party to dinner, of Charles Lamb, Wordsworth, Keats, and Monkhouse, his friend, and a very pleasant party we had. I wrote to Lamb, and told him the address was " 22, Lisson Grove, North, at Rossi's, half way up, right-hand corner." I received his characteristic reply.

" My dear Haydon,
" I will come with pleasure to 22, Lisson Grove, North, at Rossi's, half way up, right-hand side, if I can find it.

" Yours,

" C. LAMB."

" 20, Russel Court,
Covent Garden East,
half way up, next the corner,
left-hand side."

On December 28th, the immortal dinner came off in my painting-room, with Jerusalem towering up behind us as a background. Wordsworth was in fine cue, and we had a glorious set-to—on Homer, Shakespeare, Milton, and Virgil. Lamb got exceedingly merry, and exquisitely witty; and his fun in the midst of Wordsworth's solemn intonations of oratory was like the sarcasm and wit of the fool in the intervals of Lear's passion. Lamb soon got delightfully merry. He made a speech and voted me absent, and made them drink my health. " Now," said Lamb, " you old lake poet, you rascally poet, why do you call Voltaire dull ? We all defended Wordsworth, and affirmed there was a state of mind when Voltaire would be dull. " Well," said

Lamb, "here's Voltaire—the Messiah of the French nation, and a very proper one too."

He then, in a strain of humour beyond description, abused me for putting Newton's head into my picture,—" a fellow," said he, " who believed nothing unless it was as clear as the three sides of a triangle." And then he and Keats agreed he had destroyed all the poetry of the rainbow, by reducing it to the prismatic colours. It was impossible to resist him, and we all drank " Newton's health, and confusion to mathematics." It was delightful to see the good humour of Wordsworth in giving in to all our frolics without affectation, and laughing as heartily as the best of us. By this time other friends joined, amongst them poor Ritchie, who was going to penetrate by Fezzan to Timbuctoo. I introduced him to all as " a gentleman going to Africa." Lamb seemed to take no notice; but all of a sudden he roared out, " Which is the gentleman we are going to lose ? " We then drank the victim's health, in which Ritchie joined.

In the morning of this delightful day, a gentleman, a perfect stranger, had called on me. He said he knew my friends, had an enthusiasm for Wordsworth, and begged I would procure him the happiness of an introduction. He told me he was a comptroller of stamps, and often had correspondence with the poet. I thought it a liberty; but still, as he seemed a gentleman, I told him he might come.

When we retired to tea we found the comptroller. In introducing him to Wordsworth I forgot to say who he was. After a little time the comptroller looked down, looked up, and said to Wordsworth, " Don't you think, sir, Milton was a great genius ? " Keats looked at me, Wordsworth looked at the comptroller. Lamb, who was dozing by the fire, turned round and said, " Pray, sir, did you say Milton was a great genius ? " " No, sir, I asked Mr. Wordsworth if he were not." " Oh," said Lamb, " then you are a silly fellow." " Charles, my dear Charles," said Wordsworth; but Lamb, perfectly innocent of the confusion he had created, was off again by the fire. After an awful pause the comptroller said, " Don't you think Newton a great genius ? " I could not stand it any longer. Keats put his head into my books. Ritchie squeezed in a laugh. Wordsworth seemed asking himself, " who is this ? " Lamb got up, and taking a

candle, said, " Sir, will you allow me to look at your phreno-
logical development ? " He then turned his back on the
poor man, and at every question of the comptroller he
chaunted,

> " Diddle, diddle, dumpling, my son John
> Went to bed with his breeches on."

The man in office, finding Wordsworth did not know who
he was, said in a spasmodic and half-chuckling anticipation
of assured victory, " I have had the honour of some corre-
spondence with you, Mr. Wordsworth." "With me, sir ? "
said Wordsworth, " not that I remember." " Don't you,
sir ? I am a comptroller of stamps." There was a dead
silence; the comptroller evidently thinking that was enough.
While we were waiting for Wordsworth's reply, Lamb sung
out

> " Hey diddle diddle,
> The cat and the fiddle."

" My dear Charles," said Wordsworth,

> " Diddle, diddle, dumpling, my son John,"

chaunted Lamb; and then rising, exclaimed, " Do let me
have another look at that gentleman's organs." Keats and
I hurried Lamb into the painting-room, shut the door, and
gave way to inextinguishable laughter. Monkhouse followed,
and tried to get Lamb away. We went back, but the comp-
troller was irreconcileable. We soothed and smiled, and
asked him to supper. He stayed, though his dignity was
sorely affected. However, being a good-natured man, we
parted all in good humour, and no ill effects followed. All
the while, until Monkhouse succeeded, we could hear Lamb
struggling in the painting-room, calling at intervals, " Who
is that fellow ? Allow me to see his organs once more."
It was indeed an immortal evening. Wordsworth's fine
intonation as he quoted Milton and Virgil, Keats's eager
inspired look, Lamb's quaint sparkle of lambent humour, so
speeded the stream of conversation, that in my life I never
passed a more delightful time. All our fun was within
bounds. Not a word passed that an apostle might not have
listened to. It was a night worthy of the Elizabethan age,

and my solemn Jerusalem flashing up by the flame of the fire, with Christ hanging over us like a vision, all made up a picture which will long glow upon

> " that inward eye
> Which is the bliss of solitude."

Keats[1] made Ritchie promise he would carry his *Endymion* to the great desert of Sahara, and fling it in the midst. Poor Ritchie went to Africa, and died, as Lamb foresaw, in 1819. Keats died in 1821, at Rome. C. Lamb is gone, joking to the last. Monkhouse is dead, and Wordsworth[2] and I are the only two now living (1841) of that glorious party.

THE WORKS OF CHARLES LAMB
[2 vols., 1818]

[*Leigh Hunt, in* The Examiner, *March* 1819; *rep.,* Indicator, 1821.]

. . . There is a spirit in Mr. Lamb's productions, which is in itself so *anti-critical,* and tends so much to reconcile us to all that is in the world, that the effect is almost neutralizing to every thing but complacency and a quiet admiration. We must even plainly confess, that one thing which gave a Laputan flap to our delay in speaking of these volumes, was

[1] Keats says of this evening: " then there was Wordsworth, Lamb, Monk-house, Landseer, Kingston and your Humble Servant. Lamb got tipsey and blew up Kingston—proceeding so far as to take the Candle across the Room, hold it to his face and show us wh-a-at-sort-fellow-he-was." (Letter, January 1818.)—*B.*

[2] It is uncertain to what year J. P. Collier's record of Wordsworth and Lamb in discussion of *Fairfax's Tasso* belongs: " Lamb mentioned the translation of Tasso by Fairfax, of which Wordsworth said he had no copy, and was not well acquainted with it. Lamb gave it as his opinion, that it was the very best, yet the very worst translation in English; and being asked for an explanation of his apparent paradox, he stammered a little, and then went on, pretty flowingly, to say that it was the best for the air of originality and ease, which marked many of the stanzas, and the worst, as far as he was able to judge (and he had been told the same by competent Italians) for [un]literal-ness, and want of adherence to the text. Nothing could be more wanton than Fairfax's deviations, excepting some of those in Sir John Harington's version of Ariosto, into which whole octaves had often been thrust without need or notice." Hazlitt said Fairfax had perforce " approached so near Spenser as absolutely to tread upon his heels. ' But,' (added Lamb stuttering) ' he has not only trodden upon his heels, but upon his toes too: I hope he had neither kibes nor corns."—*B.*

F

the meeting with a flimsy criticism is an orthodox review, which mistook the exquisite simplicity and apprehensiveness of Mr. Lamb's genius for want of power; and went vainly brushing away at some of the solidest things in his work under the notion of its being chaff.

That the poetical part of Mr. Lamb's volumes (and as this comes first, we will make the first half of our criticism upon it) is not so striking as the critical, we allow. And there are several reasons for it;—first, because criticism inevitably explains itself more to the reader; whereas poetry, especially such as Mr. Lamb's, often gives him too much credit for the apprehensiveness in which it deals itself;—second, because Mr. Lamb's criticism is obviously of a most original cast, and directly informs the reader of a number of things which he did not know before; whereas the poetry, for the reason just mentioned, leaves him rather to gather them;—third, because the author's genius, though in fact of an anti-critical nature (his very criticisms chiefly tending to overthrow the critical spirit) is also less busied with creating new things, which is the business of poetry, than with inculcating a charitable and patient content with old, which is a part of humanity:—fourth and last, because from an excess of this content, of love for the old poets, and of diffidence in recommending to others what has such infinite recommendations of its own, he has really, in three or four instances, written pure common-places on subjects deeply seated in our common humanity, such as the recollections of childhood, the poem that follows it, and one or two of the sonnets. But he who cannot see, that the extreme old simplicity of style in *The Three Friends* is a part and constituent recommendation of the very virtue of the subject; that the homely versification of the *Ballad noticing the Difference of Rich and Poor* has the same spirit of inward reference; that the little Robert Burton-like effusion, called *Hypochondriacus*, has all the quick mixture of jest and earnest belonging to such melancholy, and that the *Farewell to Tobacco* is a piece of exuberant pleasantry, equally witty and poetical, in which the style of the old poets becomes proper to a wit overflowing as theirs,—such a man may be fit enough to set up for a critic once a month, but we are sure he has not an idea in his head once a quarter. . . .

There is something very touching as well as vivid in the poem that stands first, entitled " Hester." The object of it is a female Quaker who died young, and who appears to have been of a spirit that broke through the cold shell of her sect. She was of a nature so sprightly and strong, that the poet, for some time, says he could not

> By force be led
> To think upon the wormy bed,
> And her together.

> My sprightly neighbour, gone before,
> To that unknown and silent shore,
> Shall we not meet, as heretofore,
> Some summer morning,

> When from thy chearful eyes a ray
> Hath struck a bliss upon the day,
> A bliss that would not go away
> A sweet fore-warning ?

The tragedy of *John Woodvil*, which we think liable in some measure to Mr. Coleridge's objection mentioned in the Dedication, of its being a little too over-antique in the style, gave rise, partly on that account, to less fortunate objection from the critics on its first appearance. People were not acquainted then as they are now with the older dramatists; and the critics, finding it a new production which was like none of their select common-places, confounded the oldness of the style and the manly and womanly simplicity of the sentiments with something hitherto unheard of, equally barbarous and mawkish. They have since learnt better, partly, perhaps chiefly, from the information of this very author; and it is doubtless a good deal owing to this circumstance, that some of them chuse to abstain from noticing this publication, the better natured from a feeling of awkwardness, and the malignant from having since turned commentators on old plays themselves. The tragedy of *John Woodvil* has this peculiarity, that it is founded on a frailty of a very unheroic nature, and ends with no punishment to

the offender but repentance. Yet so finely and humanly is it managed, with such attractions of pleasantry and of pathos, that these circumstances become distinguishing features of its excellence; and the reader begins to regret that other poets have not known how to reconcile moral lessons, so familiar and useful, with the dignity of dramatic poetry.

.

The pathetic of this tragedy is after all inferior to that of the story of *Rosamund Gray*, which very properly stands at the head of Mr. Lamb's Works, and is one of the most painful yet delightful in the world. There is one part of it, in which, to be sure, the pain greatly predominates; but this is told briefly, and with something beyond delicacy: and we have here to make a remark which has often struck us; namely, that in the most painful, most humiliating, and even most overwhelming and stupifying death of a virtuous person, there is something still which conquers the conqueror. The mere fact that the virtue, the good-heartedness, the sentiment (in whatever shape it may) of the sufferer survives to the last, leaves the happy-making faculty victorious over the temporary misfortune however dreadful; so that goodness in its most passive shape is greater and more powerful than vice is in its most active. *Rosamund*, like *Clarissa Harlowe*, is violated; but good God! what a difference in the management of the two stories. Mr. Lamb need not be alarmed: we are not going to say that Richardson is not a very extraordinary person.

.

The piece that follows is entitled *Recollections of Christ's Hospital*, and is a favourite with us on many accounts, not the least of which is, that we had the honour of being brought up in that excellent foundation as well as Mr. Lamb himself. Our *Recollections* of the school were somewhat later than his; but with the exception of a little less gratitude to one individual, and of a single characteristic, which his friend Mr. Coleridge had the chief hand, we suspect, in altering (and we trust not essentially or for the worse), we can give cordial testimony, up to that later period, of the fidelity of his descriptions. We know not how completely

or otherwise they may remain; but from what we see of the Christ Hospital boys in the streets, especially of the older and more learned part of them, and from the share which some of our old school-fellows have in the present tuition, we should guess that they still apply.

In coming to the *Essays* and their masterly criticism, we must repress our tendency to make extracts, or we shall never have done. We must content ourselves with but one noble passage; and with expressing our firm conviction, that to these *Essays,* including remarks on the performance of Shakspeare's tragedies, and the little notices of his contemporaries originally published in the well-known *Specimens of the Old English Dramatists,* the public are indebted for that keener perception and more poetical apprehension of the genius of those illustrious men, which has become so distinguishing a feature among the literary opinions of the day. There was a relish of it in *Seward,* but a small one, nor did his contemporaries sympathize even with that. The French Revolution, which for a time took away attention from everything but politics, had a great and new effect in rousing up the thinking faculties in every respect; and the mind, strengthened by unusual action, soon pierced through the flimsy common-places of the last half-century. By degrees, they were all broken up; and though some lively critics, who saw only the more eccentric part of the new genius and confounded it with the genius itself, re-edified them, they were too late, as now begins to be pretty generally felt. Mr. Lamb, whose resemblance to the old poets in his tragedy was ludicrously taken for imbecility, had sown his criticisms as well as his example against a genial day; it came; and lo and behold! the very critics, who cried out the most disdainfully against him, adopted these very criticisms, most of them, we are ashamed to say, without any acknowledgment. But he is now beginning to receive his proper praise, after waiting for it in the most quiet and unassuming manner perhaps of any writer living.

With the Letters under assumed signatures, some of which are in an exquisite taste of humour and wisdom united, many

of our readers are acquainted through the medium of *The Reflector*. Some of the pleasantries are among what may be called our *prose tunes*,—things which we repeat almost involuntarily when we are in the humour,—as the one for instance about the coffin handles " with wrought gripes," and the drawn battle between Death and the ornamental drops.

The undramatic mistake of the *Farce* at the conclusion of the volume is, that the humour is really too entertaining and the interest too much excited not to lead to inevitable disappointment when the mysterious Mr. H——, who has such a genteel horror of disclosing his name, turns out to have no worse a patronymic than *Hogsflesh*.[1] It is too desperate an appeal to the nominal infirmities common to great numbers of people. Had it been Mr. Horridface, or Mr. Hangman, or Mr. Highwayman, or Mr. Horn-owl, Hag-laugh, or Mr. Hellish, it might have been a little better; but then these would not have been so natural; in short, nothing would have done to meet so much expectation.

If we were to make a summary of Mr. Lamb's merits as a writer, we should say that there was not a deeper or more charitable observer existing. He has none of the abhorrent self-loves that belong to lesser understandings. He takes little, and grants much. He sees through all the causes or circumstances that modify the human character; and while he likes from sympathy, he dislikes with generosity and sincerity, and differs rather than pretends to be better. If there is anything indeed that looks like affectation in the most sincere and unaffected temper of his writings, it arises partly from the excess of his sympathy with his species, and partly from a wish to make the best of all which they do or suffer; and it leads him into the only inconsistency that we can trace to him. As an admirer for instance of Christianity, and perhaps as a Christian himself in the truest sense of the word, he sympathizes exceedingly with patience and gentleness and the forgiveness of wrongs. This also appears to be

[1] " Thomas Hood was sent to a school [about 1804] in Tokenhouse Yard, in the city, as a day-boarder. The two maiden sisters who kept the school, and with whom Hood took his dinner, had the odd name of Hogsflesh, and they had a sensitive brother, who was always addressed as ' Mr. H.,' and who subsequently became the prototype of Charles Lamb's unsuccessful farce called *Mr. H.*" (*Penny Cyclopædia*, 1846.)—B.

his own temper; but then he seems fearful lest this should be construed into a weakness instead of a strength; and so from turning his sympathy to another side of human nature, he palliates some of the most vehement and doubtful passions, and has a good word to say now and then in behalf of revenge itself. The consequence of this exceeding wish to make the best of things as they are (we do not speak politically, but philosophically), is, that his writings tend rather to prepare others for doing good wisely, than to help the progress of the species themselves. It is this sympathy also, which tends to give his criticisms a more prominent effect, than his poetry. He seems to think that poetry as well as prose has done enough, when it reconciles men to each other as they are; and that after Shakspeare and others, it is useless to say much on this subject; so that he deals little in the abstractions of fancy and imagination. He desires no better Arcadia than Fleet Street; or at least pretends as much, for fear of not finding it.—Mr. Lamb's style is sound idiomatic English, equally free from the foreign invasions of the pedantic, and the freaks of us prose coiners, who dabble in a light mint of our own for lawless purposes. It is variously adapted to the occasion. If he is somewhat too antiquated in his verse, he is familiar, short, and striking, in his more passionate prose narrative; and in his criticisms, flowing and eloquent.

Among the poems we ought not to forget two or three by the author's sister, who is the main writer, if we mistake not, in some excellent little publications for schools. There is a delightful family likeness in the turn of her genius. One of these little pieces in particular (*On a Picture of Two Females by Leonardo Da Vinci*) looks like an epitome of his whole philosophy,—full of sympathies with this world, yet with a thoughtful eye to the world unknown. It sets out in a fine stately-moving manner, like the noble young beauty of which it speaks.—Mr. Lamb has addressed a sonnet to his sister, full of a charming deference and gratitude.

1818-25

ELIA AND HIS ADMIRERS

A PUNSTER'S ANGUISH
1818

[*J. Keats, letter of December* 1818.]

I have seen Lamb lately—Brown and I were taken by Hunt to Novello's—there we were devastated and excruciated with bad and repeated puns—Brown don't want to go again.

SHELLEY
1819

I

[*P. B. Shelley to Leigh Hunt, September* 3rd, 1819.]

At length has arrived Ollier's parcel. With it came, too, Lamb's *Works.*[1]—I have looked at none of the other books yet.—What a lovely thing is his *Rosamund Gray*, how much knowledge of the sweetest and deepest parts of our nature is in it! When I think of such a mind as Lamb's—when I see how unnoticed remain things of such exquisite and complete perfection, what should I hope for myself, if I had not higher objects in view than fame ? . . .

II

[*Hunt to Shelley, September* 6th, 1819.]

. . . I showed Lamb that passage about his *Rosamund*, upon which he said with the greatest air of sincerity, " I am proud of it."

[1] Wordsworth's appreciation of the *Works* was made public about now in the Dedication of "The Waggoner" to Charles Lamb, Esq.

III

[Shelley to Hunt, September 27th, 1819.]

. . . Of Lamb you know my opinion, and you can bear witness to the regret which I felt, when I learned that the calumny[1] of an enemy had deprived me of his society whilst in England.

A PORTRAIT

c. 1819

[Charles Lloyd, Desultory Thoughts in London, 1821.]

Irony delicate and exquisite,
 Delicious raillery's provoking zest;
Half-playful, and a half-malicious wit,
 Which, at what stings us most, makes us smile best:—
A subtle, sly, insinuating hit,
 Which, in great gravity and reverence drest,
With irresistibly demure abord,
To every adversary gives *le tort*:—

These are not mine! Let me no longer talk
 About myself, but of my friends; at least
Of one of them; and this would be no baulk
 To the reader, if he knew to what a feast
He is invited: for though you should walk
 From Bow to Chelsea, nay from point most west
Of Cornwall's coast, to house of John o' Groat,
That you would find his match I still must doubt.

He is a man whom many painful duties
 In early life mark'd as the son of grief;
Yet did he never render a pursuit his
 With any view of premature relief:
Or, with equivocal resource, pollute his
 Most noble soul, by thought that could be thief
E'en of the tender bloom, that lay upon
Its lovely surface, like the ripe fruit's down.

[1] Lamb was beyond fresh persuasion. His comments in letters on Shelley's death are ruthless. " Shelley the great Atheist has gone down by water to eternal fire." Was Hazlitt, whose verdict on Shelley's writings Lamb quotes with satisfaction, the " enemy "?—B.

He walk'd along his path in steadiness,
 In solitude, and in sublimity;
None ever knew his desolate distress,
 And none shall ever know it now from me.
But with a love, temper'd with awfulness,
 Have I beheld the forc'd serenity,
That, like an envelope fine, on it he laid:
Though 'twas transparent none dar'd pierce its shade.

And now, my friend, I turn again to thee,
 Thou pure receptacle of all that's good!
Thou hast contriv'd an art, I own, by me,
 As feasible, so little understood,
That, thou being unknown, with avowal free,
 I should have said it ne'er could be pursu'd—
The child of impulse ever to appear,
And yet through duty's path strictly to steer.

Nay, more—Thou has contriv'd to be that child,
 And not alone hast held, through duty's path,
In lofty unimpeachableness, and mild,
 Thy way, but through strange suffering, and scath
Of worldly comfort, hast been unbeguil'd
 Of life's first innocence; God's blessing hath,—
Like " Shadrach, Meshek, and Abednego,"—
Through fiery furnace made thee safely go.

Thy God hath said to thee, " When[1] through the wave
 Thou passest, servant, I with thee will be!
When through the floods, thou shalt their fury brave;
 When through the flames, their hurtful quality
They shall renounce, nor shall thy garments have
 A smell of fire, recalling it to thee.
As thou hast done by me, by thee I'll do:—
I am, have been, and will to thee be true."

Oh [Lamb], thou art a mystery to me!
 Thou art so prudent, and so mad with wildness,
Thou art a source of everlasting glee!
 Yet desolation of the very childless

[1] Isaiah, xliii, 2.

Has been thy lot! Never in one like thee
 Did I see worth majestic from its mildness;
So far, in thee, from being an annoyance
E'en to the vicious, 'tis a source of joyance.

Like a vast castle that has sieges seen,
 Its outer walls shaken, and prostrate laid,
Thou seem'st to me! Each outlet to the scene,
 Where thy great wealth, like troops in ambuscade,
Was stor'd, has oft been ransack'd; thou hast been
 Of sympathy so frank, so overpaid
Their price to all! Yet much as thou'st been shaken
Thou, like that castle's fortress, ne'er wert taken.

Most men from principle their virtues draw—
 In thee would principle shew like a failing,
Thy heart sublime frames thy life's safest law;
 And 'twould condense the fresh dews thence exhaling
Their rich exuberance by rule to awe;
 Others deem self-denial most availing
To rule man's conduct; but so pure thy mind is,
Thou hid'st its talents lest their beams should find us.

No! thou, in many ways, reversest all
 That may to men in general be imputed,
Better in thee the virtues natural,
 Than those in other men by culture rooted.
Never thy lips, by word, or great or small,
 That other men could injure, were polluted.
Thy censure, if in critic chair thou sit,
Falls but on those too great to shrink from wit.

No! Let a man, in body, or in mind,
 In character, condition, or estate,
Be doom'd, in form, in talents, from mankind,
 To be disadvantageous estimate;
By thee, to him, shall never be assign'd
 A word his destiny to aggravate:
In thy praise, as of Heaven, it might be sounded,
None that in thee e'er trusted were confounded.

Now shall I not this living portrait wrong—
 In it the features are not very common—
By mentioning to whom it doth belong!
 The writer trust; its prototype is human!
If thou that read'st it catch the likeness strong,
 Respect the secret as thou art a true man.
He that has furnished matter for these lays,
Is singular in this—he spurns at praise.

LAMB'S LITERARY POSITION IN 1820

[*Talfourd, closing passage of his " Remarks on the Writings of Charles Lamb,"* New Monthly Magazine.]

. . . The world has, until lately, felt far more than it has acknowledged, the influences of Mr. Lamb's genius. He is, at length, beginning to enjoy a wider fame. Even now, however, he has attained some rare and indisputable successes. His admiring remarks on the elder dramatists have been expanded by more ambitious writers, and have gradually led the people to these old springs of delight which they had almost forgotten. In an age where " envy and all uncharitableness " have been active in our literature, he has been gently counteracting their tendencies, and breathing a spirit of good-will and kindness into criticism. He has deprived witty malice of its sting, and shaken the seat of the scorner. In some measure, has he stopped the progress of that love of mere *strength* in writing before which the human-ities of poetry were declining, by delighting us with glimpses of a new and fresh beauty, and disclosing lovely nooks in the calmest regions of imagination, where hitherto none had invited us to repose. There are those to whom his happiest creations have long been " personal themes " most dear, and who have felt the benign influences of his genius in their inmost souls. They think of his works as the sweeteners of their moral and intellectual natures—they blend the idea of him with their most genial trains of thought, and their sweetest remembrances, which he has awakened in their hearts—and never can they become cold to his merits or indifferent to his fame, until the inmost affections of the soul shall cease to warm them.

MR. HAYDON'S PICTURE
1820

[Morning Post, *March 30th*, 1820.]

The Private Show[1] on Saturday last (March 25th). The principal persons distinguished for rank and talent, in the company, were Wilkie, C. Lamb, Keats, Procter, Raimbach, Mrs. Garrick, Mrs. Siddons, &c.

AT CAMBRIDGE
1820

[*Crabb Robinson.*]

July 18th. After a day's work at Huntingdon, I had just settled for the evening, when I was agreeably surprised by a call from Miss Lamb. I was heartily glad to see her, and accompanying her to her brother's lodgings, I had a very pleasant rubber of whist with them and a Mrs. Smith. An acceptable relief from circuit society.

July 20th. I had nothing to do to-day, and therefore had leisure to accompany Lamb and his sister on a walk among the colleges. All Lamb's enjoyments are so pure and hearty, that it is an enjoyment to see him enjoy. We walked about the exquisite chapel and the gardens of Trinity.

LAMIA, ISABELLA, &c.
1820

[*Leigh Hunt, " Lord Byron, &c.,"* 1828.]

I

Mr. Keats . . . came to reside with me, when his last and best volume of poems appeared, containing *Lamia, Isabella,* the *Eve of St. Agnes,* and the noble fragment of *Hyperion.* I remember Charles Lamb's delight and admiration on reading this work; how pleased he was with the designation

[1] Of the *Entry into Jerusalem.*—B.

of Mercury as " the star of Lethe " (rising, as it were, and glittering, as he came upon that pale region); with the fine daring anticipation in that passage of the second poem,—

" So the two brothers and *their murdered man*
Rode past fair Florence ";

and with the description, at once delicate and gorgeous, of Agnes praying beneath the painted window.

II

[*Crabb Robinson.*]

December 8th. I read a little of Keats' poems to the Aders',— the beginning of *Hyperion,*—really a piece of great promise. There are a force, wildness, and originality in the works of this young poet which, if his perilous journey to Italy does not destroy him, promise to place him at the head of the next generation of poets. Lamb places him next to Wordsworth[1]—not meaning any comparison, for they are dissimilar.

AN UNLUCKY PUBLIC ALLUSION:
W. W., S. T. C., C. L.
1820

[*S. T. Coleridge to J. G. Lockhart*, 1820. *From* Unpublished Letters, *ed. E. L. Griggs.*]

Merciful Heaven! had I had the most distant anticipation, the slightest suspicion, of either my name or your's being brought forward to the Public on the circumstance, I should have hastened to have first taken the whole on myself, and then to have reproached the Friend, if a Friend as in the case of Charles Lamb, with having even *intended* to make bad worse and bring one once more before the Public Bar, as if for the mere wanton purpose of forcing an open breach between me and Wordsworth's friends and family.—But not

[1] There are numerous allusions to Lamb's enjoyment of Keats's poems. Cowden Clarke's statement " Upon the publication of the last volume of poems, Charles Lamb wrote one of his finely appreciative and cordial critiques in the *Morning Chronicle* " sums them up—except that, as Mr. Lucas discovered, the critique was printed in the *New Times.* See his notes in Lamb's *Works*, 1903, i 470.—B.

G

feeling myself under any obligation to enter into any detail
that was painful to me, and not *suspecting* the least occasion
for it, I said just what was sufficient to put a stop to the
conversation—and this is one reason, why I conclude, that
it was Lamb who spoke to me.—We have loved each other
from earliest manhood—and he has a right on many accounts
to be borne with by me, even in cases that any other Friend
I could not have borne without resentment—as the keeping
up any friendly connection with Hazlitt—his writing in and
for the same publication, by choice, and as if by some
fatality.

THE NAME "ELIA"

1821

[*L. Hunt*, Indicator, 1821.]

I

Jan. 31*st.* . . . We believe we are taking no greater
liberty with Mr. Lamb than our motives will warrant, when
we add that he sometimes writes in the *London Magazine*
under the signature of Elia. [" Elia " having retorted in that
Magazine for March, the following appeared in the *Indicator*.]

II

Feb. 28*th.* ELIA *versus* INDICATOR. The ingenious author
(we hate resentment) of the articles with the signature of
Elia, in the *London Magazine*, complains of us for saying that
he was " a Mr. L——b." This is an evasion but too charac-
teristic, we understand, of the clever but mendacious writer.
Call himself what he may, we deny that we called him
L——b. . . . This Mr. L——b is so impatient of having his
soul or better half of him looked at, that as rabbits will fall
upon their young if you stare at them, he flies upon himself
for very anger, and tears out his inward man. . . . He
abolishes all his intermediate faculties, as an Egyptian
lets nothing be seen about his wife but her eyes and feet.
It really disturbs the natural current of our tropical blood
to see these capricious-climated, peevish-veined English
(Genoese[1] forsooth!) insisting upon being at once loved and

[1] Elia having claimed " progenitors from stately Genoa."—B.

not loved, laudable and not praised, personal yet anonymous. There *was*, by the bye, a family of the name of Elia who came from Italy,—Jews; which may account for this boast about Genoa. See also in his last article in the *London Magazine* some remarkable fancies of conscience in reference to the Papal religion. They further corroborate what we have heard; viz. that the family were obliged to fly from Genoa for saying that the Pope was the author of Rabelais; and that Elia is not an anagram, as some have thought it, but the Judaico-Christian name of the writer before us, whose surname, we find, is not Lamb, but Lomb;—Elia Lomb! What a name! He told a friend of ours so in company, and would have palmed himself upon him for a Scotchman, but that his countenance betrayed him. . . .

A WHALE PASSES
June, 1821

[*Charles Cowden Clarke*, Recollections of Writers.]

It was while we were at Ramsgate that I remember hearing of Charles Lamb and his sister being at Margate for a " sea change," and I went over to see them. It seems as if it were but yesterday that I noted his eager way of telling me about an extraordinarily large whale that had been captured there, of its having created lively interest in the place, of its having been conveyed away in a strong cart, on which it lay a huge mass of colossal height; when he added with one of his sudden droll penetrating glances:—The eye has just gone past our window.

GRACE BEFORE WORDSWORTH ?
1821

[*Richard Woodhouse, " Notes " printed in R. Garnett's edition of* Confessions of an Opium-Eater, 1885.]

Meeting one time with Charles Lamb, who he understood had praised Wordsworth's poetry [de Quincey], was induced to mention that poet's name, and to speak of him in high terms. Lamb gave him praise, but rather more qualified

than the Opium-Eater expected, who spoke with much warmth on the subject, and complained that Lamb did not do Wordsworth justice; upon which Lamb, in his dry, facetious way, observed, " If we are to talk in this strain, we ought to have said grace before we began our conversation." This observation so annoyed the Opium-Eater that he instantly left the room, and has never seen Lamb since.

" This anecdote the Opium-Eater told me," said Hessey, " himself . . . in exemplification of points in his character. He told it with much humour, and was quite sensible how ridiculous his conduct was; and he will be glad to see Lamb again, who he supposes must have long since forgotten or forgiven the circumstance."

DE QUINCEY DINES

1821-2

[Thomas de Quincey.]

But as regarded Lamb, I was sure to see him or to hear of him again in some way or other within a short time. This opportunity, in fact, offered itself within a month through the kindness of the Lambs themselves. They had heard of my being in solitary lodgings, and insisted on my coming to dine with them, which more than once I did in the winter of 1821-2.

The mere reception by the Lambs was so full of goodness and hospitable feeling, that it kindled animation in the most cheerless or torpid of individuals. I cannot imagine that any memorabilia occurred during the visit; but I will use the time that would else be lost upon the settling of that point, in putting down any triviality that occurs to my recollection.

There were no strangers; Charles Lamb, his sister, and myself made up the party. Even this was done in kindness. They knew that I should have been oppressed by an effort such as must be made in the society of strangers; and they placed me by their own fireside, where I could say as much or as little as I pleased.

We dined about five o'clock, and it was one of the hospi-
talities inevitable to the Lambs, that any game which they
might receive from rural friends in the course of the
week, was reserved for the day of a friend's dining with
them.

In regard to wine, Lamb and myself had the same habit—
perhaps it rose to the dignity of a principle—viz., to take a
great deal during dinner—none after it. Consequently, as
Miss Lamb (who drank only water) retired almost with the
dinner itself, nothing remained for men of our principles,
the rigour of which we had illustrated by taking rather too
much of old port before the cloth was drawn, except talking;
amœbæan colloquy, or, in Dr. Johnson's phrase, a dialogue
of " brisk reciprocation." But this was impossible; over
Lamb, at this period of his life, there passed regularly, after
taking wine, a brief eclipse of sleep. It descended upon him
as softly as a shadow. In a gross person, laden with super-
fluous flesh, and sleeping heavily, this would have been
disagreeable; but in Lamb, thin even to meagreness, spare
and wiry as an Arab of the desert, or as Thomas Aquinas,
wasted by scholastic vigils, the affection of sleep seemed
rather a network of aerial gossamer than of earthly cobweb—
more like a golden haze falling upon him gently from the
heavens than a cloud exhaling upwards from the flesh.
Motionless in his chair as a bust, breathing so gently as
scarcely to seem certainly alive, he presented the image of
repose midway between life and death, like the repose of
sculpture; and to one who knew his history, a repose
affectingly contrasting with the calamities and internal
storms of his life. I have heard more persons than I can now
distinctly recall, observe of Lamb when sleeping that his
countenance in that state assumed an expression almost
seraphic, from its intellectual beauty of outline, its child-like
simplicity, and its benignity. It could not be called a
transfiguration that sleep had worked in his face; for the
features wore essentially the same expression when waking;
but sleep spiritualized that expression, exalted it, and also
harmonized it. Much of the change lay in that last process.
The eyes it was that disturbed the unity of effect in Lamb's
waking face. They gave a restlessness to the character of his
intellect, shifting, like northern lights, through every mode

of combination with fantastic playfulness, and sometimes by fiery gleams obliterating for the moment that pure light of benignity which was the predominant reading on his features. Some people have supposed that Lamb had Jewish blood in his veins, which seemed to account for his gleaming eyes. It might be so; but this notion found little countenance in Lamb's own way of treating the gloomy mediaeval traditions propagated throughout Europe about the Jews, and their secret enmity to Christian races. Lamb, indeed, might not be more serious than Shakspeare is supposed to have been in his Shylock; yet he spoke at times as from a station of wilful bigotry, and seemed (whether laughingly or not) to sympathize with the barbarous Christian superstitions upon the pretended bloody practices of the Jews, and of the early Jewish physicians. Being himself a Lincoln man he treated Sir Hugh of Lincoln, the young child that suffered death by secret assassination in the Jewish quarter rather than suppress his daily anthems to the Virgin, as a true historical personage on the rolls of martyrdom; careless that this fable, like that of the apprentice murdered out of jealousy by his master, the architect, had destroyed its own authority by ubiquitous diffusion. All over Europe the same legend of the murdered apprentice and the martyred child reappears under different names—so that in effect the verification of the tale is none at all, because it is unanimous, is too narrow, because it is too impossibly broad. Lamb, however, though it was often hard to say whether he were not secretly laughing, swore to the truth of all these old fables, and treated the liberalities of the present generation on such points as mere fantastic and effeminate affectations, which, no doubt, they often are as regards the sincerity of those who profess them. The bigotry, which it pleased his fancy to assume, he used like a sword against the Jew, as the official weapon of the Christian, upon the same principle that a Capulet would have drawn upon a Montague, without conceiving it any duty of his to rip up the grounds of so ancient a quarrel; it was a feud handed down to him by his ancestors, and it was their business to see that originally it had been an honest feud. I cannot yet believe that Lamb, if seriously aware of any family interconnexion with Jewish blood, would even in jest, have held that one-sided language. More probable

it is, that the fiery eye recorded not any alliance with Jewish blood, but that disastrous alliance with insanity which tainted his own life, and laid desolate his sisters.

The mercurialities of Lamb were infinite, and always uttered in a spirit of absolute recklessness for the quality or the prosperity of the sally. It seemed to liberate his spirits from some burthen of blackest melancholy which oppressed it, when he had thrown off a jest: he would not stop one instant to improve it; nor did he care the value of a straw whether it were good enough to be remembered, or so mediocre as to extort high moral indignation from a collector who refused to receive into his collection of jests and puns any that were not felicitously good or revoltingly bad.

After tea, Lamb read to me a number of beautiful compositions, which he had himself taken the trouble to copy out into a blank paper folio from unsuccessful authors. Neglected people in every class won the sympathy of Lamb. One of the poems, I remember, was a very beautiful sonnet from a volume recently published by Lord Thurlow—which and Lamb's just remarks upon which, I could almost repeat verbatim at this moment, nearly twenty-seven years later, if your limits would allow me. But these, you tell me, allow of no such thing; at the utmost they allow only twelve lines more. Now all the world knows that the sonnet itself would require fourteen lines; but take fourteen from twelve and there remains very little, I fear; besides which, I am afraid two of my twelve are already exhausted. This forces me to interrupt my account of Lamb's reading, by reporting the very accident that did interrupt it in fact; since that no less characteristically expressed Lamb's peculiar spirit of kindness (always quickening itself towards the ill-used or the down-trodden) than it had previously expressed itself in his choice of obscure readings. Two ladies came in, one of whom at least had sunk in the scale of worldly consideration. They were ladies who would not have found much recreation in literary discussions; elderly, and habitually depressed. On their account, Lamb proposed whist, and in that kind effort to amuse them, which naturally drew forth some momentary gaieties from himself, but not of a kind to impress themselves on the recollection, the evening terminated.

A SUBSCRIPTION FOR GODWIN
1822

[Sir Walter Scott, letter to B. R. Haydon, n.d.]

Dear Sir,

I am much obliged to Mr. Lamb and you for giving me an
opportunity of contributing my mite for the relief of Mr.
Godwin, whose distresses I sincerely commiserate. I enclose
a cheque for 10*l.*, which I beg Mr. Lamb will have the
kindness to apply as he judges best in this case. I should not
wish my name to be made public as a subscriber (supposing
publicity to be given to the matter at all), because I dissent
from Mr. Godwin's theory of politics and morality as
sincerely as I admire his genius, and it would be indelicate
to attempt to draw such a distinction in the mode of sub-
scribing.

I was much amused with Mr. Godwin's conversation
upon his return from Edinburgh, some years ago, when he
passed a day at this place. I beg my respects to Mr. Lamb,
whom I should be happy to see in Scotland, though I have
not forgotten his metropolitan preference of houses to rocks,
and citizens to wild rustics and highland men. . . .

PARIS
1822

[Crabb Robinson.]

August 20th—(Paris). Mary Lamb has begged me to give
her a day or two. She comes to Paris this evening, and stays
here a week. Her only male friend is a Mr. Payne, whom she
praises exceedingly for his kindness and attentions to Charles.
He is the author of *Brutus*, and has a good face.

August 21st—(With Mary Lamb). When Charles went
back to England he left a note for his sister's direction. After
pointing out a few pictures in the Louvre, he proceeds:—
" Then you must walk all along the borough side of the Seine,
facing the Tuileries. There is a mile and a half of print-
shops and bookstalls. If the latter were but English! Then
there is a place where the Paris people put all their dead

people, and bring them flowers, and dolls, and gingerbread-
nuts, and sonnets, and such trifles; and that is all, I think,
worth seeing as sights, except that the streets and shops of
Paris are themselves the best sight." I had not seen this
letter when I took Mary Lamb a walk that corresponds
precisely with Lamb's taste, all of whose likings I can always
sympathize with, but not generally with his dislikings.

THOMAS HOOD BECOMES LAMB'S FRIEND

c. 1822

[*T. Hood*, Literary Reminiscences, 1839.]

Before my departure from England,[1] I was one of the few
who saw the grave close over the remains of one whom to
know as a friend was to love as a relation. Never did a better
soul go to a better world! Never perhaps (giving the lie
direct to the common imputation of envy, malice, and
hatred, amongst the brotherhood), never did an author
descend—to quote his favourite Sir T. Browne—into ' the
land of the mole and the pismire ' so hung with golden
opinions, and honoured and regretted with such sincere
eulogies and elegies, by his contemporaries. To him, the
first of these, my reminiscences, is eminently due, for I lost
in him not only a dear and kind friend, but an invaluable
critic; one whom, were such literary adoptions in modern
use, I might well name, as Cotton called Walton, my
' father.' To borrow the earnest language of old Jean
Bertaut, as Englished by Mr. Cary—

' Thou, chiefly, noble spirit, for whose loss
Just grief and mourning all our hearts engross,
Who seeing me devoted to the Nine,
Didst hope some fruitage from these buds of mine;
Thou didst excite me after thee t'ascend
The Muses' sacred hill; not only lend
Example, but inspirit me to reach
The far-off summit of thy friendly speech.

[1] Hood was writing from the Continent. " In all his wanderings and changes,"
his son remarks, " there were two pictures which went with my father every-
where, and hung in his study for the time being—the one of Charles Lamb
(for whom he entertained a brotherly affection), the other of Joe Grimaldi."—*B.*

May gracious Heaven, O honour of our age!
Make the conclusion answer thy presage,
Nor let it only for vain fortune stand,
That I have seen thy visage—touch'd thy hand! '

I was sitting one morning beside our Editor, busily
correcting proofs, when a visitor was announced, whose
name, grumbled by a low ventriloquial voice, like Tom
Pipes[1] calling from the hold through the hatchway, did not
resound distinctly on my tympanum. However, the door
opened, and in came a stranger—a figure remarkable at a
glance, with a fine head, on a small spare body, supported
by two almost immaterial legs. He was clothed in sables of a
bygone fashion, but there was something wanting, or some-
thing present about him, that certified he was neither a
divine, nor a physician, nor a schoolmaster: from a certain
neatness and sobriety in his dress, coupled with his sedate
bearing, he might have been taken, but that such a costume
would be anomalous, for a Quaker in black. He looked still
more like (what he really was) a literary Modern Antique,
a New-Old Author, a living anachronism, contemporary at
once with Burton the Elder, and Colman the Younger.
Meanwhile he advanced with rather a peculiar gait, his
walk was plantigrade, and with a cheerful ' How d'ye,' and
one of the blandest, sweetest smiles that ever brightened a
manly countenance, held out two fingers to the Editor.

The two gentlemen in black soon fell into discourse; and
whilst they conferred, the Lavater principle within me, set to
work upon the interesting specimen thus presented to its
speculations. It was a striking intellectual face, full of wiry
lines, physiognomical quips and cranks, that gave it great
character. There was much earnestness about the brows,
and a deal of speculation in the eyes, which were brown and
bright, and ' quick in turning '; the nose, a decided one,
though of no established order; and there was a handsome
smartness about the mouth. Altogether it was no common
face—none of those willow-pattern ones, which Nature turns
out by thousands at her potteries;—but more like a chance
specimen of the Chinese ware, one to the set—unique,
antique, quaint. No one who had once seen it, could pretend

[1] In Smollett's *Peregrine Pickle*.

not to know it again. It was no face to lend its countenance
to any confusion of persons in a Comedy of Errors. You
might have sworn to it piece-meal,—a separate affidavit for
every feature. In short, his face was as original as his figure;
his figure as his character; his character as his writings; his
writings as the most original of the age. After the literary
business had been settled, the editor invited his contributor
to dinner, adding ' we shall have a hare——'

' And—and—and—and many friends! '

The hesitation in the speech, and the readiness of the
allusion, were alike characteristic of the individual, whom
his familiars will perchance have recognized already as the
delightful essayist, the capital critic, the pleasant wit and
humorist, the delicate-minded and large-hearted Charles
Lamb! He was shy like myself with strangers, so that
despite my yearnings, our first meeting scarcely amounted
to an introduction. We were both at dinner, amongst the
hare's many friends, but our acquaintance got no farther,
in spite of a desperate attempt on my part to attract his
notice. His complaint of the Decay of Beggars presented
another chance[1]: I wrote on coarse paper, and in ragged
English, a letter of thanks to him as if from one of his
mendicant clients, but it produced no effect. I had given
up all hope, when one night, sitting sick and sad, in my bed-
room, racked with the rheumatism, the door was suddenly
opened, the well-known quaint figure in black walked in
without any formality, and with a cheerful ' Well, boy, how
are you ? ' and the bland sweet smile extended the two
fingers. They were eagerly clutched of course, and from that
hour we were firm friends.

LONDON MAGAZINE EVENINGS

1822

[Thomas Hood, in Hood's Own.]

On the right hand then of the editor sits Elia, of the
pleasant smile, and the quick eyes—Procter said of them
that "they looked as if they could pick up pins and needles"

[1] London Magazine, June 1822.—B.

—and a wit as quick as his eyes, and sure, as Hazlitt described, to stammer out the best pun and the best remark in the course of the evening. Next to him, shining verdantly out from the grave-coloured suits of the literati, like a patch of turnips amidst stubble and fallow, behold our Jack i' the Green—John Clare! In his bright, grass-coloured coat, and yellow waistcoat (there are greenish stalks too, under the table), he looks a very cowslip, and blooms amongst us as Goldsmith must have done in his peach-blossom. No wonder the door-keeper of the Soho Bazaar, seeing that very countrified suit, linked arm-in-arm with the editorial sables, made a boggle at admitting them into his repository, having seen, perchance, such a made-up peasant "playing at playing" at thimble-rig about the Square. No wonder the gentleman's gentleman, in the drab-coat and sealing-wax smalls, at W[ainewright']s, was for cutting off our Green Man, who was modestly the last in ascending the stairs, as an interloper, though he made amends afterwards by waiting almost exclusively on the peasant, perfectly convinced that he was some eccentric notable of the Corinthian order, disguised in rustic. Little wonder either, that in wending homewards on the same occasion through the Strand, the peasant and Elia, Sylvanus et Urban, linked comfortably together, there arose the frequent cry of "Look at Tom and Jerry!" for truly, Clare in his square-cut green coat, and Lamb in his black, were not a little suggestive of Hawthorn and Logic, in the plates to *Life in London*.[1]

But to return to the table. Elia—much more of house Lamb than of grass Lamb—avowedly caring little or nothing for pastoral—cottons, nevertheless, very kindly to the Northamptonshire poet, and still more to his ale, pledging him again and again as "Clarissimus," and "Princely Clare," and sometimes so lustily as to make the latter cast an anxious glance into his tankard. By his bright happy look, the Helpstone visitor is inwardly contrasting the unlettered country company of Clod, and Hodge and Podge, with the delights of "London" society—Elia, and Barry, and Herbert, and Mr. Table Talk, *cum multis aliis*—i.e. a multiplicity of all. Besides the tankard, the two "drouthie

[1] *Life in London*, by Pierce Egan, published 1821, with illustrations by the Cruikshanks.—B.

neebors " discuss poetry in general,[1] and Montgomery's
" Common Lot " in particular, Lamb insisting on the beauty
of the tangential sharp turn at " O! she was fair!" thinking,
mayhap, of his own Alice W——, and Clare swearing
" Dal!" (a clarified d—n).

" Dal! if it isn't like a dead man preaching out of his
coffin!" Anon, the humorist begins to banter the peasant
on certain " Clare-obscurities " in his own verses, originating
in a contempt for the rules of Priscian, whereupon the
accused, thinking with Burns

> " What sairs their grammars ?
> They'd better ta'en up spades and shools,
> Or knappin-hammers,"

vehemently denounces all philology as nothing but a sort of
man-trap for authors, and heartily dals Lindley Murray for
" inventing it! "

THE LONDON MAGAZINE

I. CARY AND LAMB. 1822

[*Henry Cary*, Memoirs of H. F. Cary, 1847.]

My father's connection with the *London Magazine* made him
acquainted with several of our ablest popular writers; such
as Charles Lamb, Hazlitt, De Quincey, Proctor, Allan
Cunningham, Carlyle, Hood, Darley, and John Clare, the
poet. With two of these, Lamb and Darley, he contracted a
cordial intimacy and friendship, which was terminated only
by death. Most of these he met at the table of Mr. Taylor,
the publisher, and when once brought together, they not
unfrequently met at the house of one or other of the number.
At the first of these *Magazine* dinners, as they were called,
held at Mr. Cary's own house, I remember that, among
others, Lamb, Kenney. the farce-writer, and Clare were
present. The conversation, which never flagged, consisted
of a strange mixture of learning, wit, and puns, bad and
good. The graver talk of the more serious guests was con-
stantly interrupted by the sportive and light jests of Kenney,

[1] Talking of poetry, Lamb told me one day that he had just met with the
most vigorous line he had ever read. " Where ? " " Out of the Camden's
Head, all in one line—To One Hundred Pots of Porter, £2 1s. 8d."—*H.*

or a palpable, and to all appearance schoolboy pun of
Lamb's; which, however, was frequently pregnant with a
deep meaning not at first observable. At times the light
artillery of the punsters got the better of the heavier ordnance,
and all gave in to the joyousness of the moment. Among the
rest, I remember that a quotation from one of our elder
dramatists provoked a round of puns on the names of various
herbs; the last two introduced had been " mint and anise,"
when Lamb sputtered out, " Now, Cary, it's your turn."
" It's coming," was the prompt rejoinder. " Then I won't
make another pun to-day," stammered Lamb.

II. EFFECT OF " ELIA "
[M. R. Mitford to Sir Wm. Elford, April 28th, 1822.]

Charles Lamb's articles, signed " Elia," are incomparably
the finest specimens of English prose in the language. The
humour is as delicate as Addison's, and far more piquant.
Oh! how you would enjoy it! Do borrow or hire *all* the
numbers of Taylor and Hessey's *London Magazine*, and read
all Elia's articles, as well as the " Table Talks," and the
" Confessions of an English Opium Eater," and the " Dra-
matic Sketches," and tell me how you like Charles Lamb.

LAMB'S BOOKS
[before 1823]

[Leigh Hunt, Literary Examiner, 1823.]

I looked sideways at my Spenser, my Theocritus, and my
Arabian Nights; then above them at my Italian poets; then
behind me at my Dryden and Pope, my romances, and my
Boccaccio; then on my left side at my Chaucer, who lay
on a writing-desk; and thought how natural it was in
C[harles] L[amb] to give a kiss to an old folio, as I once saw
him do to Chapman's *Homer*. At the same time I wondered
how he could sit in that front room of his with nothing but a
few unfeeling tables and chairs, or at best a few engravings
in trim frames, instead of putting a couple of armchairs into
the back-room with the books in it, where there is but one
window. Would I were there, with both the chairs properly

filled, and one or two more besides! " We had talk, Sir,"—
the only talk capable of making one forget the books. . . .

Conscious of my propriety and comfort in these matters,
I take an interest in the bookcases as well as the books of my
friends. I long to meddle, and dispose them after my own
notions. When they see this confession, they will acknow-
ledge the virtue I have practised. I believe I did mention
his book-room to C. L., and I think he told me that he often
sat there when alone. It would be hard not to believe him.
His library, though not abounding in Greek or Latin (which
are the only things to help some persons to an idea of
literature), is anything but superficial. The depths of
philosophy and poetry are there, the innermost passages of
the human heart. It has some Latin too. It has also a hand-
some contempt for appearance. It looks like what it is, a
selection made at precious intervals from the bookstalls;—
now a Chaucer at nine and twopence, now a Montaigne or
a Sir Thomas Browne at two shillings; now a Jeremy
Taylor; a Spinoza; an old English Dramatist, Prior, and
Sir Philip Sidney; and the books are " neat as imported."
The very perusal of the backs is a " discipline of humanity."
There Mr. Southey takes his place again with an old Radical
friend: there Jeremy Collier is at peace with Dryden: there
the lion, Martin Luther, lies down with the Quaker lamb,
Sewell: there Guzman d'Alfarache thinks himself fit company
for Sir Charles Grandison, and has his claims admitted.
Even the " high fantastical " Duchess of Newcastle, with
her laurel on her head, is received with grave honours, and
not the less for declining to trouble herself with the constitu-
tions of her maids.

SONNET TO ELIA
1823

[*Bernard Barton*, London Magazine, *February* 1823.]

Delightful author! unto whom I owe
 Moments and moods of fancy and of feeling,
 Afresh to grateful memory now appealing,
Fain would I " bless thee—ere I let thee go! "
From month to month has the exhaustless flow

Of thy original mind, its wealth revealing,
 With quaintest humour, and deep pathos healing
The World's rude wounds, revived Life's early glow:
 And, mixt with this, at times, to earnest thought
 Glimpses of truth most simple and sublime
 By thy imagination have been brought
 Over my spirit. From the olden time
Of authorship thy patent should be dated,
And thou with Marvell, Browne, and Burton mated.

THE STYLE OF ELIA
1823

[*William Hazlitt*, Table Talk, 1824, *vol. ii.*]

There are those who hoard up and make a cautious dis-
play of nothing but rich and rare phraseology;—ancient
medals, obscure coins, and Spanish pieces of eight. They
are very curious to inspect; but I myself would neither offer
nor take them in the course of exchange. A sprinkling of
archaisms is not amiss; but a tissue of obsolete expressions
is more fit for keep than wear. I do not say I would not use
any phrase that had been brought into fashion before the
middle or the end of the last century; but I should be shy of
using any that had not been employed by any approved
author during the whole of that time. Words, like clothes,
get old-fashioned, or mean and ridiculous, when they have
been for some time laid aside. Mr. Lamb is the only imitator
of old English style I can read with pleasure; and he is so
thoroughly imbued with the spirit of his authors, that the
idea of imitation is almost done away. There is an inward
unction, a marrowy vein both in the thought and feeling, an
intuition, deep and lively, of his subject, that carries off any
quaintness or awkwardness arising from an antiquated style
and dress. The matter is completely his own, though the
manner is assumed. Perhaps his ideas are altogether so
marked and individual, as to require their point and pun-
gency to be neutralized by the affectation of a singular but
traditional form of conveyance. Tricked out in the prevail-
ing costume, they would probably seem more startling and
out of the way. The old English authors, Burton, Fuller,

Coryat, Sir Thomas Browne, are a kind of mediators between us and the more eccentric and whimsical modern, reconciling us to his peculiarities. I do not however know how far this is the case or not, till he condescends to write like one of us. I must confess that what I like best of his papers under the signature of Elia (still I do not presume to decide what is most excellent) is the account of Mrs. Battle's Opinions on Whist, which is also the most free from obsolete allusions and turns of expression—

" A well of native English undefiled."

To those acquainted with his admired prototypes, these Essays of the ingenious and highly gifted author have the same sort of charm and relish, that Erasmus's Colloquies or a fine piece of modern Latin have to the classical scholar. Certainly, I do not know any borrowed pencil that has more power or felicity of execution than the one of which I have here been speaking.

LAMB'S PROSE: AN ANALYSIS

[*Thomas de Quincey*, *in* Leaders in Literature.]

The elaborate, indeed, without which much truth and beauty must perish in germ, was by name the object of his invectives. The instances are many, in his own beautiful essays, where he literally collapses, literally sinks away from openings suddenly offering themselves to flights of pathos or solemnity in direct prosecution of his own theme. On any such summons, where an ascending impulse, and an untired pinion were required, he refuses himself (to use military language) invariably. The least observing reader of Elia cannot have failed to notice that the most felicitous passages always accomplish their circuit in a few sentences. The gyration within which his sentiment wheels, no matter of what kind it may be, is always the shortest possible. It does not prolong itself—it does not repeat itself—it does not propagate itself. But, in fact, other features in Lamb's mind would have argued this feature by analogy, had we by accident been left unaware of it directly. It is not by chance, or without a deep ground in his nature, common to all his qualities, both affirmative and negative, that Lamb had an

H

insensibility to music more absolute than can have been often shared by any human creature, or perhaps than was ever before acknowledged so candidly. The sense of music—as a pleasurable sense, or as any sense at all other than of certain unmeaning and impertinent differences in respect to high and low, sharp or flat—was utterly obliterated as with a sponge by nature herself from Lamb's organization.[1] It was a corollary, from the same large substratum in his nature, that Lamb had no sense of the rhythmical in prose composition. Rhythmus, or pomp of cadence, or sonorous accent of clauses, in the structure of sentences, were effects of art as much thrown away upon him as the voice of the charmer upon the deaf adder. We ourselves, occupying the very station of polar opposition to that of Lamb, being as morbidly, perhaps, in the one excess as he in the other, naturally detected this omission in Lamb's nature at an early stage of our acquaintance. Not the fabled Regulus, with his eyelids torn away, and his uncurtained eyeballs exposed to the noon-tide glare of a Carthaginian sun, could have shrieked with more anguish of recoil from torture than we from certain sentences and periods in which Lamb perceived no fault at all. Pomp, in our apprehension, was an idea of two categories; the pompous might be spurious, but it might also be genuine. It is well to love the simple—we love it; nor is there any opposition at all between that and the very glory of pomp. But, as we once put the case to Lamb, if, as a musician, as the leader of a mighty orchestra, you had this theme offered to you—" Belshazzar the king gave a great feast to a thousand of his lords "—or this, " And on a certain day, Marcus Cicero stood up, and in a set speech rendered solemn thanks to Caius Cæsar for Quintus Ligarius pardoned, and for Marcus Marcellus restored "— surely no man would deny that, in such a case, simplicity, though in a passive sense not lawfully absent, must stand aside as totally insufficient for the positive part. Simplicity might guide, even here, but could not furnish the power; a rudder it might be, but not an oar or a sail. This Lamb

[1] Lamb's " no ear " was one of his pretences, to which De Quincey has fallen a victim. There are many intimations in his Works that he had a passion for *some* music; but he was not going to be bullied into the fashionable worship of prescribed composers.—*B*.

was ready to allow; as an intellectual quiddity, he recognised pomp in the character of a privileged thing; he was obliged to do so; for take away from great ceremonial festivals, such as the solemn rendering of thanks, the celebration of national anniversaries, the commemoration of public benefactors, &c., the element of pomp, and you take away their very meaning and life; but, whilst allowing a place for it in the rubric of the logician, it is certain that, sensuously, Lamb would not have sympathised with it, nor have felt its justification in any concrete instance. We find a difficulty in pursuing this subject, without greatly exceeding the just limits. We pause, therefore, and add only this one suggestion as partly explanatory of the case. Lamb had the Dramatic intellect and taste, perhaps in perfection; of the Epic, he had none at all. Here, as happens sometimes to men of genius preternaturally endowed in one direction, he might be considered as almost starved. A favourite of nature, so eminent in some directions, by what right could he complain that her bounties were not indiscriminate? From this defect in his nature it arose, that, except by culture and by reflection, Lamb had no genial appreciation of Milton. The solemn planetary wheelings of the *Paradise Lost* were not to his taste. What he did comprehend, were the motions like those of lightning, the fierce angular coruscations of that wild agency which comes forward so vividly in the sudden Περιπέτεια, in the revolutionary catastrophe, and in the tumultuous conflicts, through persons or through situations, of the tragic drama.

TALKS WITH LAMB

1823

[*Crabb Robinson.*]

I

January 8th. Went in the evening to Lamb. I have seldom spent a more agreeable few hours with him. He was serious and kind—his wit was subordinate to his judgment, as is usual in *tête-à-tête* parties. Speaking of Coleridge, he said, " He ought not to have a wife or children; he should have a

sort of diocesan care of the world—no parish duty." Lamb
reprobated the prosecution of Byron's "Vision of Judg-
ment." Southey's poem of the same name is more worthy
of punishment, for his has an arrogance beyond endurance.
Lord Byron's satire is one of the most good-natured descrip-
tion—no malevolence.

II

[*Mary Shelley, letter to Leigh Hunt.*]

On Saturday, August the 30th, I went with Jane to the
Gisbornes'. I know not why, but seeing them seemed more
than anything else to remind me of Italy. Evening came on
drearily. The rain splashed on the pavement, nor star nor
moon deigned to appear. I looked upward, to seek an image
of Italy, but a blotted sky told me only of my change. I tried
to collect my thoughts, and then again dared not think, for
I am a ruin where owls and bats live only, and I lost my last
singing bird when I left Albaro. It was my birthday, and it
pleased me to tell the people so—to recollect and feel that
time flies; and what is to arrive is nearer, and my home not
so far off as it was a year ago. This same evening, on my
return to the Strand, I saw Lamb, who was very entertaining
and amiable, though a little deaf. One of the first questions
he asked me was, whether they made puns in Italy. I said,
"Yes, now Hunt is there." He said that Burney made a pun
in Otaheite, the first that was ever made in that country;
at first the natives could not make out what he meant, but
all at once they discovered the pun, and danced around him
in transports of joy. L. said one thing, which I am sure will
give you pleasure. He corrected for Hazlitt a new edition of
Elegant Extracts, in which living poets are included. He said
he was much pleased with many of your things, with a little
of Montgomery and a little of Crabbe. Scott he found tire-
some. Byron had many fine things but was tiresome;
but yours appeared to him the freshest and best of all.
These *Extracts* have never been published; they have been
offered to Mr. Hunter; and seeing the book at his house, I
had the curiosity to look at what the extracts were that
pleased L. There was the canto of the Fatal Passion from
"Rimini," several things from "Foliage," and from the
"Amintas." L. mentioned also your "Conversation with

Coleridge," and was much pleased with it. He was very
gracious to me, and invited me to see him when Miss L.
should be well.

III

[Mary Shelley, letter to Marianne Hunt, 1823.]

I see the Lambs rather often: she ever amiable, and Lamb
witty and delightful. I must tell you one thing, and make
H. laugh. Lamb's new house, at Islington, is close to the
New River, and George Dyer, after having paid them a visit,
on going away at twelve at noonday, walked deliberately
into the water, taking it for the high road. But, as he said
afterwards to Procter, " I soon found that I was in the water,
sir." So Miss L. and the servant had to fish him out. I must
tell Hunt, also, a good saying of Lamb's: talking of some
one, he said, " Now some men who are very veracious are
called matter-of-fact men; but such an one I should call a
matter-of-lie man."

SHACKLEWELL
1823

[Clara Novello, Reminiscences.]

The cottage had several parlours, all looking into the garden.
Into these often came to tea, Leigh Hunt; Mrs. Shelley,
widow of the poet; Mrs. Williams—later Mrs. Hogg;
Charles Lamb and his sister. Even thus early I felt those
sympathies, and the reverse, which have been mine all
through life. How I loved dear Charles Lamb! I once hid—
to avoid the ignominy of going to bed—in the upright
(cabinet) pianoforte, which in its lowest part had a sort of
tiny cupboard. In this I fell asleep, awakening only when
the party was supping. My appearance from beneath the
pianoforte was hailed with surprise by all, and with anger
from my mother; but Charles Lamb not only took me under
his protection, but obtained that henceforth I should never
again be sent to bed *when he came,* but—glory and delight!—
always sit up to supper. Later, in Frith Street days, my
father made me sing to him one day; but he stopped me,

saying, " Clara, don't make that d—d noise! " for which, I think, I loved him as much as for all the rest. Some verses he sent me were addressed to " St. Clara "!

LETTER TO R. SOUTHEY, ESQ.
1823
[*Crabb Robinson.*]

October 26th. I met with Talfourd, and heard from him much of the literary gossip of the last quarter. Sutton Sharpe,[1] whom I called on, gave me a second edition, and lent me the last *London Magazine,* containing Lamb's delightful letter to Southey.[1] His remarks on religion are full of deep feeling, and his eulogy on Hazlitt and Leigh Hunt most generous. Lamb must be aware that he would expose himself to obloquy by such declarations. It seems that he and Hazlitt are no longer on friendly terms. Nothing that Lamb has ever written has impressed me more strongly with the sweetness of his disposition and the strength of his affections.

DECEASE OF ELIA
1823
[*T. G. Wainewright,* London Magazine.]

I

Elia is dead!—at least so a Friend says; but if he be dead, we have seen him in one of those hours " when he is wont to walk "; and his ghostship has promised us very material assistance in our future Numbers. We were greatly tempted to put the Irish question to him of " Why did you die ? "—But as we know how very unusual a thing it is for a gentleman to give his reasons for such a step, we resisted the

[1] Nephew of S. Rogers. Afterwards Q. C., and eminent at the equity bar.
[2] Southey had said in a review of *Elia's Essays:* " It is a book which wants only a sounder religious feeling, to be as delightful as it is original." He did not intend to let the word " sounder " stand, but the passage was printed without his seeing a proof of it.—*B.*

temptation. Mercy on us!—we hope we are wrong,—but we have our shadowy suspicions, that Elia, poor gentleman! has not been honestly dealt by. Mercutio was killed by one Will Shakspeare, a poacher, though his death was laid to other hands;—and Sir Roger de Coverley (a gentleman more near our own time) perished under very mysterious circumstances. We could lay our finger upon the very man we suspect as being guilty of Elia's death! Elia's ghost, however, cannot sleep in its grave, for it has been constantly with us since his death, and vows it must still write for its peace of mind. Indeed the first paper in our present number is one of its grave consolations.

II

But Elia's ghost is impatient. Yet what can I say of thee more than all know? that thou hadst the gaiety of a boy, with the knowledge of a man;—as gentle a heart as ever sent tears to the eyes.—Marry! the black bile would some-times slip over his tongue's tip; then would he spit it out, and look more sweetly for the riddance.—How wittily would he mistake your meaning, and put in a conceit most season-ably out of season! His talk without affectation was com-pressed, like his beloved Elizabethans, even into obscurity;—like grains of fine gold, his sentences would beat out into whole sheets.—I say " without affectation," for he was not the blind-brained man to censure in others his own vice.—Truly " without affectation," for nothing rubbed him the wrong way so much as pretence;—then the sparks flew about!—yet, though he would strip and whip soundly such beggars in velvet rags, the thong never flew in the face of a wise moderation to do her any hurt.[1] He had small mercy on spurious fame; and a caustic observation on the fashion for men of genius (vulgarly so termed) was a standing dish:—he contended that several of our minor talents, who now emulate Byron, Coleridge, and the old Dramatists, had, fifty years ago, rested contented satellites to old Sylvanus Urban—tranquil imitators of Johnson and Goldsmith. One of these flaunting, arrogant ephemera was particularly odious to him—(in one species of his scribbling he resembleth a gilt chimney sweeper—in another a blow-fly;—this is my

[1] Somewhere in Fuller.

remark). Sometimes would he defame " after a sort " his
printed (not painted) mistresses.

> As perplexed lovers use
> At a need, when in despair;
> To paint forth their fairest fair;
> Or in part but to express
> That exceeding comeliness
> Which their fancies doth so strike,
> They borrow language of dislike,
> no other way they know
> A contentment to express,
> Borders so upon excess,
> That they do not rightly wot
> Whether it be pain or not.
>
> (" Farewell to Tobacco.")

Sir Thomas Browne was a " bosom cronie " of his—so was
Burton, and old Fuller. In his amorous vein he dallied with
that peerless Duchess of many-folio odour;—and with the
hey-day comedies of Beaumont and Fletcher he induced
light dreams. He would deliver critical touches on these
like one inspired; but it was good to let him choose his own
game;—if another began, even on the acknowledged pets,
he was liable to interrupt—or rather append, in a mode
difficult to define, whether as misapprehensive or mis-
chievous. One night, at C——'s, the above dramatic
partners were the temporary subject of chat. Mr. * * * com-
mended the passion and haughty style of a tragedy (I don't
know which of them), but was instantly taken up by Elia;
who told him, " That was nothing,—the lyrics were the high
things—the lyrics!"—and so having stricken * * * with some
amaze—he concluded with a brief intense eulogy on the
" Little Thief "!

He had likewise two perversities—a dislike to all German
literature,—by which language he was, I believe, scrupu-
lously intact;—the other was a most vehement assertion of
equality between Harrington and Fairfax, as translators—
Venial aberrations!—I know of no others.

His death was somewhat sudden; yet he was not without
wormy forebodings. Some of these he expressed, as you may
recollect, Dear Proprietor! at your hospitable table, the ——

of last ——. I accompanied him home at rather an early
hour in the morning, and being benignantly invited to
enter, I entered. His smoking materials were ready on the
table,—I cannot smoke, and therefore, during the exhaustion
of a pipe, I soothed my nerves with a single tumbler of * * *
and water. He recurred several times to his sensation of
approaching death—not gloomily—but as of a retirement
from business,—a pleasant journey to a sunnier climate.
The serene solemnity of his voice overcame me;—the tears
poured thick from their well-heads—I tried to rally myself
and him:—but my throat swelled and stopped my words.

His pipe had gone out—he held it to the flame of the candle
—but in vain.

It was empty!—his mind had been wandering. He smiled
placidly and knocked out the ashes—" even so silently," said
he, " may my fiery spark steal from its vehicle of ashes and
clay! "

I felt oppressed—many things had contributed lately to
break and daunt my once elastic spirits—I rose to go—he
shook me by the hand,—neither of us spoke—with that I
went my way—and I saw him no more—

How much is lost to this miserable world—which knew
him not while it possessed him!—I knew him—I,—who am
left to weep.—Eheu! Elia! Vale!

Good Night to All.[1]

III

[*J. H. Reynolds*, London Magazine, *February* 1823.]

THE LITERARY POLICE OFFICE, BOW-STREET

Charles Lamb was brought up, charged with the barbarous
murder of the late Mr. Elia. He was taken late in the evening,
at the house of a resort for characters of his description, in
Fleet Street[2]—and he had with him at the time of his capture
a crape mask—a phosphorus (or hock) bottle—a dark
lanthorn—a skeleton key—a centre bit (out of the haunch)—
and a large clasp knife (and fork). The evidence was in-
disputable—and Mr. Lamb was committed. There appears
to have been no apparent motive for this horrible murder,

[1] Janus was here taken too sick-hearted to proceed. He is now——.Ed. (1823).
[2] Mr. Taylor's house. The hock was also Taylor's.—*B.*

unless the prisoner had an eye to poor Mr. Elia's situation in the *London Magazine*. The prisoner is a large gaunt-looking fellow, with a queer eye, and a broad overhanging brow. If no witnesses had come forward—his looks would have appeared against him!

ESCORTED
1824

[J. A. Hessey to John Taylor, 1824.]

Thomas[1] went home with C. Lamb after much debating of the Point of Etiquette between them, Lamb declaring he could go very well by himself, and Thomas, like a wary old cat, letting his mouse go along for a little way and then pouncing upon him again—at length, finding he could manage no longer Thomas put him into a Coach and went with him to Islington—He found the house with some difficulty, and kept him from tumbling into the river, an event by no means improbable, and then by way of a finish sat down and smoked a pipe and drank gin and water with him for an hour. Thomas is the only fellow for a Job of this kind and I dare say they both enjoyed the frolic equally. . . .

THEOLOGICAL SUBJECTS
1824

[Mary Sabilla Novello, letter to L. Hunt, December 19th, 1824.]

The Lambs I told you are no longer our near neighbours, it being about 2 miles from Shacklewell to Islington, consequently as I have been too ill to go out and am at present a close nurse to Master Charles Arthur we see but little of each other. Miss Lamb is as kind and delightful as ever, Mr. Lamb has not improved his peevishness by having taken lately to theological subjects, he sometimes swears at the folly of infidels and calls us cursed hereticks, and the next moment relates some blasphemous anecdote he told when in company with Mr. Irving the Scotch preacher.

[1] Thomas Benyon, porter to Taylor & Hessey at 93 Fleet Street.—*B.*

COLEBROOK COTTAGE

c. 1824

[*Thomas Hood, in* Hood's Own.]

So I put on my great-coat, and in a few minutes found myself, for the first time, at a door that opened to me as frankly as its master's heart; for, without any preliminaries of hall, passage, or parlour, one single step across the threshold brought me into the sitting-room, and in sight of the domestic hearth. The room looked brown with "old bokes," and beside the fire sate Wordsworth, and his sister, the hospitable Elia, and the excellent Bridget. As for the bard of Rydal, his outward man did not, perhaps, disappoint one; but the palaver, as the Indians say, fell short of my anticipations. Perhaps my memory is in fault; 'twas many years ago, and, unlike the biographer of Johnson, I have never made Bozziness my business. However, excepting a discussion on the value of the promissory notes issued by our younger poets, wherein Wordsworth named Shelley, and Lamb took John Keats for choice, there was nothing of literary interest brought upon the carpet. But a book man cannot always be bookish. A poet, even a Rydal one, must be glad at times to descend from Saddleback, and feel his legs. He cannot, like the Girl in the Fairy Tale, be always talking diamonds and pearls. It is a "Vulgar Error" to suppose that an author must be always authoring, even with his feet on the fender. Nevertheless, it is not an uncommon impression, that a writer sonnetises his wife, sings odes to his children, talks essays and epigrams to his friends, and reviews his servants. It was in something of this spirit that an official gentleman to whom I mentioned the pleasant literary meetings at Lamb's, associated them instantly with his parochial mutual instruction evening schools, and remarked, "Yes, yes, all very proper and praiseworthy—of course, you go there to improve your minds."

And very pleasant and improving, though not of set purpose, to both mind and heart, were those extempore assemblies at Colebrook Cottage. It was wholesome for the soul but to breathe its atmosphere. It was a House of Call for

All Denominations. Sides were lost in that circle, men of all
parties postponed their partisanship, and met as on a neutral
ground. There were but two persons, whom L. avowedly did
not wish to encounter beneath his roof, and those two, merely
on account of private and family differences. For the rest,
they left all their hostilities at the door, with their sticks.
This forebearance was due to the truly tolerant spirit of the
host, which influenced all within its sphere. Lamb, whilst
he willingly lent a crutch to halting humility, took delight in
tripping up the stilts of pretension. Anybody might trot out
his hobby; but he allowed nobody to ride the high horse.
If it was a High German one like those ridden by the Devil
and Doctor Faustus, he would chaunt

> " Gëuty Gëuty
> Is a great Beauty,"

till the rider moderated his gallop. He hated anything like
cock-of-the-walk-ism; and set his face and his wit against
all ultraism, transcendentalism, sentimentalism, conventional
mannerism, and above all, separatism. In opposition to the
exclusives, he was emphatically an inclusive.
As he once owned to me, he was fond of antagonising.
Indeed, in the sketch of himself, prefacing the *Last Essays of
Elia*—a sketch fit for its truth to have delighted Mason the
Self-Knowledge man—he says, " with the religionist I pass
for a free-thinker, while the other faction set me down for a
bigot." In fact, no politician ever laboured more to preserve
the balance of power in Europe, than he did to correct any
temporary preponderances. He was always trimming in the
nautical, not in the political, sense. Thus in his " magnani-
mous letter,"[1] as Hazlitt called it, to High Church Southey,
he professed himself a Unitarian.[2] With a Catholic he would
probably have called himself a Jew; as amongst Quakers,
by way of a set-off against their own formality, he would
indulge in a little extra levity. I well remember his chuck-

[1] Letter of Elia to Robert Southey, Esq., *London Magazine*, October 1823.
[2] As regards his Unitarianism, it strikes me as more probable that he was what
the unco guid people call " nothing at all," which means that he was everything
but a bigot. As he was in spirit an Old Author, so he was in faith an Ancient
Christian, too ancient to belong to any of the modern sub-hubbub divisions
of —Ists, —Arians, and —Inians.—*H.*

ling at having spirited on his correspondent Bernard Barton
to commit some little enormities, such as addressing him as
C. Lamb, Esquire.

WIT AND SNUFF
1824
[John Clare, MSS.]

Then there is Charles Lamb, a long remove from his friend
Hazlitt in ways and manners. He is very fond of snuff, which
seems to sharpen up his wit every time he dips his plentiful
finger into his large bronze-coloured box; and then he
sharpens up his head, throws himself backward in his chair,
and stammers at a joke or pun with an inward sort of
utterance ere he can give it speech, till his tongue becomes a
sort of packman's strop turning it over and over till at last
it comes out whetted as keen as a razor; and expectation,
when she knows him, wakens into a sort of danger as bad as
cutting your throat. But he is a good sort, and if he offends
it is innocently done. Who is not acquainted with Elia, and
who would believe him otherwise ? As soon as the cloth is
drawn, the wine and he become comfortable; his talk now
doubles and trebles into a combination of repetitions, urging
the same thing over and over again, till at last he leaves off
with scarcely " good-night " in his mouth, and disappears,
leaving his memory like a pleasant ghost hanging about his
chair. And there is his sister Bridget, a good sort of woman,
though her kind cautions and tender admonitions are nearly
lost upon Charles, who, like an undermined river bank,
leans carelessly over his jollity, and receives the gentle lap-
ping of the waves of woman's tongue unheedingly till it
ebbs; and then in the same careless posture sits and receives
it again. Though it is all lost on Charles she is a good woman
and her cautions are very commendable: for the New River
runs very near his house, and the path for a dark night is
but very precarious, to make the best of it. And he, hearty
fellow, is not blind to dangers; so I hope the advice of his
sister Bridget will be often taken in time to retire with the
cloth and see home by daylight.

LAMB'S CHARITY

c. 1824

[B. W. Procter, Memoirs of Lamb, 1866.]

I remember that, at one of the monthly *Magazine* dinners, when John Wilkes was too roughly handled, Lamb quoted the story (not generally known) of his replying, when the blackbirds were reported to have stolen all his cherries, " Poor birds, they are welcome." He said that those impulsive words showed the inner nature of the man more truly than all his political speeches. Lamb's charity extended to all things. I never heard him speak spitefully of any author. He thought that every one should have a clear stage, unobstructed. His heart, young at all times, never grew hard or callous during life. There was always in it a tender spot, which Time was unable to touch. He gave away greatly, when the amount of his means are taken into consideration; he gave away money,—even annuities, I believe, to old impoverished friends whose wants were known to him.[1] I remember that once, when we were sauntering together on Pentonville Hill, and he noticed great depression in me, which he attributed to want of money, he said, suddenly, in his stammering way, " My dear boy, I—I have a quantity of useless things. I have now—in my desk, a—a hundred pounds—that I don't—don't know what to do with. Take it." I was much touched: but I assured him that my depression did not arise from want of money. He was very home-loving; he loved London as the best of places; he loved his home as the dearest spot in London: it was the inmost heart of the sanctuary. Whilst at home he had no curiosity for what passed beyond his own territory. His eyes were never truant; no one ever saw him peering out of window, examining the crowds flowing by; no one ever surprised him gazing on vacancy. " I lose myself," he says, " in other men's minds. When I am not walking I am reading; I cannot sit and think; books think for me." If it was

[1] Talfourd has an eloquent passage on this (*Final Memorials*, 1850 ed., 342-4.) " He used to seek out occasions of devoting a part of his surplus to those of his friends whom he believed it would really serve, and almost forced loans, or gifts in the disguise of loans, upon them."—*B.*

not the time for his pipe, it was always the time for an old play, or for a talk with friends. In the midst of this society his own mind grew green again and blossomed; or, as he would have said " burgeoned."

" *SIC TRANSIT GLORIA* MUNDEN " (*M. LAMB*)
1824
[*T. N. Talfourd*, 1837.]

In the year 1824, one of Lamb's last ties to the theatre, as a scene of present enjoyment, was severed. Munden, the rich peculiarities of whose acting he has embalmed in one of the choicest *Essays of Elia*, quitted the stage in the mellowness of his powers. His relish for Munden's acting was almost a new sense: he did not compare him with the old comedians, as having common qualities with them, but regarded him as altogether of a different and original style. On the last night of his appearance, Lamb was very desirous to attend, but every place in the boxes had long been secured; and Lamb was not strong enough to stand the tremendous rush, by enduring which, alone, he could hope to obtain a place in the pit; when Munden's gratitude for his exquisite praise anticipated his wish, by providing for him and Miss Lamb places in a corner of the orchestra, close to the stage. The play of the *Poor Gentleman*, in which Munden played " Sir Robert Bramble," had concluded, and the audience were impatiently waiting for the farce, in which the great comedian was to delight them for the last time, when my attention was suddenly called to Lamb by Miss Kelly,[1] who sat with my party far withdrawn into the obscurity of one of the upper boxes, but overlooking the radiant hollow which waved below us, to our friend. In his hand, directly beneath the line of stage lights, glistened a huge porter pot, which he was draining; while the broad face of old Munden was seen thrust out from the door by which the musicians enter, watching the close of the draught, when he might receive

[1] Miss Kelly always retained the opinion that *she* sent Lamb this historic pot of porter. An account of the occasion found its way into the *New Monthly* soon after.

and hide the portentous beaker from the gaze of the ad-
miring neighbours. Some unknown benefactor had sent
four pots of stout to keep up the veteran's heart during his
last trial; and, not able to drink them all, he bethought him
of Lamb, and without considering the wonder which would
be excited in the brilliant crowd who surrounded him, con-
veyed himself the cordial chalice to Lamb's parched lips.
At the end of the same farce, Munden found himself unable
to deliver from memory a short and elegant address which
one of his sons had written for him; but, provided against
accidents, took it from his pocket, wiped his eyes, put on his
spectacles, read it, and made his last bow. This was, per-
haps, the last night when Lamb took a hearty interest in the
present business scene; for though he went now and then to
the theatre to gratify Miss Isola, or to please an author who
was his friend, his real stage henceforth only spread itself out
in the selectest chambers of his memory.

LAMB IN 1824

[Crabb Robinson.]

I

January 10*th.* Walked out and called on Miss Lamb. I
looked over Lamb's library in part. He has the finest collec-
tion of shabby books I ever saw; such a number of first-rate
works in very bad condition is, I think, nowhere to be found.

II

March 5*th.* Walked over to Lamb's. Meant a short visit,
but Monkhouse was there as well as Manning; so I took tea
and stayed the whole evening, and played whist. Besides,
the talk was agreeable. On religion, Monkhouse talked as I
did not expect; rather earnestly on the Atonement, as the
essential doctrine of Christianity, but against the Trinity,
which he thinks by a mere mistake has been adopted from
Oriental philosophy, under a notion that it was necessary
to the Atonement. The dogmatism of theology has disgusted

Lamb, and it is that alone which he opposes; he has the organ of theosophy, and is by nature pious.

III

June 1st. I was induced to engage myself to dine with C. Lamb. After dinner he and I took a walk to Newington. We sat an hour with Mrs. Barbauld. She was looking tolerably, but Lamb (contrary to his habit) was disputatious with her, and not in his best way. He reasons from feelings and those often idiosyncrasies; she from abstractions and verbal definitions. Such people can't agree.

IV

June 10th. On my walk with Lamb, he spoke with enthusiasm of Manning, declaring that he is the most wonderful man he ever knew, more extraordinary than Wordsworth or Coleridge. Yet he does nothing. He has travelled even in China, and has been by land from India through Thibet, yet, as far as is known, he has written nothing. Lamb says his criticisms are of the very first quality.

V

July 5th. I dined at Castle Street, and took tea at Lamb's. Mr. Irving and his friend, Mr. Carlyle, were there. An agreeable evening enough; but there is so little sympathy between Lamb and Irving, that I do not think they can or ought to be intimate.

VI

July 6th. Took tea with Lamb. Hessey gave an account of De Quincey's description of his own bodily sufferings. " He should have employed as his publishers," said Lamb, " Pain and Fuss " (Payne and Foss).

VII

November 21st. Dined at the Bar mess in Hall, and then went to Lamb's. Allsop was there, an amiable man. I believe his acquaintance with Lamb originated in his sending Coleridge a present of £100, in admiration of his genius.

I

MISS MITFORD'S *OUR VILLAGE*
1824

[M. R. Mitford to Sir William Elford, March 5th, 1824.]

Charles Lamb (the matchless "Elia" of the *London Magazine*) says that nothing so fresh and characteristic has appeared for a long while. It is not over modest to say this; but who would not be proud of the praise of such a *proser*?

BARBARA S——
1825

[Fanny Kelly, letter to Charles Kent, September 28th, 1875.]

I perfectly remember relating an incident of my childhood to Charles Lamb and his dear sister, and I have not the least doubt that the intense interest he seemed to take in the recital, induced him to adopt it as the principal feature in his beautiful story of *Barbara S——*. But, beautiful as it is, I am a little concerned to learn that in Sir Charles Dilke's Memoir of his Grandfather prefixed to the *Papers of a Critic*, recently published by Mr. Murray, it is referred to in a letter from Charles Lamb as "shadowing under that name Miss Kelly's early life." Much, however, as I venerate the wonderful powers of Charles Lamb as a writer, grateful as I ever must feel to have enjoyed for so many years the friendship of himself and his dear sister, and proudly honoured as I am by the two exquisite sonnets he has given to the world as tributary to my humble talent, I have never been able thoroughly to appreciate the extraordinary skill with which he has, in the construction of his story, desired and contrived so to mystify and characterize the events, as to keep me out of sight, and render it utterly impossible for any one to guess at me as the original heroine. Such, I know, was his intention; otherwise, so to have avoided and altered the facts in every point as he has done, would have surprised and disheartened me. As it is, I persuade myself, that I only second his delicate motives, when I object to appear in the garb in which he has so skilfully presented the young lady. So that if I am to be, as it seems, considered and announced

as the *bona fide* heroine of the tale, I frankly declare, that I infinitely prefer the position and feelings of " little Fanny Kelly " to those of Miss Barbara. The question is, how truly, and to what extent, it even " shadows " the early life of Frances Maria Kelly? I was not a little playhouse " Super," snatched from respectable poverty, to be plunged (alas! as such too often are) without instruction, or protection, into a life of risk to health and morals. I was a well-born, cared-for child of a devoted mother, whose position and education as a gentlewoman, taught her that self-esteem which, with mental courage, patient endurance, and unceasing sacrifices, enabled her with her five children to " take arms against a siege of troubles." . . .

LAMB AND THE SPIRIT OF THE AGE
1825

[*William Hazlitt*, The Spirit of the Age, 1825.]

Antiquity after a time has the grace of novelty, as old fashions revived are mistaken for new ones; and a certain quaintness and singularity of style is an agreeable relief to the smooth and insipid monotony of modern composition. Mr. Lamb has succeeded not by conforming to the Spirit of the Age, but in opposition to it. He does not march boldly along with the crowd, but steals off the pavement to pick his way in the contrary direction. He prefers bye-ways to highways. When the full tide of human life pours along to some festive show, to some pageant of a day, Elia would stand on one side to look over a bookstall, or stroll down some deserted pathway in search of a pensive inscription over a tottering door-way, or some quaint device in architecture, illustrative of embryo art and ancient manners.

Mr. Lamb has the very soul of an antiquarian, as this implies a reflecting humanity; the film of the past hovers forever before him. He is shy, sensitive, the reverse of every thing coarse, vulgar, obtrusive, and commonplace. He would fain, " shuffle off this mortal coil," and his spirit clothes itself in the garb of elder time, homelier, but more durable. He is borne along with no pompous paradoxes, shines in no glittering tinsel of a fashionable phraseology; is

neither fop nor sophist. He has none of the turbulence or
froth of new-fangled opinions. His style runs pure and clear,
though it may often take an underground course, or be
conveyed through old-fashioned conduit-pipes. Mr. Lamb
does not court popularity, nor strut in gaudy plumes, but
shrinks from every kind of ostentatious and obvious preten-
sion into the retirement of his own mind.

> "The self-applauding bird, the peacock see:—
> Mark what a sumptuous pharisee is he!
> Meridian sun-beams tempt him to unfold
> His radiant glories, azure, green, and gold:
> He treads as if, some solemn music near,
> His measured step were governed by his ear:
> And seems to say—' Ye meaner fowl, give place,
> I am all splendour, dignity, and grace!'
> Not so the pheasant on his charms presumes,
> Though he too has a glory in his plumes.
> He, Christian-like, retreats with modest mien
> To the close copse or far sequestered green,
> And shines without desiring to be seen."

These lines well describe the modest and delicate beauties
of Mr. Lamb's writings, contrasted with the lofty and vain-
glorious pretensions of some of his contemporaries. This
gentleman is not one of those who pay all their homage to
the prevailing idol: he thinks that

> "New-born gauds are made and moulded of
> things past,"

nor does he

> "Give to dust that is a little gilt
> More laud than gilt o'er-dusted."

His convictions " do not in broad rumour lie," nor are they
" set off to the world in the glistering foil " of fashion; but
" live and breathe aloft in those pure eyes, and perfect judge-
ment of all-seeing time." Mr. Lamb rather affects and is
tenacious of the obscure and remote: of that which rests on
its own intrinsic and silent merit; which scorns all alliance,
or even the suspicion of owing any thing to noisy clamour, to
the glare of circumstances. There is a fine tone of chiaro-
scuro, a moral perspective in his writings. He delights to
dwell on that which is fresh to the eye of memory; he yearns

after and covets what soothes the frailty of human nature.
That touches him most nearly which is withdrawn to a cer-
tain distance, which verges on the borders of oblivion:—that
piques and provokes his fancy most, which is hid from a
superficial glance. That which, though gone by, is still
remembered, is in his view more genuine, and has given
more " vital signs that it will live," than a thing of yesterday,
that may be forgotten to-morrow. Death has in this sense the
spirit of life in it; and the shadowy has to our author some-
thing substantial in it. Ideas savour most of reality in his
mind; or rather his imagination loiters on the edge of each,
and a page of his writings recalls to our fancy the stranger on
the grate, fluttering in its dusky tenuity, with its idle super-
stition and hospitable welcome!

Mr. Lamb has a distaste to new faces, to new books, to
new buildings, to new customs. He is shy of all imposing
appearances, of all assumptions of self-importance, of all
adventitious ornaments, of all mechanical advantages, even
to a nervous excess. It is not merely that he does not rely
upon, or ordinarily avail himself of them; he holds them in
abhorrence, he utterly abjures and discards them, and
places a great gulph between him and them. He disdains
all the vulgar artifices of authorship, all the cant of criticism,
and helps to notoriety. He has no grand swelling theories to
attract the visionary and the enthusiast, no passing topics to
allure the thoughtless and the vain. He evades the present,
he mocks the future. His affections revert to, and settle on
the past, but then, even this must have something personal
and local in it to interest him deeply and thoroughly; he
pitches his tent in the suburbs of existing manners; brings
down the account of character to the few straggling remains
of the last generation; seldom ventures beyond the bills of
mortality, and occupies that nice point between egotism and
disinterested humanity. No one makes the tour of our
southern metropolis, or describes the manners of the last
age, so well as Mr. Lamb—with so fine, and yet so formal an
air—with such vivid obscurity, with such arch piquancy,
such picturesque quaintness, such smiling pathos. How
admirably he has sketched the former inmates of the South-
Sea House; what " fine fretwork he makes of their double
and single entries! " With what a firm, yet subtle pencil he

has embodied Mrs. Battle's Opinions on Whist! How notably
he embalms a battered beau: how delightfully an amour,
that was cold forty years ago, revives in his pages! With
what well-disguised humour he serves up his friends!
Certainly, some of his portraits are fixtures, and will do to
hang up as lasting and lively emblems of human infirmity.
Then there is no one who has so sure an ear for " the chimes
at midnight," not even excepting Mr. Justice Shallow; nor
could Master Silence himself take his " cheese and pippins "
with a more significant and satisfactory air. With what a
gusto Mr. Lamb describes the inns and courts of law, the
Temple and Gray's Inn, as if he had been a student there
for the last two hundred years, and had been as well ac-
quainted with the person of Sir Francis Bacon as he is with
his portrait or writings! It is hard to say whether St. John's
Gate is connected with more intense and authentic associa-
tions in his mind, as a part of old London Wall, or as the
frontispiece (time out of mind) of the *Gentleman's Magazine*.
He haunts Watling-street like a gentle spirit; the avenues
to the play-houses are thick with panting recollections, and
Christ's Hospital still breathes the balmy breath of infancy
in his description of it! Whittington and his Cat are a fine
hallucination for Mr. Lamb's historic Muse, and we believe
he never heartily forgave a certain writer who took the
subject of Guy Faux out of his hands. The streets of London
are his fairy-land, teeming with wonder, with life and
interest to his retrospective glance, as it did to the eager
eye of childhood; he has contrived to weave its tritest
traditions into a bright and endless romance!

Mr. Lamb's taste in books is also fine, and it is peculiar.
It is not the worse for a little idiosyncrasy. He does not go
deep into the Scotch novels, but he is at home in Smollett or
Fielding. He is little read in Junius or Gibbon, but no man
can give a better account of Burton's *Anatomy of Melancholy*,
or Sir Thomas Browne's *Urn-Burial*, or Fuller's *Worthies*, or
John Bunyan's *Holy War*. No one is more unimpressible
to a specious declamation; no one relishes a recondite
beauty more. His admiration of Shakespeare and Milton
does not make him despise Pope; and he can read Parnell
with patience, and Gay with delight. His taste in French
and German literature is somewhat defective; nor has he

made much progress in the science of Political Economy or
other abstruse studies, though he has read vast folios of
controversial divinity, merely for the sake of the intricacy of
style, and to save himself the pain of thinking. Mr. Lamb is
a good judge of prints and pictures. His admiration of
Hogarth does credit to both, particularly when it is con-
sidered that Leonardo da Vinci is his next greatest favourite,
and that his love of the actual does not proceed from a want
of taste for the ideal. His worst fault is an over-eagerness of
enthusiasm, which occasionally makes him take a surfeit of
his highest favourites.—Mr. Lamb excels in familiar con-
versation almost as much as in writing, when his modesty
does not overpower his self-possession. He is as little of a
proser as possible; but he blurts out the finest wit and sense
in the world. He keeps a good deal in the back-ground at
first, till some excellent conceit pushes him forward, and
then he abounds in whim and pleasantry. There is a primi-
tive simplicity and self-denial about his manners; and a
Quakerism in his personal appearance, which is, however,
relieved by a fine Titian head, full of dumb eloquence!
Mr. Lamb is a general favourite with those who know him.
His character is equally singular and amiable. He is
endeared to his friends not less by his foibles than his virtues;
he insures their esteem by the one, and does not wound
their self-love by the other. He gains ground in the opinion
of others, by making no advances of his own. We easily
admire genius where the diffidence of the possessor makes
our acknowledgment of merit seem like a sort of patronage,
or act of condescension, as we willingly extend our good
offices where they are not exacted as obligations, or repaid
with sullen indifference.—The style of the *Essays of Elia* is
liable to the charge of a certain mannerism. His sentences
are cast in the mould of old authors; his expressions are
borrowed from them; but his feelings and observations are
genuine and original, taken from actual life, or from his own
breast; and he may be said (if any one can) " to have coined
his heart for jests," and to have split his brain for fine
distinctions! Mr. Lamb, from the peculiarity of his exterior
and address as an author, would probably never have made
his way by detached and independent efforts; but, for-
tunately for himself and others, he has taken advantage of

the Periodical Press, where he has been stuck into notice,
and the texture of his compositions is assuredly fine enough
to bear the broadest glare of popularity that has hitherto
shone upon them. Mr. Lamb's literary efforts have procured
him civic honours (a thing unheard of in our times), and he
has been invited, in his character of ELIA, to dine at a select
party with the Lord Mayor. We should prefer this distinction
to that of being poet-laureat. We would recommend to
Mr. Waithman's perusal (if Mr. Lamb has not anticipated
us) the *Rosamund Gray* and the *John Woodvil* of the same
author, as an agreeable relief to the noise of a City feast, and
the heat of city elections. A friend, a short time ago, quoted
some lines[1] from the last-mentioned of these works, which
meeting Mr. Godwin's eye, he was so struck with the beauty
of the passage, and with a consciousness of having seen it
before, that he was uneasy till he could recollect where, and
after hunting in vain for it in Ben Jonson, Beaumont and
Fletcher, and other not unlikely places, sent to Mr. Lamb
to know if he could help him to the author!

THE THREE ESSAYISTS

c. 1825

[*B. W. Procter*, Memoirs of Lamb, 1866.]

Charles Lamb, William Hazlitt, and Leigh Hunt formed a
remarkable trio of men; each of whom was decidedly
different from the others. Only one of them (Hunt) cared
much for praise. Hazlitt's sole ambition was to sell his
essays, which he rated scarcely beyond their marketable
value; and Lamb saw enough of the manner in which
praise and censure were at that time distributed, to place
any high value on immediate success. Of posterity neither
of them thought. Leigh Hunt, from temperament, was
more alive to pleasant influences (sunshine, freedom for
work, rural walks, complimentary words) than the others.
Hazlitt cared little for these things; a fierce argument or a
well-contested game at rackets was more to his taste; whilst
Lamb's pleasures (except perhaps from his pipe) lay amongst

[1] The description of sports in the forest:
 " To see the sun to bed and to arise,
 Like some hot amourist with glowing eyes," etc.

the books of the old English writers. His soul delighted in communion with ancient generations; more especially with men who had been unjustly forgotten. Hazlitt's mind attached itself to abstract subjects; Lamb's was more practical, and embraced men. Hunt was somewhat indifferent to persons as well as to things, except in the cases of Shelley and Keats, and his own family; yet he liked poetry and poetical subjects. Hazlitt (who was ordinarily very shy) was the best talker of the three. Lamb said the most pithy and brilliant things. Hunt displayed the most ingenuity. All three sympathized often with the same persons or the same books; and this, no doubt, cemented the intimacy that existed between them for so many years. Moreover, each of them understood the others, and placed just value on their objections when any difference of opinion (not infrequent) arose between them. Without being debaters, they were accomplished talkers. They did not argue for the sake of conquest, but to strip off the mists and perplexities which sometimes obscure truth. These men—who lived long ago— had a great share of my regard. They were all slandered; chiefly by men who knew little of them, and nothing of their good qualities: or by men who saw them only through the mist of political or religious animosity. Perhaps it was partly for this reason that they came nearer to my heart.

DEDICATORY POEM TO C. L.
1825

[*J. P. Collier*, The Poet's Pilgrimage, 1825.]

Charles, to your liberal censure I commit
This book, of which I say with judgment cool
'Tis worth an hour. I were too gross a fool
Not to think that, for I have printed it.
You'll haply prize my poem, and 'tis fit,
Because it emulates the antique school;
Is written on that model, plan, and rule:
Not that it owns its vigour, fancy, wit.
But if you like it I am well content;
'Tis easy to approve it more than I;
And while you read the young-old trifle sent,

Can, no one better, its worst wants supply.
This is the reason why the wise relent,
And genius judges with such charity.

MENAGIANA
1825

[Leigh Hunt, New Monthly Magazine, 1825.]

The Duke of Orleans was in the garden of Luxembourg when it was very hot. The sun beat directly on the heads of his courtiers, who were uncovered. M. de Bautru, who was present, observed, that princes did not love their friends. The Duke said, the reproach could not attach to him, for he loved them very much. "Your Highness must love them boiled then," returned Bautru, "or, at least, well roasted."

Ha! C. [Lamb], have you been here among your old books? C. was plagued by a foolish woman to know whether he loved children. "Yes, Madam," said he; "boiled."[1]

MEMORIES OF *ROSAMUND GREY*
1825

[L. (perhaps Procter) in New Monthly Magazine, 1825.]

This soft, highly-flavoured Port, in every drop of which you seem to taste an aromatic flower, revives that delicious evening, when, after days of search for the tale of Rosamund Grey, of which I had indistinctly heard, I returned from an obscure circulating library with my prize, and brought out a long-cherished bottle, given me two years before as a curiosity, by way of accompaniment to that quintessence of imaginative romance. How did I enjoy, with a strange delight, its scriptural pathos, like a newly discovered chapter of the Book of Ruth; hang enamoured over its young beauty, lovelier for the antique frame of language in which it was set; and long to be acquainted with the author, though I scarcely dared aspire so high, and little anticipated those hundreds of happy evenings since passed in his society, which now crowd on me in rich confusion!

[1] But, if the remark had any origin other than irritation, would it not be Swift's *Modest Proposal*?—B.

1825-34
THE SUPERANNUATED MAN

LAMB'S CLERKSHIP ENDED
1825

I

[Crabb Robinson.]

April 22nd. In the evening called on C. Lamb. He and his sister in excellent spirits. He has obtained his discharge from the India House, with the sacrifice of rather more than a third of his income. He says he would not be condemned to a seven years' return to his office for a hundred thousand pounds. I never saw him so calmly cheerful as now.

II

[Crabb Robinson to Miss Wordsworth, June 1825.]

I have not seen the Lambs so often as I used to do, owing to a variety of circumstances. Nor can I give you the report you so naturally looked for of his conduct at so great a change in his life. . . . The expression of his delight has been childlike (in the good sense of that word). You have read *The Superannuated Man.* I do not doubt, I do not fear, that he will be unable to sustain the " weight of chance desires." Could he—but I fear he cannot—occupy himself in some great work requiring continued and persevering attention and labour, the benefit would be equally his and the world's. Mary Lamb has remained so long well, that one might almost advise, or rather permit, a journey to them. But Lamb has no desire to travel. If he had, few things would give me so much pleasure as to accompany him. I should be proud of taking care of him. But he has a passion for solitude, he says, and hitherto he finds that his retirement from business has not brought leisure.

AN AWKWARD INTRODUCTION

1826

[*P. G. Patmore*, My Friends and Acquaintance, 1854.]

My first introduction to Charles Lamb took place acci-
dentally, at the lodgings of William Hazlitt, in Down-street,
Piccadilly, in 1824,[1] and under circumstances which have
impressed it with peculiar vividness on my memory. Mr.
Colburn had published anonymously, only two or three
days before, a jeu-d'esprit of mine [*Rejected Articles*], which
aimed at being, to the prose literature of the day, something
like what the *Rejected Addresses* was to the poetry,—with this
marked difference, however, that my imitations were in a
great measure bona fide ones, seeking to re-produce or
represent, rather than to ridicule, the respective qualities
and styles of the writers imitated; merely (for the sake of
" effect ") pushing their peculiarities to the verge of what
the truth permitted.

As I was very young in author-craft at that time, and
proportionately nervous as to the personal consequences
that might attend a literary adventure of this peculiar
character, I had called on Hazlitt on the day in question,
in the hope of learning from him anything that might have
transpired on the subject in his circle, he himself, and
several of his personal friends, being among the imitated.
We met from opposite directions at his door, and he had
(what was the rarest thing in the world with him) a book in
his hand, the uncut leaves of which he had been impatiently
tearing open with his finger as he came along, and before
we had reached the top of the stairs I found, to my
no small alarm, it was the book which occupied all my
thoughts.

This was an ominous commencement of my investigation;
for the book contained a portrait of Hazlitt himself, drawn
with a most unsparing hand, because professing to be his
own, and to have been " Rejected," for obvious reasons,
from his own *Spirit of the Age*, then recently published.

[1] 1826, if the rest is accurate, that being the date of *Rejected Articles.*—B.

Hazlitt's looks, however, which were an infallible criterion of the temper of his mind at the moment of consulting them, were quite sufficient to satisfy me that he was not displeased with what he had been reading. But before anything could be said on the matter beyond his asking me if I had seen the book, the door opened, and two persons entered whom, though I had never before seen either of them, I at once felt to be Charles Lamb and his sister.

The plot now thickened; for scarcely had I been introduced to the new-comers, when Hazlitt pointed to the book which he had laid on the table on their entrance, and said to Miss Lamb, " There's something there about Charles and you. Have you seen it ? "

Miss Lamb immediately took up the book, and began to read to herself (evidently with no very good will) the opening paper, which was an imitation of an Essay by Elia.

Here was an accumulation of embarrassments, which no consideration could have induced me to encounter willingly, but which, being inevitable, I contrived to endure with great apparent composure; though the awkwardness of my position was not a little enhanced by Miss Lamb presently turning to her brother, and expressing feelings about what she had read, which indicated that her first impression was anything but a favourable or agreeable one. Lamb himself seemed to take no interest whatever in the matter.

They stayed but a very short time, spoke only on the ordinary literary topics of the day, and on taking leave, Lamb pressed me to visit him at Islington, where he then resided.

During this brief interview with the Lambs, nothing in the smallest degree characteristic occurred; and if I had not seen Charles Lamb again, I might have set him down as an ordinary person, whose literary eccentricities and oddities had been gratuitously transferred by report to his personal character and way of life.

I visited Lamb shortly afterwards at his house in Colebrook Row, and an intimacy ensued which lasted till his death, if, indeed, one is entitled to describe as intimacy an intercourse which, as in the case of all the rest of Lamb's friends, consisted of pleasant visits on the one part, and a

gratified and grateful reception of them on the other, which seemed intended to intimate that there was nothing he did not owe you, and was not willing to pay, in return for the dispensation you granted him from the ceremony of visiting you in return: for the Lambs rarely left home, and when they did, were never themselves till they got back again.

The foregoing remarks point at what I afterwards learned to consider as the leading and distinctive feature of Lamb's intellectual character, and also that of his sister—at least at and after the time at which I first became acquainted with them. All their personal thoughts, feelings, and associations were so entirely centred in those of each other, that it was only by an almost painful effort they were allowed to wander elsewhere, even at the brief intervals claimed by that social intercourse which they nevertheless could not persuade themselves wholly to shun. They had been for so many years accustomed to look to each other alone for sympathy and support, that they could scarcely believe these to exist for them apart from themselves;—and the perpetual consciousness of this mutual failing, in a social point of view, and the perpetual sense of its results upon their intellectual characters respectively, gave to both of them an absent and embarrassed air—always excepting when they sought and found temporary shelter from it in that profuse and somewhat indiscriminate hospitality, which, at this period, marked their simple home at Islington.

It is true they were, perhaps, never so happy as when surrounded by those friends and acquaintance who sought them at their own house. But this was at best a happiness little suited to the intellectual habits and temperament of either, and one, therefore, for which they paid much more than it was worth to them—so much more that they, not long after the period to which I am now alluding, sought refuge from the evil in a remedy that was worse than the disease. Always in extremes, and being now able, by his retirement from the India House, to fix their whereabouts wherever they pleased, they fled from too exciting scenes of the great metropolis to the (for them) anything but " populous solitude " of that country life for which they were equally unfitted and unprepared.

WRITING FOR COLBURN
1826

I

[Crabb Robinson.]

The Lambs are really improving. If you look into the last *New Monthly Magazine*, you will be delighted by perceiving that Charles Lamb is himself again. His peculiar mixture of wit and fancy is to be found there in all its charming individuality. No one knows better than he the proportions of earnestness and gaiety for his undefinable compositions. His health, I think, is decidedly improving.

A few evenings ago I met at his house one of the attachés to the great Lombard Street shop. He said that Mr. Wordsworth's works had been repeatedly inquired after lately; and that the inquirers had been referred to Hurst's house. This led to a talk about the new edition, and the new arrangement. Lamb observed, " There is only one good order—and that is the order in which they were written—that is, a history of the poet's mind."

II

[Edmund Ollier, introduction to Elia, *1867.]*

Lamb, by the way, never liked writing for the *New Monthly* so much as for the *London*; and once, when my father took up to his house, at Islington, a cheque for £50, in payment of contributions to the former (a sum in excess of the rate per page), he burst out into denunciations of what he called Colburn's meanness, and mourned the days when he wrote for the other Magazine, then defunct.

HAY'S *DEFORMITY: AN ESSAY*
1826

[Crabb Robinson.]

April 23rd. Called late on Lamb. He lent me a humorous " Essay on Deformity," which I read with pleasure. It is very much in Lamb's own style of humour, and is a piece of

K

playful self-satire, if not written in the assumed character of a hump-backed, diseased member of Parliament. Published by Dodsley, 1794,[1] the author, William Hay, Esq. He would have been known to the wits of his age.

LAMB'S APPEARANCE
c. 1826

[*P. G. Patmore*, My Friends and Acquaintance, 1854.]

I do not know whether Lamb had any oriental blood in his veins, but certainly the most marked complexional characteristic of his head was a Jewish look, which pervaded every portion of it, even to the sallow and uniform complexion, and the black and crisp hair standing off loosely from the head, as if every single hair were independent of the rest. The nose, too, was large and slightly hooked, and the chin rounded and elevated to correspond. There was altogether a Rabbinical look about Lamb's head which was at once striking and impressive.

Thus much of form chiefly. In point of intellectual character and expression, a finer face was never seen, nor one more fully, however vaguely, corresponding with the mind whose features it interpreted. There was the gravity usually engendered by a life passed in book-learning, without the slightest tinge of that assumption and affectation which almost always attend the gravity so engendered; the intensity and elevation of general impression that mark high genius, without any of its pretension and its oddity; the sadness waiting on fruitless thoughts and baffled aspirations, but no evidences of that spirit of scorning and contempt

[1] The Essay appeared in 1754, and was included in Dodsley's *Fugitive Pieces*. There is in it an argument on Bacon's assertion, " Deformed Persons are commonly even with Nature; for as Nature hath done ill by them, so do they by Nature, being for the most part (as the Scripture saith) *void of Natural Affection*." Hay comments: " I can neither find out this Passage in Scripture, nor the Reason of it; nor can I give my Assent or Negative to a Proposition, till I am well acquainted with the Terms of it. If by natural Affection is here meant Universal Benevolence, and Deformity necessarily implies a Want of it, a deformed Person must then be a complete Monster. But however common the Case may be, my own Sensations inform me, that it is not universally true." On this general notion, it may be, Lamb was induced to write his half-serious article: " On the Danger of Confounding Moral with Personal Deformity."—*B.*

which these are apt to engender. Above all, there was a
pervading sweetness and gentleness which went straight to
the heart of everyone who looked on it; and not the less so,
perhaps, that it bore about it an air, a something, seeming
to tell that it was, not put on—for nothing would be more
unjust than to tax Lamb with assuming anything, even a
virtue, which he did not possess—but preserved and per-
severed in, spite of opposing and contradictory feelings
within, that struggled in vain for mastery. It was a thing to
remind you of that painful smile which bodily disease and
agony will sometimes put on, to conceal their sufferings from
the observation of those they love.

The truth is, that Lamb was what is by no means so
uncommon or so contradictory a character as the unobser-
vant may deem it: he was a gentle, amiable, and tender-
hearted misanthrope. He hated and despised men with his
mind and judgment, in proportion as (and precisely because)
he loved and yearned towards them in his heart; and
individually, he loved those best whom everybody else hated,
and for the very reasons for which others hated them. He
generally through life had two or three especial pets, who
were always the most disagreeable people in the world—to
the world. To be taken into Lamb's favour and protection
you had only to get discarded, defamed, and shunned by
everybody else; and if you deserved this treatment, so much
the better! If I may venture so to express myself, there was
in Lamb's eyes a sort of sacredness in sin, on account of its
sure ill consequences to the sinner; and he seemed to open
his arms and his heart to the rejected and reviled of man-
kind in a spirit kindred at least with that of the Deity.

Returning to my description of Lamb's personal appear-
ance,—his head might have belonged to a full-sized person,
but it was set upon a figure so petite that it took an appear-
ance of inappropriate largeness by comparison. This was
the only striking peculiarity in the ensemble of his figure;
in other respects it was pleasing and well-formed, but so
slight and delicate as to bear the appearance of extreme
spareness, as if of a man air-fed, instead of one rejoicing in a
proverbial predilection for " roast pig." The only defect of
his figure was that the legs were too slight even for the slight
body.

LAMB AND GEORGE HERBERT
1826
[S. T. Coleridge to Lady Beaumont, March 18th, 1826.]

My dear old friend Charles Lamb and I differ widely
(and in point of taste and moral feeling this is a rare occur-
rence) in our estimation and liking of George Herbert's
sacred poems. He greatly prefers Quarles, nay, he *dis*likes
Herbert.

WORDSWORTH MISAPPLIED
c. 1827
[Edmund Ollier, 1867.]

Lamb had a great partiality for the epithet " damned ";
and he got a certain droll impression out of that odd stanza
in Wordsworth's *Peter Bell*, in which, after describing the
reflection of the donkey's head in the stream, which so
alarmed Peter, the poet asks:—

" Is it a party in a parlour,
 Cramm'd just as they on earth were cramm'd ?
Some sipping punch, some sipping tea,
But, as you by their faces see,
 All silent—and all damn'd."

One night, in going home from my father's house, Lamb
observed a lighted parlour window in Berkeley-street,
Portman-square, and an unmistakable " party " inside,
enjoying themselves after their kind. Wordsworth's lines at
once occurred to him, and, clinging to the area railings, he
shook them, and shrieked, " You damned party in a parlour!
You damned party in a parlour! "

THOMAS ALLSOP'S ANECDOTES
c. 1826
[Allsop's Letters, &c., of S. T. Coleridge, 1835.]

I am quite aware that I can convey no notion of what
Charles Lamb was, hardly even of what he said, as far the
greatest part of its value depended upon the manner in

which it was said. Even the best of his jokes—and how good
they were you can never know—depended upon the circum-
stances, which to narrate would be to overlay and weary
the attention.

The first night I ever spent with Lamb was after a day
with Coleridge, when we returned by the same stage; and
from something I had said or done of an unusual kind, I
was asked to pass the night with him and his sister. Thus
commenced an intimacy which never knew an hour's
interruption to the day of his death.

He asked me what I thought of Coleridge. I spoke as I
thought. "You should have seen him twenty years ago,"
said he, with one of his sweet smiles, "when he was with me
at the Cat and Salutation in Newgate Market. Those were
days (or nights), but they were marked with a white stone.
Such were his extraordinary powers, that when it was time
for him to go and be married, the landlord entreated his
stay, and offered him free quarters if he would only talk."

" I once wrote to Wordsworth to inquire if he was really a
Christian. He replied, ' When I am a good man, then I am
a Christian.' "

" Irving once came back to ask me if I could ever get in a
word with Coleridge. ' No! ' said I, ' I never want.'
" ' Why, perhaps it is better not,' said the parson, and
went away, determined how to behave in future."

" I made that joke first (the Scotch corner in hell, fire
without brimstone), though Coleridge somewhat licked it
into shape."

" Wordsworth, the greatest poet of these times. Still he
is not, nor yet is any man, an Ancient Mariner."

" Procter is jealous of his own fame,[1] which he cannot now
claim."

" Somerset House, Whitehall Chapel (the old Banqueting
Hall), the church at Limehouse and the new church at

[1] As " Barry Cornwall."—B.

Chelsea, with the Bell house at Chelsea College, which
always reminded him of Trinity College, Cambridge, were
the objects most interesting to him in London.[1] He did not
altogether agree with Wordsworth, who thought the view
from Harewood-place one of the finest in old London;
admired more the houses at the Bond-street corner of
George-street, which Manning said were built of bricks
resembling in colour the great wall of China."

Martin Burney, whilst earnestly explaining the three kinds
of acid, was stopped by Lamb's saying,—" The best of all
kinds of acid, however, as you know, Martin, is uity—
assiduity."

Lamb then told us a story of that very dirty person, Tom
Bish, which I give here for its felicity.
Some one, I think it was Martin, asserted Bish was a name
which would not afford a pun. Lamb at once said, I went
this morning to see him, and upon coming out of his room,
I was asked by a jobber if he was alive ? " Yes," said I,
" he is B—— B—— Bish-yet."

Martin defined poetry as the highest truth, which Lamb
denied, and, amongst other instances, quoted the song of
Deborah.

The conversation turned one night on the evidence
against the Queen, especially Majocchi. Lamb said he
should like to see them; he would ask them to supper.
Mr. Talfourd observed,—
" You would not sit with them ? "
" Yes," said Lamb, " I would sit with anything but a hen
or a tailor."

A few days before, he had been with Jameson to the Tower,
and, in passing by Billingsgate, was witness to a quarrel and
fight between two fish-women, one of whom, taking up a

[1] " Wardour Street is famous for bookstalls and curiosity shops . . . I have
heard Lamb expatiate on the pleasure of strolling up ' Wardour Street on a
summer's day '." Leigh Hunt in P. Cunningham's *Handbook of London*, 1850;
and elsewhere Hunt has an anecdote of Lamb's liking for Primrose Hill (in its
primrose days).—*B.*

knife, cut off her antagonist's thumb. "Ha!" said Lamb, looking about him as if he only just recognised the place, "this is Fair-lop Fair."

I retain a very vivid recollection of Manning, though so imperfect in my memory of persons that I should not recollect him at this time. I think few persons had so great a share of Lamb's admiration, for to few did he vouchsafe manifestations of his very extraordinary powers. Once, and once only, did I witness an outburst of his unembodied spirit, when such was the effect of his more than magnetic, his magic power (learnt was it in Chaldea, or in that sealed continent to which the superhuman knowledge of Zoroaster was conveyed by Confucius, into which he was the first to penetrate with impunity?), that we were all rapt and carried aloft into the seventh heaven. Passing from a state which was only not of the highest excitement, because the power was felt, not shown, he, by an easy, a graceful, and, as it seemed at the time, a natural transition, entered upon the discussion, or, as it rather seemed, the solution of some of the most interesting questions connected with the early pursuits of men. Amongst other matters, the origin of cooking, which it seems was deemed of sufficient importance by older, and therefore wiser, nations to form part of their archives. How this transcript was obtained, whether from that intuitive knowledge to which allusion has been made, or whether application was had to the keeper of the state paper office of the Celestial Empire, I cannot now say. I can only vouch for the truth of what follows, which, with the reply to a letter of acknowledgment from Coleridge, who, having received a roast pig, and not knowing whence it came, fixed upon Lamb as the donor, were afterwards fused into an essay, perhaps the most delightful in our language.

"A child, in the early ages, was left alone by its mother in a house in which was a pig. A fire took place; the child escaped, the pig was burned. The child scratched and pottered amongst the ashes for its pig, which at last it found. All the provisions being burnt, the child was very hungry, and not yet having any artificial aids, such as golden ewers

and damask napkins, began to lick or suck its fingers to free
them from the ashes. A piece of fat adhered to one of his
thumbs, which, being very savoury alike in taste and odour,
he rightly judged to belong to the pig. Liking it much, he
took it to his mother, just then appearing, who also tasted
it, and both agreed that it was better than fruit or vegetables.

" They rebuilt the house, and the woman, after the fashion
of good wives, who, says the chronicle, are now very scarce,
put a pig into it, and was about to set it on fire, when an old
man, one whom observation and reflection had made a
philosopher, suggested that a pile of wood would do as well.
(This must have been the father of economists.) The next
pig was killed before it was roasted, and thus

> " From low beginnings,
> We date our winnings."

Sunday.—Dined with Lamb alone. A most delightful day
of reminiscences. Spoke of Mrs. Inchbald as the only
endurable clever woman he had ever known; called them
impudent, forward, unfeminine, and unhealthy in their
minds. Instanced, amongst many others, Mrs. Barbauld,
who was a torment and curse to her husband. " Yet," said
Lamb, " Laetitia was only just tinted; she was not what
the she-dogs now call an intellectual woman." Spoke of
Southey most handsomely; indeed he never would allow
any one but himself to speak disparagingly of either
Coleridge, Wordsworth, or Southey, and with a sort of
misgiving of Hazlitt as a wild, mad being. Attributed his
secession to pique that he had not been asked to meet
Wordsworth. He had also accused Lamb of not seeing him
when with Wordsworth in Holborn. Lamb was much
pleased with Wordsworth's attentions, saying, " He gave me
more than half the time he was in London, when he is
supposed to be with the Lowthers "; and after supper spoke
with great feeling of Coleridge, and with a grateful sense of
what he had been to him, adding after a recapitulation of
the friends he admired or loved, " But Coleridge is a glorious
person," and, with a smile of that peculiar sweetness so
entirely his own, " He teaches what is best."

" Miss Lamb, in her very pleasant manner, said, ' Charles,
who is Mr. Pitman ? '

" ' Why, he is a clerk in our office.'

" ' But why do you not ask Mr. White and Mr. Field ? I do not like to give up old friends for new ones.'

" ' Pitman has been very civil to me, always asking me to go and see him; and when the smoking club at Don Saltero's[1] was broken up, he offered me all the ornaments and apparatus, which I declined, and therefore I asked him here this night. I could never bear to give pain; have I not been called th'—th'—th'— the gentle-hearted Charles when I was young, and shall I now derogate ? ' "

ANECDOTES BY PATMORE

1826

[*P. G. Patmore*, My Friends and Acquaintance, 1854.]

July 13th. Spent the evening at Leigh Hunt's, with the Lambs, Atherstone, Mrs. Shelley, and the Gliddons. Lamb talked admirably about Dryden and some of the older poets, in particular of Davenant's Gondibert. Of this Hunt wanted to show that it consisted almost entirely of monosyllables, which give a most heavy and monotonous effect to the versification; and he read some passages to that effect. Lamb would not admit this, and he read an admirable passage in reply, about a Museum of Natural Curiosities in which Man, the pretended Lord of all the other creatures, hung by the wall, dry, like all the rest, and even Woman, the Lord of Man, hung there too—" and she dried by him." The effect of the passage was prodigious. . . .

He (Lamb) spoke of Dryden as a prodigious person, so far as his wonderful power of versification went, but not a first-rate poet, or even capable of appreciating such—giving instances from his prefaces in proof of this. He spoke of Dryden's prefaces as the finest pieces of criticism, nevertheless, that had ever been written, and the better for being contradictory to each other, because not founded on any pretended rules.

[1] " A Chelsea coffee-house and museum opened in 1695 by Salter, a barber " (Cunningham's *London);* the relics there were sold in 1799. But perhaps Lamb meant a subsequent collection.—*B.*

Hunt was asking how it was necessary to manage in order
to get Coleridge to come and dine. Lamb replied that he
believed he (Coleridge) was under a kind of watch and
ward—alluding to the watchful care taken of him by the
Gilmans, with whom he was then residing. " Ah," said
H., " vain is the watch (Mrs. G.), and bootless is the ward "
(Mr. G.), who always wore shoes.

Lamb repeated one of his own enormous puns. He had
met Procter, and speaking of his little girl (then an infant),
Procter said they had called her Adelaide. " Ah," said
Lamb, " a very good name for her—Addlehead."[1]

December 5th. Spent the evening at Lamb's. When I went
in, they (Charles and his sister) were alone, playing at cards
together.

I took up a book on the table—" Almack's "—and Lamb
said—" Ay; that must be all max to the lovers of scandal."

We spoke of L. E. L., and Lamb said—" If she belonged
to me, I would lock her up and feed her on bread and water
till she left off writing poetry. A female poet, or female
author of any kind, ranks below an actress, I think."

—— was mentioned, and Lamb said he seemed to him to
be a sort of L. E. L. in pantaloons.

Bernard Barton was mentioned, and Lamb said that he
did not write nonsense, at any rate—which all the rest of
them did (meaning the Magazine poets of the day). He was
dull enough; but not nonsensical. " He writes English,
too," said Lamb, " which they do not."

H. C. R. came in about half-past eight, and put a stop to
all further conversation—keeping all the talk to himself.

Speaking of some German story, in which a man is made
to meet himself—he himself having changed forms with
someone else—the talk turned on what we should think of
ourselves, if we could see ourselves without knowing that it
was ourselves. R. said that he had all his life felt a sort of
horror come over him every time he caught a sight of his
own face in the glass; and that he was almost afraid to
shave himself for the same reason. He said that he often
wondered how anybody could sustain an intimacy with,
much less feel a friendship for, a man with such a face.

[1] In spite of this the infant became the formerly famous poetess of " Legends
and Lyrics."—*B.*

Lamb said—" I hope you have mercy on the barbers, and
always shave yourself."

Speaking of names, Lamb said " John of Gaunt, time-
honoured Lancaster," was the grandest name in the world.

AN AMERICAN VISITOR'S NOTES
c. 1826

[*Mary Balmanno*, Pen and Pencil, 1858.]

The late Charles Lamb was in private life one of the most
amiable of men. Full of attaching qualities, he lived in the
core of the hearts of his friends; even those who knew him
but as a casual acquaintance, never failed to retain a life-
long remembrance of his rare and most unique genius and
simplicity. Bound in the closest ties of friendship with
" The Hoods," with who we also were in the habit of
continually associating, we had the pleasure of meeting him
at their house one evening, together with his sister and
several other friends, amongst whom was Miss Kelly, that
most natural and unrivalled of English comic actresses.

In outward appearance Hood conveyed the idea of a
clergyman. His figure slight, and invariably dressed in
black; his face pallid; the complexion delicate, and
features regular; his countenance bespeaking sympathy by
its sweet expression of melancholy and suffering.

Lamb was altogether of a different mould and aspect.
Of middle height, with brown, and rather ruddy complexion,
grey eyes expressive of sense and shrewdness, but neither
large nor brilliant; his head and features well shaped, and
the general expression of his countenance quiet, kind, and
observant, undergoing rapid changes in conversation, as did
his manner, variable as an April-day, particularly to his
sister, whose saint-like good-humour and patience were as
remarkable as his strange and whimsical modes of trying
them. But the brother and sister perfectly understood each
other, and " Charles," as she always called him, would not
have been the " Charles " of her loving heart without the
pranks and oddities which he was continually playing off
upon her—and which were only outnumbered by the

instances of affection, and evidences of ever watchful solicitude with which he surrounded her. Miss Lamb, although many years older than her brother, by no means looked so, but presented the pleasant appearance of a mild, rather stout, and comely maiden lady of middle age.

Dressed with Quaker-like simplicity in dove-coloured silk, with a transparent kerchief of snow-white muslin folded across her bosom, she at once prepossessed the beholder in her favour, by an aspect of serenity and peace. Her manners were very quiet and gentle, and her voice low. She smiled frequently, but seldom laughed, partaking of the courtesies and hospitalities of her merry host and hostess with all the cheerfulness and grace of a most mild and kindly nature.

Her behaviour to her brother was like that of an admiring disciple, her eyes seldom absent from his face. Even when apparently engrossed in conversation with others, she would, by supplying some word for which he was at a loss, even when talking in a part of the room, show how closely her mind waited upon his. Mr. Lamb was in high spirits, sauntering about the room, with his hands crossed behind his back, conversing by fits and starts with those most familiarly known to him, but evidently mentally acknowledging Miss Kelly to be the *rara avis* of his thoughts, by the great attention he paid to every word she uttered. Truly pleasant it must have been to her, even though accustomed to see people listen breathless with admiration while she spoke to find her words have so much charm for such a man as Charles Lamb.

He appeared to enjoy himself greatly, much to the gratification of Mrs. Hood, who often interchanged happy glances with Miss Lamb, who nodded approvingly. He spoke much—with emphasis and hurry of words, sorely impeded by the stammering utterance which in him was not unattractive. Miss Kelly (charming, natural Miss Kelly, who has drawn from her audiences more heartfelt tears and smiles than perhaps any other English actress), with quiet good-humour listened and laughed at the witty sallies of her host and his gifted friend, seeming as little an actress as it is possible to conceive. Once however, when some allusion was made to a comic scene in a new play then just brought

out, wherein she had performed to the life the character of a low-bred lady's maid passing herself off as her mistress, Miss Kelly arose, and with a kind of resistless ardour repeated a few sentences so inimitably, that everybody laughed as much as if the real lady's maid, and not the actress, had been before them, while she who had so well personated the part, quietly resumed her seat without the least sign of merriment, as grave as possible.

Most striking had been the transition from the calm lady-like person, to the gay, loquacious soubrette; and not less so, the sudden extinction of vivacity, and resumption of well-bred decorum. This little scene for a few moments charmed everybody out of themselves, and gave a new impetus to conversation. Mrs. Hood's eyes sparkled with joy, as she saw the effect it had produced upon her husband, whose pale face like an illuminated comic mask, shone with fun and humour. Never was happier couple than " The Hoods "; " mutual reliance and fond faith " seemed to be their motto. Mrs. Hood was a most amiable woman—of excellent manners, and full of sincerity and goodness. She perfectly adored her husband, tending him like a child, whilst he with unbounded affection seemed to delight to yield up himself to her guidance. Nevertheless, true to his humorous nature, he loved to tease her with jokes and whimsical accusations and assertions, which were only responded to by " Hood, Hood, how can you run on so ? " " Perhaps you don't know," said he, " that Jane's besetting weakness is a desire to appear in print, and be thought a Blue." Mrs. Hood coloured, and gave her usual reply; then observed laughingly, " Hood does not know one kind of material from another—he thinks this dress is a blue print." On looking at it I saw it was a very pretty blue silk. The evening was concluded by a supper, one of those elegant little social repasts which Flemish artists delight to paint ; so fresh the fruit, so tempting the viands, and all so exquisitely arranged by the very hand of taste. Mrs. Hood has frequently smiled when I have complimented her on setting out " picture suppers "—this was truly one.

Mr. Lamb oddly walked all round the table, looking closely at any dish that struck his fancy before he would decide where to sit, telling Mrs. Hood that he should by that means

know how to select some dish that was difficult to carve, and
take the trouble off her hands; accordingly having jested in
this manner, he placed himself with great deliberation before
a lobster-salad, observing that was the thing. On her asking
him to take some roast fowl, he assented. "What part shall
I help you to, Mr. Lamb?" "Back," said he quickly;
"I always prefer back." My husband laid down his knife
and fork, and looking upwards exclaimed: "By heavens! I
could not have believed it, if anybody else had sworn it."
"Believed what?" said kind Mrs. Hood, anxiously, colour-
ing to the temples, and fancying there was something amiss
in the piece he had been helped to. "Believed what? why,
madam, that Charles Lamb was a back-biter!" Hood gave
one of his short quick laughs, gone almost ere it had come,
whilst Lamb went off into a loud fit of mirth, exclaiming:
"Now that's devilish good! I'll sup with you to-morrow
night." This eccentric flight made everybody very merry,
and amidst a most amusing mixture of wit and humour,
sense and nonsense, we feasted merrily, amidst jocose health-
drinking, sentiments, speeches and songs.

Mr. Hood, with inexpressible gravity in the upper part of
his face, and his mouth twitching with smiles, sang his own
comic song of "If you go to France be sure you learn the
lingo"; his pensive manner and feeble voice making it
doubly ludicrous.

Mr. Lamb, on being pressed to sing, excused himself in
his own peculiar manner, but offered to pronounce a Latin
eulogium instead. This was accepted, and he accordingly
stammered forth a long string of Latin words; among
which, as the name of Mrs. Hood frequently occurred, we
ladies thought it was in praise of her. The delivery of this
speech occupied about five minutes. On enquiring of a
gentleman who sat next to me whether Mr. Lamb was
praising Mrs. Hood, he informed me that was by no means
the case, the eulogium being on the lobster-salad! Thus, in
the gayest of moods progressed and concluded a truly merry
little social supper, worthy in all respects of the author of
Whims and Oddities.

On the following night, according to his promise, Mr.
Lamb honoured us with a visit, accompanied by his sister,
Mr. and Mrs. Hood, and a few others hastily gathered

together for the occasion. On entering the room, Mr. Lamb seemed to have forgotten that any previous introduction had taken place. " Allow me, madam," said he, " to introduce to you my sister Mary; she's a very good woman, but she drinks! " " Charles, Charles," said Miss Lamb, imploringly (her face at the same time covered with blushes), " how can you say such a thing ? " " Why," rejoined he, " you know it's a fact; look at the redness of your face. Did I not see you in your cups at nine o'clock this morning ? " " For shame, Charles," returned his sister; " what will our friends think ? " " Don't mind him, my dear Miss Lamb," said Mrs. Hood, soothingly, " I will answer that the cups were only breakfast-cups full of coffee."

Seeming much delighted with the mischief he had made, he turned away, and began talking quite comfortably on indifferent topics to some one else. For my own part I could not help telling Mrs. Hood I longed to shake " Charles." " Oh," replied she smiling, " Miss Lamb is so used to his unaccountable ways that she would be miserable without them." Once, indeed, as Mr. Lamb told Hood, " having really gone a little too far," and seeing her, as he thought, quite hurt and offended, he determined to amend his manners, " behave politely, and leave off joking altogether." For a few days he acted up to this resolution, behaving, as he assured Hood, " admirably, and what do you think I got for my pains ? " " I have no doubt," said Hood, " you got sincere thanks." " Bless you, no! " rejoined Lamb, " why, Mary did nothing but keep bursting into tears every time she looked at me, and when I asked her what she was crying for, when I was doing all I could to please her, she blubbered out: ' You're changed, Charles, you're changed; what have I done, that you should treat me in this cruel manner ? ' ' Treat you! I thought you did not like my jokes, and therefore tried to please you by strangling them down.' ' Oh, oh,' cried she, sobbing as if her heart would break; ' joke again, Charles—I don't know you in this manner. I am sure I should die, if you behaved as you have done for the last few days.' So you see I joke for her good "; adding, with a most elfish expression, " it saved her life then, anyhow."

This little explanation was happily illustrated the next moment, when Miss Lamb, still in an extreme trepidation,

and the blush yet lingering on her cheeks, happened to drop
her handkerchief. She did not observe it, but her brother,
although volubly describing some pranks of his boyhood to
a little knot of listeners, stepped aside and handed it to her,
with a look that said as plainly as words could say " Forgive
me, I love you well." That she so interpreted it, her pleased
and happy look at once declared, as with glistening eyes she
sat eagerly listening to the tale he was then telling; a tale
which doubtless she had heard before, ninety and nine times
at least.

Charles Lamb seemed a man who, for every minute, had
some new idea: bright and broken in conversation—fitful
and rambling—but which, in the silence of his study,
settling down in beauty and harmony, made him one of the
most charming of writers. When to this was added the
recollection of the sterling good qualities and noble points of
character which distinguished him from common men, he
formed a rare object to admire and study—none more
original.

The evening he spent with us was but a counterpart of the
one we had passed at Mr. Hood's—gaiety and wit being its
chief attractions. But who can hope to catch more than the
faintest idea of things so fleeting?—not more so " the dew
on the fountain, the foam on the river "; or, as Lamb might
say, the foam on the champagne—the drop of the mountain
dew.

BECKEY

1826

[*P. G. Patmore*, My Friends and Acquaintance, 1854.]

Another characteristic instance of Lamb's sacrifice of his
own most cherished habits and feelings to those of other
people was in the case of a favourite servant, " Beckey,"
to whose will and pleasure both Charles Lamb and his sister
were as much at the mercy as they were to those of Dash.

This Beckey was an excellent person in her way, and not
the worse that she had not the happiness of comprehending
the difference between genius and common sense—between
" an author " and an ordinary man. Accordingly, having a
real regard for her master and mistress, and a strong impres-

sion of what was or was not " good for them," she used not seldom to take the liberty of telling them " a bit of her mind," and when they did anything that she considered to be " odd " or out of the way. And as (to do them justice) their whole life and behaviour were as little directed by the rules of common-place as could well be, Beckey had plenty of occasions for the exercise of her self imposed task, of instructing her master and mistress in the ways of the world. Beckey, too, piqued herself on her previous experience in observing and treating the vagaries of extraordinary people; for she had lived some years with Hazlitt before she went to the Lambs.

In performing the duties of housekeeping the Lambs were something like an excellent friend of mine, who, when a tradesman brings him home a pair of particularly easy boots, or any other object perfectionated in a way that peculiarly takes his fancy, inquires the price, and if it happens to be at all within decent tradesmanlike limits, says—" No—I cannot give you that price—it is too little— you cannot afford it, I'm sure—I shall give you so and so " —naming a third or fourth more than the price demanded. If the Lambs' baker, for example, had charged them (as it is said bakers have been known to do) a dozen loaves in their weekly bill, when they must have known that they had not eaten two-thirds of that number, the last thing they would have thought of was complaining of the overcharge. If they had not consumed the proper quantity to remunerate him for the trouble of serving them, it was not the baker's fault, and the least they could do was to pay for it!

Now this kind of logic was utterly lost upon Beckey, and she would not hear of it. Her master and mistress, she fully admitted, had a right to be as extravagant as they pleased; but they had no right to confound the distinctions between honesty and roguery, and it was what she would not permit.

There are few of us who would not duly prize a domestic who had honesty and wit enough to protect us from the consequences of our own carelessness or indifference; but where is the one who, like Lamb, without caring one farthing for the advantages he might derive from Beckey's unimpeachable honesty, and her genius for going the best way to market, could not merely overlook, but be highly

L

gratified and amused by, the ineffable airs of superiority, amounting to nothing less than a sort of personal patronage, which she assumed on the strength of these ? The truth is, that Beckey used to take unwarrantable liberties with her quasi-master and mistress—liberties that amounted to what are usually deemed, in such cases, gross and unpardonable impertinences. Yet I do not believe any of their friends ever heard a complaint or a harsh word uttered of her, much less to her; and I believe there was no inconvenience or privation they would not have submitted to, rather than exchange her blunt honesty for the servile civility, whether accompanied by honesty or not, of anybody else. And I believe, when Beckey at last left them, to be married, it was this circumstance, much more than anything else, which caused them to give up housekeeping, never afterwards to resume it.

DASH
1826
[*P. G. Patmore*, My Friends and Acquaintance, 1854.]

Just before the Lambs quitted the metropolis for the voluntary banishment of Enfield Chace, they came to spend a day with me at Fulham, and brought with them a companion, who, " dumb animal " though it was, had for some time past been in the habit of giving play to one of Charles Lamb's most amiable characteristics—that of sacrificing his own feelings and inclinations to those of others. This was a large and very handsome dog, of a rather curious and singularly sagacious breed, which had belonged to Thomas Hood, and at the time I speak of, and to oblige both dog and master, had been transferred to the Lambs,—who made a great pet of him, to the entire disturbance and discomfiture, as it appeared, of all Lamb's habits of life, but especially of that most favourite and salutary of all, his long and heretofore solitary suburban walks: for Dash (that was the dog's name) would never allow Lamb to quit the house without him, and, when out, would never go anywhere but precisely where it pleased himself. The consequence was, that Lamb made himself a perfect slave to this dog,—who was always half-a-mile off from his companion, either before

or behind, scouring the fields or roads in all directions, up and down "all manner of streets," and keeping his attendant in a perfect fever of anxiety and irritation, from his fear of losing him on the one hand, and his reluctance to put the needful restraint upon him on the other. Dash perfectly well knew his host's amiable weakness in this respect, and took a due dog-like advantage of it. In the Regent's Park in particular Dash had his quasi-master completely at his mercy; for the moment they got within the ring, he used to squeeze himself through the railing, and disappear for half-an-hour together in the then enclosed and thickly planted greensward, knowing perfectly well that Lamb did not dare to move from the spot where he (Dash) had disappeared till he thought proper to show himself again. And they used to take this walk oftener than any other, precisely because Dash liked it, and Lamb did not.

The performance of the Pig-driver that Leigh Hunt describes so capitally in the *Companion* must have been an easy and straightforward thing compared with this enterprise of the dear couple in conducting Dash from Islington to Fulham. It appeared, however, that they had not undertaken it this time purely for Dash's gratification; but (as I had often admired the dog) to ask me if I would accept,— " if only out of charity," said Miss Lamb, " for if we keep him much longer, he'll be the death of Charles."

I readily took charge of the unruly favourite, and soon found, as I suspected, that his wild and wilful ways were a pure imposition upon the easy temper of Lamb; for as soon as he found himself in the keeping of one who knew what dog-decorum was, he subsided into the best bred and best behaved of his species.

A DEDICATION
1827
[*Thomas Hood*, " Plea of the Midsummer Fairies."]

To Charles Lamb.

My dear Friend,

I thank my literary fortune that I am not reduced, like many better wits, to barter dedications, for the hope or

promise of patronage, with some nominally great man; but
that where true affection points, and honest respect, I am
free to gratify my head and heart by a sincere inscription.
An intimacy and dearness, worthy of a much earlier date
than our acquaintance can refer to, direct me at once to
your name: and with this acknowledgment of your ever kind
feeling towards me, I desire to record a respect and admira-
tion for you as a writer, which no one acquainted with our
literature, save Elia himself, will think disproportionate or
misplaced. If I had not these better reasons to govern me,
I should be guided to the same selection by your intense yet
critical relish for the works of our great Dramatist, and for
that favourite play in particular which has furnished the
subject of my verses. . . .

LAMB AT ENFIELD

1827

[Thomas Hood, in Hood's Own.]

From Colebrooke, Lamb removed to Enfield Chase—a
painful operation at all times, for as he feelingly misapplied
Wordsworth, " the moving accident was not his trade." As
soon as he was settled, I called upon him, and found him in
a bald-looking yellowish house, with a bit of a garden, and a
wasp's nest convanient, as the Irish say, for one stung my
pony [as] he stood at the door. Lamb laughed at the fun;
but, as the clown says, the whirligig of time brought round
its revenges. He was one day bantering my wife on her
dread of wasps, when all at once he uttered a horrible
shout,—a wounded specimen of the species had slily crawled
up the leg of the table, and stung him in the thumb. I told
him it was a refutation well put in, like Smollett's timely
snowball. " Yes," said he, " and a stinging commentary on
Macbeth—

" By the pricking of my thumbs,
 Something wicked this way comes."

There were no pastoral yearnings concerned in this Enfield
removal. There is no doubt which of Captain Morris's

" Town and Country Songs " would have been most to
Lamb's taste. " The sweet shady side of Pall Mall," would
have carried it hollow. In courtesy to a friend, he would
select a green lane for a ramble, but left to himself, he took
the turnpike road as often as otherwise. " Scott," says
Cunningham, " was a stout walker." Lamb was a porter
one. He calculated distances, not by long measure, but by
ale and beer measure. " Now I have walked a pint." Many
a time I have accompanied him in these matches against
Meux, not without sharing in the stake, and then, what
cheerful and profitable talk! For instance, he once delivered
to me orally the substance of the " Essay on the Defect of
Imagination in Modern Artists," subsequently printed in the
Athenæum. But besides the criticism, there were snatches of
old poems, golden lines and sentences culled from rare
books, and anecdotes of men of note. Marry, it was like going
a ramble with gentle Izaak Walton, minus the fishing.

To make these excursions more delightful to one of my
temperament, Lamb never affected any spurious gravity.
Neither did he ever act the Grand Senior. He did not exact
that common copy-book respect, which some asinine persons
would fain command on account of the mere length of their
years. As if, forsooth, what is bad in itself, could be the
better for keeping; as if intellects already mothery, got
anything but grandmothery by lapse of time! In this par-
ticular, he was opposed to Southey, or rather (for Southey
has been opposed to himself) to his " Poem on the Holly
Tree."

> So serious should my youth appear among
> The thoughtless throng,
> So would I seem among the young and gay
> More grave than they.

There was nothing of Sir Oracle about Lamb. On the
contrary, at sight of a solemn visage that " creamed and
mantled like the standing pool," he was the first to pitch a
mischievous stone to disturb the duck-weed. " He was a
boy-man," as he truly said of Elia; " and his manners
lagged behind his years." He liked to herd with people
younger than himself. Perhaps, in his fine generalising way,
he thought that, in relation to Eternity, we are all contem-

poraries. However, without reckoning birthdays, it was always " Hail fellow, well met," and although he was my elder by a quarter of a century, he never made me feel, in our excursions, that I was " taking a walk with the school-master." I remember, in one of our strolls, being called to account, very pompously, by the proprietor of an Enfield Villa, who asserted that my dog Dash, who never hunted anything in his dog-days, had chased the sheep; whereupon, Elia taking the dog's part, said very emphatically, " Hunt Lambs, sir ? Why he has never hunted me! " But he was always ready for fun, intellectual or practical—now helping to pelt D¹——, a modern Dennis, with puns; and then to persuade his sister, God bless her! by a vox et preterea nihil, that she was as deaf as an adder. In the same spirit, being requested by a young Schoolmaster to take charge of his flock for a day, " during the unavoidable absence of the Principal," he willingly undertook the charge, but made no other use of his " brief authority " than to give the boys a whole holiday.

LAMB IN HIS HUMOUR

[*Thomas Hood*, Comic Annual *for* 1834; *he works up an article from this recollection of Lamb's talk.*]

" A Fancy Fair," said my friend L., in his usual quaint style, " is a fair subject for fancy; take up your pen and try. For instance, there was one held at the Mansion House. Conceive a shambling shock-headed clodpole, familiar with the wakes of Bow, Barnet, and Bartlemy, elbowing his awkward way into the Egyptian Hall, his round eyes and mouth all agape in the ludicrous expectation of seeing the Lord Mayor standing on his very worshipful head, the Lady Mayoress lifting a hundred weight by her Right Honourable Hair, the Sword-Bearer swallowing his blade of state, the Recorder conjuring ribands from his learned and eloquent mouth, and the Senior Alderman with a painted York-and-Lancaster face, dancing a *saraband* à la Pierrot! Or fancy Jolterhead at the fair of the Surrey Zoological, forcing his

¹ Presumably George Daniel, whose Recollections of Lamb are extensive but thin.—*B.*

clumsy destructive course through groups of female fashionables, like a hog in a tulip bed, with the equally laughable intention of inspecting long horns and short horns, prime beasts and lean stock; of handling the porkers and coughing the colts. Nay, imagine our bumpkin at the great Fancy Fair of all, blundering up to a stall kept by a Royal Duchess, and inquiring perseveringly for a gilt gingerbread King and Queen—a long promised fairing to brother Bill at Leighton Buzzard!"

Little did L. dream during this flourish of fancy, that his whimsical fiction had been forestalled by fact. . . .

EMBARRASSING CANDIDATE

? 1827

[*P. G. Patmore*, My Friends and Acquaintance, 1854.]

A young gentleman in the country, of a " literary turn,"

" A clerk foredoomed his father's soul to cross,
 Who penned a stanza when he should engross,"

solicited the favour of Lamb's correspondence and friendship; and as an unequivocal testimonial of his claims to these, he forwarded to the object of his admiration his miniature portrait; the said effigy setting forth a form and feature such as " youthful maidens fancy when they love."

It was excessively amusing to hear Lamb describe his droll embarrassment, on the reception of this naive and original mode of paying court to a man who almost piqued himself on having no eye or taste for personal comeliness, even in women, while anything like coxcombry in a man made him sick; and who yet had so exquisite a sense of what was due to the feelings of others, that when a young lady who was staying at his house, had been making some clothes for the child of a poor gipsy woman in the neighbourhood, whose husband was afterwards convicted of sheep-stealing, he would not allow her (the young lady) to quit the village without going to see and take leave of her unhappy protegée,—on the express plea that otherwise the felon's wife might imagine that she had heard of her husband's misfortune, and was

ashamed to go near her. " I have a delicacy for a sheep-stealer," said he.[1]

There are many who duly appreciate, and are ready enough to extol, the beauty and the merits of this delicacy to the personal feelings of others, and a few who can sympathize with it even in extreme cases like the one just cited; but I never knew any one who was capable of uniformly, and at all costs, practising it, except Charles Lamb and William Hazlitt,—both of whom extended it to the lowest and vilest of man and woman kind; would give the wall to a beggar if it became a question which of the two should cede it, and if they had visited a convicted felon in his cell, would have been on tenter-hooks all the time, lest anything might drop from them to indicate that they had less consideration for the object of their visit than if he had been the most " respectable " of men.

ANNUAL EXHIBITION OF THE SOCIETY OF BRITISH ARTISTS

1827

[New Monthly Magazine,[2] *May 1st*, 1827.]

211. "*Portrait of Charles Lamb, Esq.*" H. Meyer[3]—This has the great and rare comparative merit of being the only tolerable portrait that the present public have ever had an opportunity of seeing, of a person who has so much delighted and instructed them; but we must add, that it is a tolerable portrait merely. About the upper part of the face there is something of the bland gravity and deep-seated spirit of thought that cannot be overlooked in the face any more than

[1] *See* a letter to Mr. Procter, printed in the *Athenæum* immediately after his death, in which Lamb himself gives an account of this incident; also an exquisite sonnet, embodying the woman's supposed feelings towards her child on the occasion of its father's conviction.—*P.*

[2] Crabb Robinson's opinion of the Meyer portrait may be added:

May 26th, 1826. Called on Meyer of Red Lion Square, where Lamb was sitting for his portrait. A strong likeness; but it gives him the air of a thinking man, and is more like the framer of a system of philosophy than the genial and gay author of the *Essays of Elia.*—*B.*

[3] This portrait is now at the India Office: a reproduction is given as frontispiece to Lamb's *Works*, ed. E. V. Lucas, 1905, vol. vi. In vol. vii, opposite p. 728, is a reproduction of Meyer's other picture mentioned above.—*B.*

in the writings of the original. But the lower part is a failure. There is not only none of the humanity that has settled itself (as if for ever) about the mouth, but in its place there is a look of moroseness that has not only " no business there," but never was there for a single instant. Let it not be supposed, however, that we say this to detract from the merits of the artist; our wonder is, not that he has painted no better a likeness of Mr. Lamb, but that he has obliged us with one so good. We know not whether this is a furtive likeness or not, but suppose it must be. For our own parts, had we been given to portrait-painting, we should as soon have thought of asking a cloud to sit for its likeness, as the ever shifting yet never changing spirit, a portion of which is here fixed on canvass.

289. *The young Catechist. Meyer.*—This is a picture pleasingly imagined and not ill executed, of a little child teaching a black man to say the Christian's prayer. Our motive for pointing it out is, that it affords us an opportunity, not to be resisted, of brightening and beautifying our poor dry page with a copy of verses which have been appended to this picture by the poet whose portrait we noticed above. To our thinking, there are few things more touching, sweet, and simple than this in poetry:—

" Q. While this tawny Ethiop prayeth,
Painter, who is she that stayeth
By, with skin of whitest lustre,
Sunny locks, a shining cluster,
Saint-like, seeming to direct him ?
Is she of the Heaven-born three—
Meek Hope, strong Faith, sweet Charity ?—
Or some Cherub ?

" A. They you mention
Far transcend my weak invention.
'Tis a simple Christian child,
Missionary young and mild,
From her stock of Scriptural knowledge,
Bible-taught, without a college,
Which by reading she could gather,
Teaches him to say, ' Our Father,'

To the common Parent who
Colour not respects, nor hue:
White and black in him have part,
Who looks not to the skin but heart."

<div align="right">C. LAMB.</div>

BOXING DAY
1827

[Crabb Robinson.]

December 26th. Having heard from Charles Lamb that his sister was again well, I lost no time in going to see them. And accordingly, as soon as breakfast was over, I walked into the City, took the stage to Edmonton, and walked thence to Enfield. I found them in their new house—a small but comfortable place, and Charles Lamb quite delighted with his retirement. He fears not the solitude of the situation, though he seems to be almost without an acquaintance, and dreads rather than seeks visitors. We called on Mrs. Robinson, who lives opposite; she was not at home, but came over in the evening, and made a fourth in a rubber of whist. I took a bed at the near public-house.

MR. CHARLES LAMB
1828

[Leigh Hunt, in Lord Byron and Some of his Contemporaries, *1828.]*

Charles Lamb has a head worthy of Aristotle, with as fine a heart as ever beat in human bosom, and limbs very fragile to sustain it. There is a caricature of him sold in the shops, which pretends to be a likeness. P[rocte]r went into the shop in a passion, and asked the man what he meant by putting forth such a libel. The man apologized, and said that the artist meant no offence. The face is a gross misrepresentation. Mr. Lamb's features are strongly yet delicately cut: he has a fine eye as well as forehead; and no face carries in greater marks of thought and feeling. It resembles

that of Bacon, with less worldly vigour, and more sensibility.

As his frame, so is his genius. It is as fit for thought as can be, and equally as unfit for action; and this renders him melancholy, apprehensive, humorous, and willing to make the best of everything as it is, both from tenderness of heart and abhorrence of alteration. His understanding is too great to admit an absurdity; his frame is not strong enough to deliver it from a fear. His sensibility to strong contrasts is the foundation of his humour, which is that of a wit at once melancholy and willing to be pleased. He will beard a superstition, and shudder at the old phantasm while he does it. One could imagine him cracking a jest in the teeth of a ghost, and melting into thin air himself, out of a sympathy with the awful. His humour and his knowledge both, are those of Hamlet, of Molière, of Carlin, who shook a city with laughter, and, in order to divert his melancholy, was recommended to go and hear himself. Yet he extracts a real pleasure out of his jokes, because good-heartedness retains that privilege, when it fails in everything else. I should say he condescended to be a punster, if condescension were a word befitting wisdom like his. Being told that somebody had lampooned him, he said, " Very well; I'll Lamb-pun him." His puns are admirable, and often contain as deep things as the wisdom of some who have greater names. Such a man, for instance, as Nicole the Frenchman, was a baby to him. He would have cracked a score of jokes at him, worth his whole book of sentences; pelted his head with pearls. Nicole would not have understood him, but Rochefoucault would, and Pascal too; and some of our old Englishmen would have understood him still better. He would have been worthy of hearing Shakspeare read one of his scenes to him, hot from the brain. Commonplace finds a great comforter in him, as long as it is good-natured; it is to the ill-natured or the dictatorial only that he is startling. Willing to see society go on as it does, because he despairs of seeing it otherwise, but not at all agreeing in his interior with the common notions of crime and punishment, he " dumb-founded " a long tirade one evening, by taking the pipe out of his mouth, and asking the speaker, " Whether he meant to say that a thief was not a good man ? " To a person abusing Voltaire, and indiscreetly opposing his character to that of

Jesus Christ, he said admirably well, (though he by no means overrates Voltaire, nor wants reverence in the other quarter,) that " Voltaire was a very good Jesus Christ for the French." He likes to see the church-goers continue to go to church, and has written a tale in his sister's admirable little book (*Mrs. Leicester's School*) to encourage the rising generation to do so: but to a conscientious deist he has nothing to object; and if an atheist found every other door shut against him, he would assuredly not find his. I believe he would have the world remain precisely as it is, provided it innovated no farther; but this spirit in him is any thing but a worldly one, or for his own interest. He hardly contemplates with patience the fine new buildings in the Regent's Park; and, privately speaking, he has a grudge against official heaven-expounders, or clergymen. He would rather, however, be with a crowd that he dislikes, than feel himself alone. He said to me one day, with a face of solemnity, " What must have been that man's feelings who thought himself the first deist! " Finding no footing in certainty, he delights to confound the borders of theoretical truth and falsehood. He is fond of telling wild stories to children, engrafted on things about them; writes letters to people abroad, telling them that a friend of theirs has come out in genteel comedy; and persuaded G. D.[1] that Lord Castlereagh was the author of *Waverley*! The same excellent person, walking one evening out of his friend's house into the New River, Mr. Lamb (who was from home at the time) wrote a paper under his signature of Elia (now no longer anonymous), stating, that common friends would have stood dallying on the bank, have sent for neighbours, &c.; but that he, in his magnanimity, jumped in and rescued his friend after the old noble fashion. He wrote in the same magazine two Lives of Liston and Munden, which the public took for serious, and which exhibit an extraordinary jumble of imaginary facts and truth of bye-painting. Munden he makes born at " Stoke-Pogeis "; the very sound of which is like the actor speaking and digging his words. He knows how many false conclusions and pretensions are made by men who profess to be guided by facts only, as if facts could not be misconceived, or figments taken for them; and therefore

[1] " In the strictest confidence." *Talfourd*. But Dyer went off to impart the great fact to Leigh Hunt.

one day, when somebody was speaking of a person who valued himself on being a matter-of-fact man, " Now," says he, " I value myself on being a matter-of-lie man." This does not hinder his being a man of the greatest veracity, in the ordinary sense of the word; but " truth," he says, " is precious, and ought not to be wasted on every body." Those who wish to have a genuine taste of him, and an insight into his modes of life, should read his essays on " Hogarth " and " *King Lear*," his article on the " London Streets," on " Whist-Playing," which he loves, and on " Saying Grace Before Meat," which he thinks a strange moment to select for being grateful. He said once to a brother whist-player, who was a hand more clever than clean, and who had enough in him to afford the joke, " M., if dirt were trumps, what hands you would hold! "

This is an article very short of what I should wish to write on my friend's character; but perhaps I could not do it better. There is something in his modesty as well as wisdom, which hinders me from saying more. He has seen strange faces of calamity; but they have not made him love those of his fellow-creatures the less. The ingenious artist who has presented the public with his, will excuse one of his friends for thinking that he has done more justice to the moral than the intellectual character of it; which, in truth, it is very difficult to do, whether with pencil or with pen. A celebrated painter has said, that no one but Raphael could have done full justice to Raphael's face: which is a remark at once startling and consolatory to us inferior limners.

DUMMY WHIST

1828

[Crabb Robinson.]

I

April 4th. At Lamb's I found Moxon and Miss Kelly, who is an unaffected, sensible, clear-headed, warm-hearted woman. We talked about the French theatre, and dramatic matters in general. Mary Lamb and Charles were glad to have a dummy rubber, and also piquet with me.

II

December 13*th*. Walked to Enfield from Mr. Relph's. I dined with Charles and Mary Lamb, and after dinner had a long spell at dummy whist with them. When they went to bed, I read a little drama by Lamb, *The Intruding Widow*, which appeared in *Blackwood's Magazine*. It is a piece of great feeling, but quite unsuitable for performance, there being no action whatever in it.

LIFE AT ENFIELD
c. 1828

[*Charles and Mary Cowden Clarke, in* Recollections of Writers, 1878.]

I

Dear Charles and Mary Lamb, who were then residing at Chase Side, Enfield, paid us the compliment of affecting to take it a little in dudgeon that we should not have let them know when we " lurked at the Greyhound " so near to them; but his own letter, written soon after that time, shows how playfully and how kindly he really took this " stealing a march before one's face." He made us promise to repair our transgression by coming to spend a week or ten days with him and his sister; and gladly did we avail ourselves of the offered pleasure under name of reparation.

During the forenoons and afternoons of this memorable visit we used to take the most enchanting walks in all directions of the lovely neighbourhood. Over by Winchmore Hill, through Southgate Wood to Southgate and back: on one occasion stopping at a village linendraper's shop that stood in the hamlet of Winchmore Hill, that Mary Lamb might make purchase of some little household requisite she needed; and Charles Lamb, hovering near with us, while his sister was being served by the mistress of the shop, addressed her, in a tone of mock sympathy, with the words, " I hear that trade's falling off, Mrs. Udall, how's this ? " The stout, good-natured matron only smiled, as accustomed to Lamb's whimsical way, for he was evidently familiarly known at the houses where his sister dealt. Another time a longer excursion was proposed, when Miss Lamb declined

accompanying us, but said she would meet us on our return, as the walk was farther than she thought she could manage. It was to Northaw; through charming lanes, and country by-roads, and we went hoping to see a famous old giant oak tree there. This we could not find; it had perhaps fallen, after centuries of sturdy growth, but our walk was delightful, Lamb being our conductor and confabulator. It was on this occasion that—sitting on a felled tree by the way-side under a hedge in deference to the temporary fatigue felt by the least capable walker of the three—he told us the story of the dog that he had tired out and got rid of by that means. The rising ground of the lane, the way-side seat, Charles Lamb's voice, our own responsive laughter—all seem present to us as we write. Mary Lamb was as good as her word—when was she otherwise ? and came to join us on our way back and be with us on our reaching home, there to make us comfortable in old-fashioned easy-chairs for " a good rest " before dinner. The evenings were spent in cosy talk; Lamb often taking his pipe, as he sat by the fire-side, and puffing quietly between the intervals of discussing some choice book, or telling some racy story, or uttering some fine, thoughtful remark. On the first evening of our visit he had asked us if we could play whist, as he liked a rubber; but on our con-fessing to very small skill at the game, he said, " Oh, then, you're right not to play; I hate playing with bad players." However, on one of the last nights of our stay he said, " Let's see what you're like, as whist-players "; and after a hand or two, finding us not to be so unproficient as he had been led to believe, said, " If I had only known you were as good as this, we would have had whist every evening."

His style of playful bluntness when speaking to his inti-mates was strangely pleasant—nay, welcome: it gave you the impression of his liking you well enough to be rough and unceremonious with you: it showed you that he felt at home with you. It accorded with what you knew to be at the root of an ironical assertion he made—that he always gave away gifts, parted with presents, and sold keepsakes. It underlay in sentiment the drollery and reversed truth of his saying to us, " I always call my sister Maria when we are alone to-gether, Mary when we are with our friends, and Moll before the servants."

He was at this time expecting a visit from the Hoods, and talked over with us the grand preparations he and his sister meant to make in the way of due entertainment: one of the dishes he proposed being no other than " bubble and squeak." He had a liking for queer, out-of-the-way names and odd, startling, quaint nomenclatures; bringing them in at unexpected moments, and dwelling upon them again and again when his interlocutors thought he had done with them. So on this occasion " bubble and squeak " made its perpetual reappearance at the most irrelevant points of the day's conversation and evening fireside talk, till its sheer repetition became a piece of humour in itself.

As so much has of late years been hinted and loosely spoken about Lamb's " habit of drinking " and of " taking more than was good for him," we avail ourselves of this opportunity to state emphatically—from our own personal knowledge—that Lamb, far from taking much, took very little, but had so weak a stomach that what would have been a mere nothing to an inveterate drinker, acted on him like potations " pottle deep." We have seen him make a single tumbler of moderately strong spirits-and-water last through a long evening of pipe-smoking and fireside talk; and we have also seen the strange suddenness with which but a glass or two of wine would cause him to speak with more than his usual stammer—nay, with a thickness of utterance and impeded articulation akin to Octavius Cæsar's when he says, " Mine own tongue splits what it speaks." As to Lamb's own confessions of intemperance, they are to be taken as all his personal pieces of writing—those about himself as well as about people he knew—ought to be, with more than a " grain of salt." His fine sense of the humorous, his bitter sense of human frailty amid his high sense of human excellence, his love of mystifying his readers even while most taking them into his confidence and admitting them to a glimpse of his inner self—combined to make his avowal of conscious defect a thing to be received with large allowance and lenientest construction. Charles Lamb had three striking personal peculiarities: his eyes were of different colours, one being greyish blue, the other brownish hazel; his hair was thick, retaining its abundance and its dark-brown hue with scarcely a single grey hair among it until

even the latest period of his life; and he had a smile of singular sweetness and beauty.

II

He was so proud of his pedestrian feats and indefatigability, that he once told the Cowden Clarkes a story of a dog possessed by a pertinacious determination to follow him day by day when he went forth to wander in the Enfield lanes and fields; until, unendurably teased by the pertinacity of this obtrusive animal, he determined to get rid of him by fairly tiring him out. So he took him a circuit of many miles, including several of the loveliest spots round Enfield, coming at last to a by-road with an interminable vista of up-hill distance, where the dog turned tail, gave the matter up, and laid down beneath a hedge, panting, exhausted, thoroughly worn out and dead beat; while his defeater walked freshly home, smiling and triumphant.

Knowing Lamb's fashion of twisting facts to his own humorous view of them, those who heard the story well understood that it might easily have been wryed to represent the narrator's real potency in walking, while serving to cover his equally real liking for animals under the semblance of vanquishing a dog in a contested footrace. Far more probable that he encouraged its volunteered companionship, amusing his imagination the while by picturing the wild impossibility of any human creature attempting to tire out a dog—of all animals! As an instance of Charles Lamb's sympathy with dumb beasts, his two friends here named once saw him get up from table, while they were dining with him and his sister at Enfield, open the street-door, and give admittance to a stray donkey into the front strip of garden, where there was a grass-plot, which he said seemed to possess more attraction for the creature than the short turf of the common on Chase-side, opposite to the house where the Lambs then dwelt. This mixture of the humorous in manner and the sympathetic in feeling always more or less tinged the sayings and the doings of beloved Charles Lamb; there was a constant blending of the overtly whimsical expression or act with betrayed inner kindliness and even pathos of sentiment. Beneath this sudden opening of his gate to a stray donkey that it might feast on his garden grass while he

M

himself ate his dinner, possibly lurked some stung sense of wanderers unable to get a meal they hungered for when others revelled in plenty,—a kind of pained fancy finding vent in playful deed or speech, that frequently might be traced by those who enjoyed his society.

He was fond of trying the dispositions of those with whom he associated by an odd speech such as this; and if they stood the test pleasantly, and took it in good part, he liked them the better ever after. One time that the Novellos and Cowden Clarkes went down to see the Lambs at Enfield, and he was standing by his bookshelves, talking with them in his usual delightful, cordial way, showing them some precious volume lately added to his store, a neighbour chancing to come in to remind Charles Lamb of an appointed ramble, he excused himself by saying, " You see I have some troublesome people just come down from town, and I must stay and entertain them; so we'll take our walk together to-morrow." Another time, when the Cowden Clarkes were staying a few days at Enfield with Charles Lamb and his sister, they, having accepted an invitation to spend the evening and have a game of whist at a lady-schoolmistress's house there, took their guests with them. Charles Lamb, giving his arm to " Victoria," left her husband to escort Mary Lamb, who walked rather more slowly than her brother. On arriving first at the house of the somewhat prim and formal hostess, Charles Lamb, bringing his young visitor into the room, introduced her by 'saying, " Mrs.——, I've brought you the wife of the man who mortally hates your husband "; and when the lady replied by a polite inquiry after " Miss Lamb," hoping she was quite well, Charles Lamb said, " She has a terrible fit o' toothache, and was obliged to stay at home this evening; so Mr. Cowden Clarke remained there to keep her company." Then, the lingerers entering, he went on to say, " Mrs. Cowden Clarke has been telling me, as we came along, that she hopes you have sprats for supper this evening." The bewildered glance of the lady of the house at Mary Lamb and her walking-companion, her politely stifled dismay at the mention of so vulgar a dish, contrasted with Victoria's smile of enjoyment at his whimsical words, were precisely the kind of things that Charles Lamb liked and chuckled over.

On another occasion he was charmed by the equanimity
and even gratification with which the same guests and Miss
Fanny Kelly (the skilled actress whose combined artistic
and feminine attractions inspired him with the beautiful
sonnet beginning—

You are not, Kelly, of the common strain

and whose performance of *The Blind Boy* caused him to
address her in that other sonnet beginning

Rare artist! who with half thy tools or none
Canst execute with ease thy curious art,
And press thy powerful'st meanings on the heart
Unaided by the eye, (expression's throne!)

found themselves one sunny day, after a long walk through
the green Enfield meadows, seated with Charles Lamb and
his sister on a rustic bench in the shade, outside a small
roadside inn, quaffing draughts of his favourite porter with
him from the unsophisticated pewter, supremely indifferent
to the strangeness of the situation; nay, heartily enjoying
it with him. The umbrageous elm, the water-trough, the
dip in the road where there was a ford and foot-bridge,
the rough wooden table at which the little party were seated,
the pleasant voices of Charles and Mary Lamb and Fanny
Kelly,—all are vividly present to the imagination of her who
now writes these few memorial lines, inadequately describing
the ineffaceable impression of that happy time, when Lamb
so cordially delighted in the responsive ease and enjoyment
of his surrounders.

ELECTIONEERING SONGS
1829
[*T. N. Talfourd.*]

He had now a neighbour in Mr. Serjeant Wilde, to whom
he was introduced by Mr. Burney, and whom he held in high
esteem, though Lamb cared nothing for forensic eloquence,
and thought very little of eloquence of any kind; which, it
must be confessed, when printed is the most rapid of all

reading. What political interest could not excite, personal regard produced in favour of his new friend; and Lamb supplied several versified squibs and snatches of electioneering songs to grace Wilde's contests at Newark.[1]

A VISIT IN 1829

[Crabb Robinson.]

May 8th. Went by the early coach to Enfield, being on the road from half-past eight till half-past ten o'clock. Lamb ·was from home a great part of the morning. I spent the whole of the day with him and his sister, without going out of the house, except for a mile before dinner with Miss Lamb. I had plenty of books to lounge over. I read Brougham's Introduction to *The Library of Useful Knowledge*, remarkable only as coming from the busiest man living, a lawyer in full practice, a partisan in Parliament, an Edinburgh Reviewer, and a participator in all public and party matters.

May 9th. Nearly the whole day within doors. I merely sunned myself at noon on the beautiful Enfield Green. When I was not with the Lambs, I employed myself in looking over Charles' books, of which no small number are curious. He throws away all modern books, but retains even the trash he liked when a boy. Looked over a *Life of Congreve*, one of Curll's infamous publications, containing nothing. Also the first edition of the *Rape of the Lock*, with the machinery.[2] It is curious to observe the improvements in the versification. Colley Cibber's pamphlets against Pope only flippant and disgusting—nothing worth notice. Read the beginnings of two wretched novels. Lamb and his sister were both in a fidget to-day about the departure of their old servant Becky, who had been with them many years, but, being ill-tempered, had been a plague and a tyrant to them. Yet Miss Lamb was frightened at the idea

[1] " In spite of such a powerful political ally the Serjeant was defeated."— E. V. Lucas.

[2] The poem was first published in two cantos; but the author, adopting the idea of enlivening it by the machinery of sylphs, gnomes, nymphs, and salamanders, then familiar topics, enlarged the two cantos to five.

of a new servant. However, their new maid, a cheerful,
healthy girl, gave them spirits, and all the next day Lamb
was rejoicing in the change. Moxon came very late.

May 10th. All the forenoon in the back room with the
Lambs, except that I went out to take a place in the evening
stage. About noon Talfourd came: he had walked. Moxon,
after a long walk, returned to dinner, and we had an
agreeable chat between dinner and tea.

GOETHE ON LAMB

1829

[*Crabb Robinson.*]

August. I read to him [Goethe] Coleridge's *Fire, Famine,
and Slaughter*; his praise was faint. I inquired whether he
knew the name of Lamb. " Oh, yes! Did he not write a
pretty sonnet on his own name ? " Charles Lamb, though
he always affected contempt for Goethe, yet was manifestly
pleased that his name was known to him.

ALBUM VERSES, WITH A FEW OTHERS

By CHARLES LAMB, London, 1830, Moxon

I

[*William Jerdan, in the* Literary Gazette, *July* 10th, 1830.]

If anything could prevent our laughing at the present
collection of absurdities, it would be a lamentable conviction
of the blinding and engrossing nature of vanity. We could
forgive the folly of the original composition, but cannot but
marvel at the egotism which has preserved, and the conceit
which has published. What exaggerated notion must that
man entertain of his talents, who believes their slightest
efforts worthy of remembrance; one who keeps a copy of
the verses he writes in young ladies' albums, the proverbial
receptacles for trash! Here and there a sweet and natural
thought intervenes; but the chief part is best characterised

by that expressive though ungracious word "rubbish."
And what could induce our author to trench on the mascu-
line and vigorous Crabbe ? did he think his powerful and
dark outlines might with advantage be turned to " pretti-
ness and favour ? " But let our readers judge from the
following specimens. . . .

Mr. Lamb, in his dedication, says his motive for publishing
is to benefit his publisher, by affording him an opportunity
of shewing how he means to bring out works. We could have
dispensed with the specimen; though it is but justice to
remark on the neat manner in which the work is produced:
the title-page is especially pretty.

II

[Spectator, 1830.]

It is impossible to envy the disposition of the critic who
would suffer his gall to curdle that milk of human kindness
of which these verses are the overflowings. He could not
understand the feelings they express, nor, therefore, appre-
ciate their value. The reason assigned by the amiable
author of these ingenious trifles for sending them to the
press, is not a mere excuse, but a motive honourable to his
heart—that of starting a young friend as a publisher; of
whose style of getting up publications, the present is intended
as a specimen; and we must say it is a very neat one. The
verses, like their title, are unpretending in their character,
but possess sterling merit. They are quaint and ingenious
fancies—rare and curious devices; not tawdry bijoux, but
exquisite cameos of verse. These dainty morsels of thought
are dressed up with such a racy flavour, that they will be fit
meat for the palates of the few; though caviare to the
multitude. Their quality is the very reverse of the generality
of *Album Verses*, for they are neither insipid nor impertinent;
but original in thought and delicately refined in sentiment.
Mr. Lamb's humour is quaint and recondite, but his
philosophy breathes the spirit of humanity. His poetry is
relished only by the lovers of HERRICK and the admirers of
VINCENT BOURNE; some of whose Latin verses are trans-
lated in this volume, with such a union of spirit and fidelity,
evincing a kindred quality in thought and feeling, that they

read like originals—a rare merit in translations. The admirers of acrostics will find two or three of a fluency and facility of rhythm that we have not before seen even in Cowley; not that these ingenuities are valuable—but let them be appreciated according to the standard applicable to them. *The Wife's Trial, a Domestic Drama*, which has appeared in one of the periodicals, concludes this volume. It is a production remarkable for the felicity of its conduct and the neatness of its style: all the unities are preserved, and the sentiment is progressively developed with the plot. The *dénouement* is perfect. This piece has that Doric simplicity of style, that integrity of feeling, and quiet pathos, which peculiarly belong to Charles Lamb's dramatic poems.

We have been deeply gratified by the perusal of this little book of verses; but cannot recommend it to those who can see no beauty or will find no pleasure in reading the following extract. . . .

III

[The Times, *August 6th*, 1830.]

TO CHARLES LAMB

On the Reviewal of his *Album Verses* in the *Literary Gazette*

Charles Lamb, to those who know thee justly dear,
For rarest genius, and for sterling worth,
Unchanging friendship, warmth of heart sincere,
And wit that never gave an ill thought birth,
Nor ever in its sport infix'd a sting;
To us who have admired and loved thee long,
It is a proud as well as pleasant thing
To hear thy good report, has borne along
Upon the honest breath of public praise:
We know that with the elder sons of song,
In honouring whom thou hast delighted still,
Thy name shall keep its course to after days.
The empty pertness, and the vulgar wrong,
The flippant folly, the malicious will,
Which have assailed thee, now, or heretofore,
Find, soon or late, their proper meed of shame;
The more thy triumph, and our pride the more,

When wittling critics to the world proclaim,
In lead, their own dolt incapacity.
Matter it is of mirthful memory
To think, when thou wert early in the field,
How doughtily small Jeffrey ran at thee
A-tilt, and broke a bulrush on thy shield.
And now, a veteran in the lists of fame,
I ween, old Friend! thou art not worse bested
When with a maudlin eye and drunken aim,
Dulness hath thrown *a Jerdan* at thy head.

<div align="right">SOUTHEY.</div>

<div align="center">IV</div>

<div align="center">[*Jerdan*, Literary Gazette, *January 3rd*, 1835.]</div>

Of Lamb's principal productions it has been our duty to speak; and our only partial approbation of the last of them procured us a good deal of abuse. But . . . we adhere to the beauties of Mr. Lamb's poetry, inspired by a fine feeling for our elder dramatists, and a mind sweetly tuned to the amenities and kindness of life. No man was more beloved by those who enjoyed his friendship. In conversation he was pointed and witty. . . .

<div align="center">

LAMB'S WILL
1830

I
</div>

I Charles Lamb late of the Accountant General's Office East India house now resident at No. 34 Southampton Buildings Holborn London do hereby make my last Will and Testament I devise and bequeath all my property of every kind whatsoever to Thomas Noon Talfourd of the Middle Temple Esquire and Charles Ryle of the East India house Gentleman In trust to be disposed of by purchase of annuity or annuities or in any other manner at their entire discretion for the sole benefit and use of my sister Mary Ann Lamb[1] provided that if by reason of her advanced age or

[1] " He left little property behind him. Of course, the little that is left (chiefly in India bonds) devolves upon his cousin Bridget," *A Character of the late Elia*, 1823. Vincent Rice had been at Christ's Hospital; his name and those of Lowe and Ryle indicate how little Lamb's biographers can tell us of the friendships of Lamb in the City. The will was proved under £1,500.

otherwise it shall not seem expedient to them the said trustees to dispose of the whole of the said property in her lifetime and that after the payment of her just debts and funeral expenses any residue of the said property shall be remaining that then it shall be in the power of the said trustees to dispose of such residue to such purposes as she being of sound mind shall appoint by writing under her own hand provided further that in default of any such appointment then the said trustees after the payment of her debts and funeral expenses shall have power to pay the Residue of the said property to Emma Isola now residing at Fornham All Saints Bury Suffolk or in case that she shall not be living to any child or children that she may have left born in lawful wedlock And I appoint Thomas Noon Talfourd Esquire and Charles Ryle Gentleman aforesaid my Executors as witness my hand this ninth day of October 1830 ———— Charles Lamb ———— signed in the presence of ———— Vincent Rice 3 Ruffords Row Islington.

II

13th January 1835 Appeared Personally Willis Henry Lowe of the East India House Gentleman and made oath that he knew and was well acquainted with Charles Lamb . . . deceased for many years before and at the time of his death and also with his manner and character of handwriting and subscription . . . and lastly made oath he verily and in his conscience believes the whole body series and contents of the said will . . . to be of the proper handwriting and subscription of the said deceased. . . . Proved at London the 16th January 1835.

A CALEDONIAN STERN AND WILD
1831

[*Thomas Carlyle*, in *J. A. Froude's* Thomas Carlyle, 1795-1835, *vol. ii.*]

"*November 2nd.* How few people speak for Truth's sake even in its humblest modes! I return from Enfield, where I have seen Lamb[1] &c. &c. Not one of that class will tell you

[1] Other Scots who visited Lamb latterly, with very different appreciation, were John Wilson, John Hunter, and Robert Chambers.—*B.*

a straightforward story or even a credible one about any matter under the sun. All must be packed up into epigrammatic contrasts, startling exaggerations, claptraps that will get a plaudit from the galleries! I have heard a hundred anecdotes about William Hazlitt for example; yet cannot by never so much cross-questioning even form to myself the smallest notion of how it really stood with him. Wearisome, inexpressibly wearisome to me is that sort of clatter; it is not walking (to the end of time you would never advance, for these persons indeed have no Whither), it is not bounding and frisking in graceful, natural joy; it is dancing —a St. Vitus's dance. Heigh ho! Charles Lamb I sincerely believe to be in some considerable degree insane. A more pitiful, ricketty, gasping, staggering, stammering Tomfool I do not know. He is witty by denying truisms and abjuring good manners. His speech wriggles hither and thither with an incessant painful fluctuation, not an opinion in it, or a fact, or a phrase that you can thank him for—more like a convulsion fit than a natural systole and diastole. Besides, he is now a confirmed, shameless drunkard; *asks* vehemently for gin and water in strangers' houses, tipples till he is utterly mad, and is only not thrown out of doors because he is too much despised for taking such trouble with him. Poor Lamb! Poor England, when such a despicable abortion is named genius! He said there are just two things I regret in England's history: first, that Guy Fawkes' plot did not take effect (there would have been so glorious an *explosion*); second, that the Royalists did not hang Milton (then we might have laughed at them), &c. &c. *Armer Teufel!* "

Carlyle did not know at this time the tragedy lying behind the life of Charles Lamb, which explained or extenuated his faults. Yet this extravagantly harsh estimate is repeated— scarcely qualified—in a sketch written nearly forty years later.

"Among the scrambling miscellany of notables that hovered about us, Leigh Hunt was probably the best, poor Charles Lamb the worst. He was sinking into drink, poor creature; his fraction of humour &c., I recognised, and recognise—but never could accept for a great thing, a genuine, but essentially small and cockney thing; and now with gin, &c., super-added, one had to say ' Genius! This is not genius, but diluted insanity. Please remove this!' "

The gentle Elia deserved a kinder judgment. Carlyle considered " humour " to be the characteristic of the highest order of mind. He had heard Lamb extravagantly praised, perhaps, for this particular quality, and he was provoked to find it combined with habits which his own stern Calvinism was unable to tolerate.[1]

THE WESTWOODS

[*Crabb Robinson.*]

October 16*th.* Breakfasted at home, and late, so that it was between one and two when I reached Lamb, having ridden on the stage to Edmonton, and walked thence to Enfield. I found Lamb and his sister boarding with the Westwoods—good people, who, I dare say, take care of them. Lamb has rendered himself their benefactor by getting a place for their son in Aders' counting-house. They return his services by attention, which he and his sister need; but he feels the want of the society he used to have. Both he and Miss Lamb looked somewhat older, but not more than almost all do whom I have closely noticed since my return. They were heartily glad to see me. After dinner, I was anxious to leave them before it was dark, and the Lambs accompanied me, but only for a short distance. Lamb has begged me to come after dinner, and take a bed at his house; and so I must.

MR. MOXON'S PUBLICATIONS

1831

[*Leigh Hunt in* The Tatler, *June* 1831.]

Mr. Moxon has begun his career as a bookseller in singularly high taste. He has no connexion but with the select

[1] Mrs. Carlyle shared her husband's opinion of " most of the literary people here; . . . some of them, indeed (Charles Lamb, for instance), would not be tolerated in any society out of England." The Carlyle attitude to Lamb was kept up by Carlyle's latest, and most voluminous, biographer, who added a little quaint gossip about Lamb and alcohol. It appears that Lamb's observations on oatmeal in Carlyle's presence were deplorable in the extreme.—*B.*

of the earth. The least thing he does, is to give us a dandy poem, suitable to Bond-street, and not without wit. We allude to the Byronian brochure, entitled *Mischief*. But this is a mere condescension to the elegance of the street he lives in. Mr. Moxon commenced with some of the primæval delicacies of Charles Lamb. He then astonished us with Mr. Rogers' poems on Italy, full of beautiful plates after Turner and Stothard,—a golden volume. Then came the *Sonnets of Shakespeare and Milton* (which it was a refinement in the cruelty of his prosperity not to send us): then the Poetical Works of Mr. Landor, truly classical and Catullian; then the high-German hypochondrias of Tieck; and now he presents us with *Selections from the Poems of Mr. Wordsworth*, a book long a desideratum; purchaseable, portable, and containing some of the best things of the best poet of his time.

Of some of these publications we have already spoken— Mr. Lamb's *Album Verses* among them. And why (the reader may ask) not have noticed his *Satan in Search of a Wife* ? Because, to say the truth, we did not think it worthy of him. We rejoice in Mr. Lamb's accession to the good cause advocated by Sterne and Burns, refreshed by the wholesome mirth of Mr. Moncrieff, and finally carried (like a number of other astonished humanities, who little thought of the matter, and are not all sensible of it now) on the triumphant shoulders of the *Glorious Three Days*. But Mr. Lamb, in the extreme sympathy of his delight, has taken for granted, that everything which can be uttered on the subject will be held to be worth uttering, purely for its own sake, and because it could not well have been said twelve months ago.[1] He merges himself, out of the pure transport of his good will, into the joyous common-places of others; just as if he had joined a great set of children in tossing over some mighty bowl of snap-dragon, too scalding to bear; and thought that nothing could be so good as to echo their " hurras! " Furthermore, we fear that some of his old friends, on the wrong side of the House, would think a little of his merriment profane: though for our parts, if we are certain of anything in this world, it is that nothing can be more Christian.

[1] The reference is to the Reform Bill.—*B*.

INVITATION TO ITALY
1831

[*W. S. Landor to Crabb Robinson, November 6th*, 1831.]

Since I saw you, I have read in the *New Monthly
Magazine* the papers signed " Elia." Mr. Brown[1] lent me
the book. The papers are admirable; the language truly
English. We have none better, new or old. When I say, I am
" sorry " that Charles Lamb and his sister are suffering the
word is not an idle or a faint one. I feel deep pain at this
intelligence—pain certainly not disproportioned to the
enjoyment I have received by their writings. Besides, all
who know them personally speak of them with much affec-
tion. Were they ever in Italy, or are they ever likely to
come ? If so, I can offer them fruits, flowers, horses, and
Parigi.

NEW INTENTIONS
1831

[*Editorial in Moxon's* Englishman's Magazine, *August* 1831; *the
Magazine was short-lived.*]

To the Gentle Reader. . . . Proud are we of having intro-
duced to thee once again in all the subtile playfulness of his
delicate fancy, thy own " incomparable ELIA," one who,
eschewing foolish periodicals, cleaveth to the *Englishman,*
whose pages in succeeding months he promiseth to grace
with a series of Essays under the quaint appellation of
" PETER'S NET."

AN INTERVIEW
1831

[Eliza Cook's Journal, *vol. iii.*]

It was in the year 1831 when we had our last interview
with Charles Lamb. He was then residing at Enfield. . . .
On the occasion to which this paper refers, we had a literary

[1] Charles A. Brown, Keats's friend, who has already been seen in these pages,
appalled by Lamb's puns.—*B.*

favour to request of him, which we were well assured, from our knowledge of his kindness, he would grant in the readiest manner; nor were we disappointed. The door was opened by his sister, who welcomed us in her usual polite and agreeable manner. She was a staid, respectable, domestic, and matronly kind of person, without the slightest affectation or pretension, and was very pleasant in her demeanour. You could feel at home with her at once, and you loved her for her brother's sake. We waited a few moments in a plain and neat front parlour, while she went to inform her brother, and, on her return, we were introduced to Charles Lamb, in a little back room, plainly furnished, and evidently used as his study. There was a select, but by no means a large library; and we could not help observing the number of folios which it contained. He received us in his usual quiet and urbane manner, without any form, or peculiar warmth. This was characteristic of him.

As soon as we were seated we saw that we were in the presence of a superior man—a man of cultivated, powerful, and original mind. There was something about him which impressed us at once, and which we cannot adequately describe. He was stationed at a small table, and had before him an old folio—an ancient edition of the plays of Beaumont and Fletcher. His frame was slight and fragile, and his countenance was pensive and solemn. He was attired in clerk-like black, and presented a very grave and clerical appearance.

We were always struck with his head, and never more than on this occasion. The form of that head was the most dignified, and its expression the most agreeable and sweet.

After a little incidental remark or two, and gaining, without any difficulty the literary favour solicited, we proposed some questions on books and intellectual subjects, and entered seriously into conversation. There was nothing facetious—no punning—on this occasion. He was very serious, and his talk was serious; and, as Hazlitt observes, his serious conversation, like his serious writing, was his best. . . .

" You have caught me reading," said he, " and reading a large book." " Do you spend much time in reading ? " we inquired. " Yes, the mornings invariably; and sometimes

the evenings too." "You approve, then, of varied and extensive reading ? "

"Decidedly. If a man's mind be well disciplined, he can scarcely read too much. I mean, of course, that his reading should be close, careful, meditative."

"What have you been reading lately ?" we presumed to ask.

"Oh, I have been going through Massinger, and I am now perusing again, with much interest, Beaumont and Fletcher; and I intend reading old Ben Jonson and Marlowe once more. Such authors are to me a continual feast."

"You give me the preference, I perceive, to the fine old folios of our ancestors ? "

"Indeed I do," he at once exclaimed; "there is nothing like them—what solidity—what breadth—what printing —what margin—to me, what beauty! I can scarcely endure your octavos and duodecimos. I have been so accustomed to the fine old folio, that I find it almost difficult to read with comfort a book of small size; and, sure I am, I do not receive half the benefit. Here," said he, "is a favourite volume of mine,"—taking up a folio edition of Burton's *Anatomy of Melancholy*—" and I have been so used to this form, that I could scarcely read it in the dimensions of a small octavo. There is another glorious book—Philip Sidney's *Arcadia*—but how could I read it if it were in the shape of a duodecimo ? Let others have the octavos, but give me the quartos, and especially the folios."

We asked him, if he read Jeremy Taylor.

"Yes," he replied, "and always with much delight. He was one of the greatest giants of the olden time. His profusion of illustration, his richness and variety of imagery, always astonish me; and his copiousness and magnificence of expression ever afford me interest and pleasure. I read last year a large portion of his *Great Exemplar*, and was charmed and enchanted with very many passages."

"Do you like Barrow ? "

"I cannot help it. He is dry, and often tedious, but what energy and felicity of language, what force of argument, what clearness and power of thought, what rich diversified illustrations! I wish all would read Barrow." He then inquired, "and pray what are you reading ? I like to know what are the meditations and inquiries of others."

We at once told him that we had just finished again
Boswell's *Life of Johnson*. "Indeed," said he, "that is a
volume I prize. It is most descriptive and powerful. It is
a full-length of the great lexicographer. It is often prosy,
garrulous, and small in its talk and details; still who would
be without such a book—such a portraiture? You see
Johnson's mind not in his poetry, in his *Idler*, or his *Rambler*,
but in his *Rasselas*, and in his conversations; as Boswell
narrates them. Yes, I much like Boswell; a vain, weak, in
many respects, a little man; but how clever, how admirable
in sketching the character, and detailing the conversations
of Samuel Johnson!"

We proceeded to inform him that we had perused, with
much gratification, the *Life and Letters of Beattie*, by Forbes.
"Yes," remarked he, "it is a book, valuable not on account
of what Forbes does, but on the ground of the letters of the
poet. Many of those are most interesting and beautiful,
written with marked elegance and ease, abounding in nice
morsels of criticism, and rich in descriptive passages. I like
Beattie's Letters," he added, "many of them are worthy of
being compared with Cowper's."

We asked him if he had studied Cudworth's *Intellectual
System*. He replied in the affirmative, and observed, "I am
always struck with its amplitude and breadth of learning,
and the true greatness of mind which it discovers."

We told him that we examined lately, with care, the prose
of Dryden. "I am glad of it. It is the prose of ' glorious
John '—prose which few could write. It is full of energy
and erudition, and I never read it without admiration."

We then mentioned, that we had gone through Goldsmith
again. "Ah! poor Goldy! how I value him; what can be
more simple, pure, touching, natural,—than his prose—what
can be more descriptive, graceful, original, or impressive
than his poetry!"

Having just read Lamb's "Benchers of the Temple," "The
Old Margate Hoy," "Witches and other Night Fears,"
"Mackery End in Hertfordshire," and several more of
his essays, it was mentioned how much we valued and
admired them. He responded, "You are very polite and
kind. The public has been very indulgent towards them.
Whatever their faults, I endeavoured to write them with

discrimination and care. The little *Essays*, by Elia, have not been despised." He seemed gratified, and a smile played on his pensive and intellectual countenance. " When I am gone," he touchingly remarked, " I shall be remembered by a few choice and kindred spirits."

" Not by a few," we ventured to add, " but by many,— very many."

He bowed, and asked, " Have you got *John Woodvil* in your library ? It is a thing of no importance, but I should like you to have a copy." On informing him that we had not, he procured from an upper shelf a volume of this play; and, writing his name on the fly-leaf, and adding, " to his affectionate friend," put it into our hands. That little book we have prized ever since, and now that the hand and head of the writer have mouldered in the grave, we never take it up without pensive and solemn emotions being awakened. Previously to leaving, on the occasion to which this paper relates, Elia wrote for us a kind and generous note—penned in his neat and peculiar style; we have it before us now, and shall ever prize it as a little epistolary composition of the taciturn, the pensive, the grave, but gentle, true-hearted, kind-hearted Elia.

A SCHOOLBOY OBSERVER

1831-34

[*Thomas Westwood, in* Notes and Queries, *September* 1866.]

I have been asked more than once to set down my reminiscences of Lamb, but they have never seemed to me sufficiently clear and consecutive to be of any avail. At the time of my intercourse with him, I was a mere schoolboy; fond of books, it is true, and reverencing the writers of them, but living, as is natural to boys, rather the outer than the inner life, and storing in my memory only isolated facts and impressions—not a coherent and complete series of such.

My first glimpse of the Lamb household, however, is as vivid in my recollection as if it were of yesterday. It was in Enfield. Leaning idly out of window, I saw a group of three issuing from the " gambogey-looking cottage " close at

N

hand: a slim middle-aged man, in quaint, uncontemporary habiliments; a rather shapeless bundle of an old lady, in a bonnet like a mob cap; and a young girl. While before them, bounded a riotous dog (Hood's immortal " Dash ") holding a board with " This House to be Let " on it, in his jaws. Lamb was on his way back to the house-agent, and that was his fashion of announcing that he had taken the premises.

I soon grew to be on intimate terms with my neighbour; who let me loose in his library, and initiated me into a school of literature, which Mrs. Trimmer might not have considered the most salutary under the circumstances. Beaumont and Fletcher, Webster, Farquhar, Defoe, Fielding—these were the pastures in which I delighted to graze, in those early years; and which, in spite of Trimmers, I believe did me less evil than good. My heart yearns, even now, to those old books. Their faces seem all familiar to me, even their patches and botches, the work of a wizened old cobbler hard by: for little wotted Lamb of Roger Paynes and Charles Lewises. A cobbler was his bookbinder; and the rougher the restoration, the greater the success.

There were few modern volumes in his recollection; and subsequently, such presentation copies as he received were wont to find their way into my own book-case, and often through eccentric channels. A Leigh Hunt, for instance, would come skimming to my feet through the branches of the apple-trees (our gardens were contiguous); or a Bernard Barton would be rolled down stairs after me, from the library door. *Marcian Colonna* I remember finding on my window-sill, damp with the night's fog; and the *Plea of the Midsummer Fairies* I picked out of the strawberry-bed.

It was not that Lamb was indifferent to the literary doings of his friends; but their books, as books, were unharmonious on his shelves. They clashed, both in outer and inner entity, with the Marlowes and Miltons who were his household gods.

When any notable visitors made their appearance at the cottage, Mary Lamb's benevolent tap at my window-pane seldom failed to summon me out, and I was presently ensconced in a quiet corner of their sitting-room, half hid in some great man's shadow.

Of the discourse of these *dii majores* I have no recollection

now; but the faces of some of them I can still partially
recall. Hazlitt's, for instance, keen and aggressive, with
eyes that flashed out epigram. Tom Hood's, a Methodist
parson's face: not a ripple breaking the lines of it, though
every word he dropped was a pun, and every pun roused a
roar of laughter. Leigh Hunt's, parcel genial, parcel
democratic, with as much rabid politics on his lips as honey
from Mount Hybla. Miss Kelly's, plain, but engaging.
(The most unprofessional of actresses, and unspoiled of
women: the bloom of the child on her cheek, undefaced by
the rouge, to speak in a metaphor.) She was one of the
most deeply welcome of Lamb's guests. Wordsworth's,
farmerish and respectable, but with something of the great
poet occasionally breaking out and glorifying forehead and
eyes.

Then there was Martin Burney, ugliest of men, hugest of
eaters, honestest of friends. I see him closeted with Mary
Lamb, reading the Gospel of St. John *for the first time*. And
Sheridan Knowles, burly and jovial, striding into Lamb's
breakfast-room one spring morning—a great branch of
May-blossom in his hand. And George Darley, scholar and
poet—slow of speech and gentle of strain: Miss Kelly's con-
stant shadow in her walks amongst the Enfield woodlands.

Eheu, eheu! it is sorrowful work to recall those pleasant
days, and the movers in them, though ever so briefly and
slightly. It tempts me to break out into my old friend's very
moan:—

" Ghostlike I pace round the haunts of my childhood.
Earth seems a desert I am bound to traverse,
Seeking to find the old familiar faces."

Charles Lamb was a living anachronism—a seventeenth
century man, mislaid and brought to light two hundred
years too late. Never did author less belong to what was,
nominally, his own time; he could neither sympathise with
it, nor comprehend it. His quaintness of style and anti-
quarianism of taste were no affectation. He belonged to the
school of his contemporaries, but they were contemporaries
that never met him in the streets, but were mostly to be
found in Poet's Corner, or under other gravestones of the
long ago. He was happy in this, however, that though shut

out from his day and generation, his day and generation understood and appreciated him, for, with the exception of Goldsmith, no man of letters has ever been more sincerely loved or tenderly regretted.

As I have said elsewhere, something of the warmth of life seemed to die out with him—he has left a void that will never be filled. Poor Martin Burney, weeping by his graveside and refusing to be comforted, did but typify the feeling of all who knew Lamb personally; and the grief has proved a permanent one. Thirty-two years have elapsed since then, and yet I will venture to aver that amongst the scanty remnant of that once brilliant circle, the sorrow for his loss remains as fresh as ever, the consolation as far away.

My last meeting with Lamb took place at Edmonton, shortly before his decease. We had a pleasant ramble along the green Edmonton lanes, turning in more than once at wayside hostels, such as Walton would have delighted in, and moistening our discourse with draughts from the unsophisticated pewter. For each host or hostess my companion had his joke and his salutation, and was clearly an honoured and familiar presence. Later in the evening, when the lamp was lit, I ventured to slip into his hand that worst of all literary scarecrows, a volume of manuscript juvenile verse. With his customary kindness and patience he deciphered the weary pages, bantered me occasionally on my misanthropic and ultra-despairing moods, and selected for commendation such of the pieces as were simplest and sincerest. In the latter contingency, Mary Lamb was usually called on for confirmation. Then we parted, and a few days later that grave was dug, and one of the sweetest-natured, truest, most genial-hearted creatures God ever blessed the world with, went down into it.

T. W.

Brussels.

LAMB'S OLD BOOKS

[Thomas Westwood, The Angler's Notebook, 1884.]

My own principle is never to abolish the binding of an old book except from dire necessity. Think what you sacrifice, by the change—the familiar contemporary aspect of the

volume, the touching stigmata of immemorial use—the faint, subtle, impalpable perfume of a dead and buried time. Would you give up these merely to possess a gorgeous, gilded monstrosity, on your shelves, that will mock you for ever-more ? I like Charles Lamb's feeling, in the matter. In the whole course of his life, I do not suppose he ever gave a book to the binder. When his folios grew loose in their hinges, or ragged and tattered at their backs, he usually tucked them under the arm of the present deponent (at least, in his Enfield sojourning) to be handed over to an old cobbler hard by—a character—who squatting on a low bench, after peering at them through an enormous pair of goggles, stitched them here, patched them there, and returned them sound, but unchanged. Lamb considered him an artist of merit, in the same rank and file as Charles Lewis and Roger Payne. He had one advantage over them, even—his bills were shorter. Elia's library, in consequence, was of a pervading brownness. Whatever " tooling " his books might have possessed in former centuries, had been rubbed down to the vanishing point, and was not missed. Sir Thomas Browne's *Religio Medici*, old Burton's *Anatomy*, Drayton's *Polyolbion*, Hey-wood's *Hierarchy of the Blessed Angels*, the Duchess of New-castle's *Sociable Letters*, and a host of others, all wore the costume of their time and looked happy and at home in it. The general effect was harmonious, quaint, Elizabethan, and suited to the individuality of the owner. A dear old library, that, in which I passed most of my boyish leisure. Through the open window, in summer, came fresh country smells; sweet peas in the garden below, new-mown hay in the meadow beyond. Along the verge of that meadow (I may say " par parenthèse ") ran a slender ribbon of water, the New River, in which I caught my first fish and had fore-taste of the future glories of piscator-ship.

There is never a hill-side under whose oaks or chestnuts I lounge upon a smoky afternoon of August, but a pocket Elia is as coveted and as cousinly a companion as a pocket Walton, or a White of Selborne. And upon wet days, in my library, I conjure up the image of the thin, bent old man, Charles Lamb, to sit over against me, and I watch his kindly, beaming eye, as he recites, with poor stuttering voice,— between the whiffs of his pipe,—over and over, those always

new stories of " Christ's Hospital," and the cherished
" Blakesmoor," and " Mackery End." (" No, you need not
put the book back, my boy; 'tis always in place.")

Always in place—Amen.

VISITS TO WESTWOOD COTTAGE
1832

[Crabb Robinson.]

I

March 8th. I walked to Enfield, and found the Lambs in
an excellent state,—not in high health, but, what is far better,
quiet and cheerful. Miss Isola being there, I could not sleep
in the house; but I had a comfortable bed at the inn, and I
had a very pleasant evening at whist. Lamb was very
chatty, and altogether as I could wish.

II

July 23rd. I walked to Enfield to see Charles Lamb. I had
a delightful walk, reading Goethe's *Winckelmann*, and reached
Lamb at the lucky moment before tea. Miss Isola was there.
After tea, Lamb and I took a pleasant walk together. He
was in excellent health and in tolerable spirits and was to-
night quite eloquent in praise of Miss Isola. He says she is
the most sensible girl and best female talker he knows.

July 24th. I read Goethe in bed. I was, however, sum-
moned to breakfast at eight, and after breakfast read some
Italian with Miss Isola, whom Lamb is teaching Italian
without knowing the language himself.

III

(1832). *September 28th.* Landor breakfasted with me, and
also Worsley, who came to supply Hare's place. After an
agreeable chat, we drove down to Edmonton, and walked
over the fields to Enfield, where Charles Lamb and his sister
were ready dressed to receive us. We had scarcely an hour
to chat with them; but it was enough to make both Landor
and Worsley express themselves delighted with the person of

Mary Lamb; and pleased with the conversation of Charles Lamb, though I thought him by no means at his ease, and Miss Lamb was quite silent. Nothing in the conversation recollectable. Lamb gave Landor White's *Falstaff's Letters*. Emma Isola just showed herself. Landor was pleased with her and has since written verses on her.

LITERARY MAKESHIFTS
1833

[*Crabb Robinson.*]

April 9th. I reached the Lambs at tea-time. I found them unusually well in health, but not comfortable. They seem dissatisfied in their lodgings; but they have sold all their furniture, and so seem obliged to remain as they are. I spent the evening playing whist; and after Lamb and his sister went to bed, I read in his album (Holcroft's *Travels* pasted with extracts in MS. and clippings out of newspapers, &c.) Lamb says that he can write acrostics and album verses, and such things, at request, with a facility that approaches that of the Italian Improvisatori; but that he has great difficulty in composing a poem or piece of prose which he himself wishes should be excellent. The things that cost nothing are worth nothing. He says he should be happy had he some literary task. Hayward has sent him his *Faust*.[1] He thinks it well done, but he thinks nothing of the original.

THE FRIEND OF THE THEATRE
1833

[*James Sheridan Knowles, Preface to* The Wife: A Play in Five Acts. *The dramatist informs the discerning that his modest friend wrote the Prologue as well as the Epilogue.*]

To my early, my trusty, and honoured friend, Charles Lamb, I owe my thanks for a delightful Epilogue, composed almost as soon as it was requested. To an equally dear friend I am equally indebted for my Prologue.

[1] A translation begun through a remark of Lamb's ; see preface.—*B.*

THE LAST ESSAYS OF ELIA
1833

[Spectator, *February* 1833.]

Are by no means worthy of the first. This opinion is de-
liberate enough, for we have had several years to form it in;
in the course of which the whole of this volume has been
published by piece-meal. The first portions appeared so
long ago as the publication of the *London Magazine* by Taylor
and Hessey, or soon after it passed from their hands; and the
rest has the air of having been reluctantly yielded to the
importunity of applicants for assistance.

"LITERARY HISTORY OF THE LAST FIFTY YEARS"
1833

[*Allan Cunningham, in* The Athenæum, 1833.]

Critics are said to have checked some poetic spirits, and if
this be true of any, it is of Charles Lamb, who was handled
so rudely by the critics of the *Edinburgh Review*, that he for-
sook the Muses, and, directing his mind to prose, acquired a
reputation, under the name of Elia, not destined soon to die
or be forgotten. There is, nevertheless, much quaint feeling
in his verses; he has used the style of the good old days of
Elizabeth in giving form and utterance to his own emotions;
and, though often unelevated and prosaic, every line is in-
formed with thought, or with some vagrant impulse of
fancy. He was born in 1775, and educated in the school of
Christ's Hospital, where he was the companion of Coleridge,
and distinguished for a quick apprehension and a facility in
acquiring knowledge. In his earlier days he became ac-
quainted with Southey and Wordsworth, which induced
some critic, more ingenious than discerning, to number him
as a follower of what is erroneously called the Lake School.
The tone and impulse of the Lakers are all of our own times;

the line and impress of Lamb's verse is of another age: they are of the country, he is of the town; they treat of the affections of unsophisticated life; he gives portraits of men whose manners have undergone a city-change; records sentiments which are the true offspring of the mart and the custom-house, and attunes his measure to the harmony of other matters than musical breezes and melodious brooks. His prose essays, and sketches of men and manners, are in a bolder and happier spirit; there is a quaint vigour of language, a fanciful acuteness of observation, and such true humanities and noble sensibilities sparkling everywhere, as rank him among the most original critics of the age nor is he otherwise in company than he is on paper—his wit is unwearied, and his gentleness of heart ever uppermost, save when he chooses to be sarcastic, and then he soothes whomever he offends, by some happy and unhoped for compliment.

ENGLAND AND THE ENGLISH
1833

[*Edward Lytton Bulwer*, England and the English, 1833, *vol. ii.*]

The Essays of Elia, in considering the recent additions to our *belles lettres*, cannot be passed over in silence. Their beauty is in their delicacy of sentiment. Since Addison, no writer has displayed an equal refinement of humour; and if no single one of Mr. Lamb's conceptions equals the elaborate painting of Sir Roger de Coverley, yet his range of character is more extensive than Addison's, and in his humour there is a deeper pathos: His compositions are so perfectly elaborate, and so minutely finished, that they partake rather of the character of poetry than of prose; they are as perfect in their way as the *Odes* of Horace, and at times, as when commencing his invocation to " the Shade of Elliston " he breaks forth with

" Joyousest of once-embodied spirits, whither at length
 hast thou flown ? " &c.

we might almost fancy that he had set Horace before him as a model.

A WISH

1834

[*W. C. Macready*, Diaries.]

January 9th. Went to Talfourd's (from whom I had received
a note of invitation to supper in the morning) to meet Charles
Lamb; met there Price, Forster, Mr. and Mrs. Field (I
fancy a Gibraltar judge), Charles Lamb, Moxon the pub-
lisher, and not Mrs. Moxon, whose absence was noted by those
present as a most ungrateful omission of respect and duty,
as he (Lamb) had literally brought her up, and wanted her
attention and assistance. I noted one odd saying of Lamb's,
that " the last breath he drew in he wished might be through
a pipe and exhaled in a pun." Spent a pleasant evening and
walked home under a " pitiless storm " with Price.

TALES FROM THE DRAMATISTS

1834

[*C. Cowden Clarke to L. Hunt, February* 15*th*, 1834.]

" Lamb wants me to take up the *old Dramatists* after the
fashion of his Shakspeare tales, and has even been so kind
as to start me with an adaptation of his own from the ' Cupid's
Revenge.' What do you think of that for a compliment!! I
confess that the thought of following such a man almost
paralyzes me."

BREAKFAST IN THE TEMPLE

1834

[*N. P. Willis*, Pencillings by the Way, 1836.]

Invited to breakfast with a gentleman in the Temple to
meet Charles Lamb and his sister—" Elia " and " Bridget
Elia." I never in my life had an invitation more to my taste.
The essays of Elia are certainly the most charming things in
the world, and it has been for the last ten years my highest
compliment to the literary taste of a friend to present him

with a copy. Who has not smiled over the humorous description of Mrs. Battle ? Who that has read " Elia " would not give more to see him than all the other authors of his time put together ?

I arrived half an hour before Lamb, and had time to learn some of his peculiarities. He lives a little out of London, and is something of an invalid. Some family circumstances have tended to depress him considerably of late years, and, unless excited by convivial intercourse, he scarce shows a trace of what he was. He was very much pleased with the American reprint of his *Elia*, though it contains several things which are not his—written so in his style, however, that it is scarce a wonder the editor should mistake them. If I recollect right, they were " Valentine's Day," the " Nuns of Caverswell," and " Twelfth Night." He is excessively given to mystifying his friends, and is never so delighted as when he has persuaded some one into the belief of one of his grave inventions. His amusing biographical sketch of Liston was in this vein, and there was no doubt in any body's mind that it was authentic, and written in the most perfect good faith. Liston was highly enraged with it, and Lamb was delighted in proportion.

There was a rap at the door at last, and enter a gentleman in black small-clothes and gaiters, short and very slight in his person, his head set on his shoulders with a thoughtful, forward bent, his hair just sprinkled with gray, a beautiful deep-set eye, aquiline nose, and a very indescribable mouth. Whether it expressed most humour or feeling, good-nature or a kind of whimsical peevishness, or twenty other things which passed over it by turns, I cannot in the least be certain.

His sister, whose literary reputation is associated very closely with her brother's, and who, as the original of " Bridget Elia," is a kind of object for literary affection, came in after him. She is a small bent creature, evidently a victim to ill-health, and hears with difficulty. Her face has been, I should think, a fine and handsome one, and her bright gray eye is still full of intelligence and fire. They both seemed quite at home in our friend's chambers; and as there was to be no one else, we immediately drew round the breakfast table. I had set a large arm-chair for Miss Lamb. " Don't take it, Mary," said Lamb, pulling it away from her very

gravely, " it looks as if you were going to have a tooth drawn."

The conversation was very local. Our host and his guest had not met for some weeks, and they had a great deal to say of their mutual friends. Perhaps in this way, however, I saw more of the author, for his manner of speaking of them, and the quaint humour with which he complained of one, and spoke well of another, was so in the vein of his inimitable writings, that I could have fancied myself listening to an audible composition of new Elia. Nothing could be more delightful than the kindness and affection between the brother and the sister, though Lamb was continually taking advantage of her deafness to mystify her with the most singular gravity upon every topic that was started. " Poor Mary! " said he, " she hears all of an epigram but the point." " What are you saying of me, Charles ? " she asked. " Mr. Willis," said he, raising his voice, " admires your *Confessions of a Drunkard*, very much, and I was saying it was no merit of yours that you understood the subject." We had been speaking of this admirable essay (which is his own) half an hour before.

The conversation turned upon literature after a while, and our host could not express himself strongly enough in admiration of Webster's speeches, which he said were exciting the greatest attention among the politicians and lawyers of England. Lamb said, " I don't know much of American authors. Mary, there, devours Cooper's novels with a ravenous appetite, with which I have no sympathy. The only American book I ever read twice, was the *Journal of Edward [John] Woolman*, a Quaker preacher, and tailor, whose character is one of the finest I ever met with. He tells a story or two about negro slaves, that brought the tears into my eyes. I can read no prose now, though Hazlitt some-times, to be sure—but then Hazlitt is worth all modern prose-writers put together."

Mr. R. spoke of buying a book of Lamb's a few days before, and I mentioned my having bought a copy of *Elia* the last day I was in America, to send as a parting gift to one of the most lovely and talented women in our country.

" What did you give for it ? " said Lamb.

" About seven and sixpence."

" Permit me to pay you that," said he, and with the utmost earnestness he counted out the money upon the table.

" I never yet wrote any thing that would sell," he continued. " I am the publisher's ruin. My last poem won't sell a copy. Have you seen it, Mr. Willis ? "

I had not.

" It's only eighteen pence, and I'll give you sixpence toward it " ; and he described to me where I should find it sticking up in a shop-window in the Strand.

Lamb ate nothing, and complained in a querulous tone of the veal-pie. There was a kind of potted fish (of which I forget the name at this moment) which he had expected our friend would procure for him. He inquired whether there was not a morsel left perhaps in the bottom of the last pot. Mr. R. was not sure.

" Send and see," said Lamb, " and if the pot has been cleaned, bring me the cover. I think the sight of it would do me good."

The cover was brought, upon which there was a picture of the fish. Lamb kissed it with a reproachful look at his friend, and then left the table and began to wander round the room with a broken, uncertain step, as if he almost forgot to put one leg before the other. His sister rose after a while, and commenced walking up and down very much in the same manner on the opposite side of the table, and in the course of half an hour they took their leave.

To any one who loves the writings of Charles Lamb with but half my own enthusiasm, even these little particulars of an hour passed in his company will have an interest. To him who does not, they will seem dull and idle. Wreck as he certainly is, and must be, however, of what he was, I would rather have seen him for that single hour, than the hundred-and-one sights of London put together.

PHENOMENA, BY A PHILOSOPHER
1834

[*T. Carlyle*, Reminiscences, 1881, *ii*, 164.]

Badams with his wife was living out at Enfield, in a big old rambling sherd of a house among waste gardens; thither I twice or thrice went, much liking the man, but never now

getting any good of him; she once for three or four days
went with me; sorry enough days, had not we, and especially
she, illumined them a little. Charles Lamb and his sister
came daily once or oftener; a very sorry pair of phenomena.
Insuperable proclivity to gin in poor old Lamb. His talk
contemptibly small, indicating wondrous ignorance and
shallowness, even when it was serious and good-mannered,
which it seldom was, usually ill-mannered (to a degree),
screwed into frosty artificialities, ghastly make-believe of
wit, in fact more like " diluted insanity " (as I defined it)
than anything of real jocosity, humour, or geniality. A most
slender fibre of actual worth in that poor Charles, abundantly
recognisable to me as to others, in his better times and
moods; but he was cockney to the marrow; and cockney-
dom, shouting " glorious, marvellous, unparalleled in
nature! " all his days had quite bewildered his poor head,
and churned nearly all the sense out of the poor man. He
was the leanest of mankind, tiny black breeches buttoned to
the knee-cap and no further, surmounting spindle-legs also
in black, face and head fineish, black, bony, lean, and of a
Jew type rather; in the eyes a kind of smoky brightness or
confused sharpness; spoke with a stutter; in walking tot-
tered and shuffled; emblem of imbecility bodily and spiritual
(something of real insanity I have understood), and yet
something too of human, ingenuous, pathetic, sportfully
much enduring. Poor Lamb! he was infinitely astonished
at my wife, and her quiet encounter of his too ghastly London
wit by a cheerful native ditto. Adieu, poor Lamb! He soon
after died, as did Badams, much more to the sorrow of us
both.

AN ASPIRANT

1834

[*Rev. J. Fuller Russell, F.S.A.*, Notes and Queries, *April* 1882.]

CHARLES LAMB AT HOME

I availed myself of Charles Lamb's friendly invitation on
Tuesday, August 5, 1834. On reaching his cottage—which
stood back from the road (nearly opposite the church),

between two houses which projected beyond it, and was
screened by shrubs and trees—I found that he was out,
taking his morning's stroll. I was admitted into a small,
panelled, and agreeably shaded parlour. The modest room
was hung round with engravings by Hogarth in dark frames.
Books and magazines were scattered on the table and on
the old-fashioned window seat. I chatted awhile with Miss
Lamb—a meek, intelligent, very pleasant, but rather deaf
elderly lady, who told me that her brother had been grati-
fied by parts of my poem (" Emily de Wilton "), and had
read them to her. " Elia " came in soon after—a short, thin
man. His dress was black, and he wore a capacious coat,
breeches and gaiters, and a white neck-handkerchief. His
dark and shaggy hair and eyebrows, heated face, and very
piercing jet-black eyes gave to his appearance a singularly
wild and striking expression. The sketch of him in *Fraser's
Magazine* gives a true idea of his dress and figure, but his
portraits fail to represent adequately his remarkably " fine
Titian head, full of dumb eloquence," as Hazlitt described
it. He grasped me cordially by the hand, sat down, and
taking a bottle from a cupboard behind him, mixed some
rum and water. On another occasion his sister objected to
this operation, and he refrained. Presently after he said,
" May I have a little drop now ? Only a *leetle* drop ? "
" No," said she; " be a good boy." At last, however, he
prevailed, and took his usual draught. On each visit (that
of August 5 having been quickly succeeded by another) I
found he required to be drawn into conversation. He
would throw out a playful remark, and then pause awhile.
He spoke by fits and starts, and had a slight impediment in
his utterance, which made him, so to say, grunt once or
twice before he began a sentence; but his tones were loud
and rich, and once, when he read to me a passage from a
folio of Beaumont and Fletcher (which his sister had brought
down to show me Coleridge's MS. remarks at the end of
each play), the deep pathos of his voice gave great weight to
the impression made by the poetry. He would jump up and
slap his sister playfully on the back, and a roomy snuffbox
often passed between them on the old round table. There
was not that point in his conversation which we find in
William Hone's. He agreed with me that Moore's poetry

was like very rich plum cake—very nice, but too much of it at a time makes one sick. He said that Byron had written only one good-natured thing, and that was the *Vision of Judgment*. " Mary," he added to Miss Lamb, " don't you hate Byron ? " " Yes, Charles," she replied. " That's right," said he. Of " Conversation " Sharpe's *Essays*, which had just been published, and praised in the *Quarterly Review*, he asserted, " They are commonplace, and of the two attempts at criticism in them worthy of notice, one—that on Cowper's ' boundless contiguity of shade '—is completely incorrect." He had a very high opinion of Wordsworth, saying, " He is a very noble fellow." He thinks he undervalued Coleridge's poetry. He regarded the *Ancient Mariner* and *Christabel* as Coleridge's best productions in verses; the former, in his opinion, was miserably clumsy in its arrangement, and the latter was injured by the " mastiff bitch " at the beginning. Coleridge was staying with Lamb when he wrote it, and thinking of Sir William Curtis, Lamb advised Coleridge to alter the rhyme thus:

> " Sir Leoline, the Baron *round*
> Had a toothless mastiff *hound*."

Elia thought little of James Montgomery, who had only written one poem which pleased him, and that was among his minor pieces. *Philip van Artevelde* had been sent him as equal to Shakespeare. He thought it was nothing extraordinary. He had a good opinion of Tennyson's poems, which had lately been very sarcastically condemned in the *Quarterly*. When at Oxford,[1] he saw Milton's MSS. of *L'Allegro*, &c., and was grieved to find from the corrections and erasures how the poet had laboured upon them. He had fancied that they had come from his mind, almost spontaneously. He said that to be a true poet a man must serve a long and rigorous apprenticeship. He must, like the mathematician, sit with a wet towel about his head if he wishes to excel. It was far easier to scribble verses than to hammer out good poetry, worthy of immortality. Of metres, Lamb observed, there were plenty of old ones, now little known, which were better than any new ones which could be devised, and would be quite as novel. He lost 25 *l.* by his best effort,

[1] At Cambridge. [Ed.]

John Woodvil. The first edition of this " tragedy," which he kindly gave me, I still possess. It is a small thin volume, bound in blue papered boards with a pink back, and dated 1802. He had, he said, a curious library of old poetry, &c., which he had bought at stalls cheap. " I have *nothing useful*," he added; " as for science, I know and care nothing about it." Coleridge used to write on the margin of his books when staying in his house. It was during one of his visits that he translated *Wallenstein*. Lamb thought the *Lay* the best of Scott's poetical works. He told me that he knew his letters before he could speak, and called on his sister to vouch for the truth of this story. He hated the country, and loved to walk on the London road, because then he could fancy that he was wending thither. He was a great walker. He never read what any of the reviews said about him. He showed me a copy of Coleridge's will, and observed, with some indignation, that the conductors[1] of the *Athenæum* had written to him for reminiscences of his old friend. " It was very indelicate," he said, " to make any such request," and he refused. He had written a poem called the *Devil's Marriage to a tailor's daughter*, but suppressed it on finding that Dr. C——, the Vicar of E——, had similarly committed himself. On rising to leave him, on my last visit, I could not open the parlour door. " Ah," he exclaimed, with a sweet smile, " you can unlock the springs of Helicon, but you cannot open the door! "

I regret that I never saw him again. . . .

[1] Dilke. Lamb was inclined to think him a " blockhead " without this provocation.—*B.*

" PROSE ELEGIES "
1834-1835

H. F. CARY, AND LAMB'S DEATH
1834
[*Henry Cary*, Memoirs of H. F. Cary, 1847.]

For some time prior to this, Charles Lamb and his sister had dined at my father's table regularly every third Wednesday in each month. Excepting his old friends Mr. Digby and Mr. Bullock, I believe he had no friend living for whom he felt a more sincere affection, than he did for Lamb. That there might be no uncertainty in their times of meeting, my father proposed that he and Miss Lamb should dine at the Museum on a fixed day in each month; at first, Lamb, from feelings of modesty, was for declining the proffered hospitality, but his sister said, "Ah, when we went to Edmonton, I told Charles something would turn up, and so it did you see." And I believe that this "third Wednesday" was regarded by all the party as a red-letter day; as such, at all events, my father used to mark it, long beforehand in his almanack. The last time of their meeting was in September of this year, 1834.

Not many weeks after, Lamb died. He had borrowed of my father Phillip's *Theatrum Poetarum Anglicanorum*, which was returned by Lamb's friend, Mr. Moxon, with the leaf folded down at the account of Sir Philip Sydney.

Mr. Cary acknowledged the receipt of the book by the following

> Lines to the Memory of Charles Lamb.
>
> So should it be, my gentle friend;
> Thy leaf last closed at Sydney's end.
> Thou too, like Sydney, wouldst have given
> The water, thirsting and near heaven;
> Nay were it wine, fill'd to the brim,
> Thou hadst look'd hard, but given like him.

And art thou mingled then among
Those famous sons of ancient song?
And do they gather round, and praise
Thy relish of their nobler lays?
Waxing in mirth to hear thee tell
With what strange mortals thou didst dwell!
At thy quaint sallies more delighted,
Than any's long among them lighted!
'Tis done: and thou hast joined a crew,
To whom thy soul was justly due;
And yet I think, where'er thou be,
They'll scarcely love thee more than we.

At a somewhat later period he, at Mr. Moxon's request, composed an epitaph, to be inscribed on his friend's monument at Edmonton:

Epitaph to Charles Lamb

Farewell, dear friend, that smile, that harmless mirth,
No more shall gladden our domestic hearth;
That rising tear, with pain forbid to flow,
Better than words, nor more assuage our woe;
That hand outstretch'd, from small but well-earned
　　store,
Yield succour to the destitute no more:
Yet art thou not all lost: thro' many an age,
With sterling sense and humour shall thy page
Win many an English bosom pleased to see
That old and happier vein revived in thee.
This for our earth. And if with friends we share
Our joys in heaven, we hope to meet thee there.

TALFOURD REPORTS TO H. C. R.

[*T. N. Talfourd.*]

Temple, 31st December, 1834.

My dear Robinson,

　　I am very sorry that I did not know where you were, that I might have communicated poor Lamb's death to you

before you saw it in the newspaper; but I only judged you were out of town by not having received any answer to a note (written before I was aware of Lamb's illness), asking you to dine with us on Saturday next. I first heard of his illness last Friday night, and on Saturday morning I went to see him. He had only been seriously ill since the preceding Wednesday. The immediate disease was erysipelas[1]; but it was, in truth, a breaking up of the constitution, and he died from mere weakness. When I saw him, the disease had so altered him that it was a very melancholy sight; his mind was then almost gone, and I do not think he was conscious of my presence; but he did not, I believe, suffer any pain, nor was he at all conscious of danger. Ryle saw him the day before, then he was perfectly sensible; talked of common things, and said he was only weak, and should be well in a day or two. He died within two hours after I saw him, . . . I doubt whether Mary Lamb will ever be quite herself again, so as to feel her loss with her natural sensibility. She went with Ryle yesterday to the churchyard, and pointed out a place where her brother had expressed a wish to be buried; and that wish will be fulfilled. The funeral will take place on Saturday, from the house where he died, at one o'clock. It will be attended by Moxon, Ryle, who is executor with me, a gentleman from the India House, who witnessed the will, and was an old companion there, Brock, Allsop, and, I believe, Cary. If you had been in town, we should, of course, have proposed it to you to attend, if you saw fit; but this is no occasion which should bring you to town for the purpose, unless for the gratification of your own feelings, as there will be quite sufficient in point of number, and Miss Lamb is not capable of deriving that comfort from seeing you which I am sure she would do, if she were herself. . . . Pray act exactly as you think best. . . .

· [*Crabb Robinson.*]

January 12*th.* I resolved to-day to discharge a melancholy duty, and went down by the Edmonton stage to call on poor Miss Lamb. It was a melancholy sight, but more so to the -reflection than to the sense. A stranger would have seen

[1] Caused by a fall, which took place on Monday, and which made some slight wounds on the face.

little remarkable about her. She was neither violent nor unhappy; nor was she entirely without sense. She was, however, out of her mind, as the expression is; but she could combine ideas, although imperfectly. On my going into the room where she was sitting with Mr. Waldron, she exclaimed with great vivacity, "Oh! here's Crabby." She gave me her hand with great cordiality, and said, "Now this is very kind—not merely good-natured, but very, very kind to come and see me in my affliction." And then she ran on about the unhappy, insane family of my old friend ——. It would be useless to attempt recollecting all she said; but it is to be remarked that her mind seemed turned to subjects connected with insanity, as well as with her brother's death. She spoke of Charles repeatedly. She is nine years and nine months older than he, and will soon be seventy. She spoke of his birth, and said that he was a weakly, but very pretty child. I have no doubt that if ever she be sensible of her brother's loss, it will overset her again. She will live for ever in the memory of her friends as one of the most amiable and admirable of women.

MISS KELLY HEARS OF LAMB'S DEATH

1835

[*P. G. Patmore*, My Friends and Acquaintance, 1854, *vol. i.*]

There is something inexpressibly shocking in first hearing of a dear friend's death through the medium of a public newspaper, at a time, perhaps, when you believe him to be in perfect health, and are on the point of paying him a too long delayed visit. Such was my case in respect to Charles Lamb. Still more painful was the case of a lady, formerly a distinguished ornament of the English Stage, to whom Lamb was attached by the double tie of admiration and friendship. Several days after Lamb's death, she was conversing of him with a mutual friend, who, taking for granted her knowledge of Lamb's death, abruptly referred to some circumstance connected with the event, which for the first time made her acquainted with it.

JOHN RICKMAN HEARS

1835

[John Rickman to Southey, January 24th, 1835.]

. . . Lamb died just before I left town and Mr. Ryle of the E. India House, one of his extors., whom I know, notified it to me, and promised to call, but he has not yet done so, and I believe his letter gave too favourable a statement of circumstances. He said Miss L. was resigned and composed at the event, but it was from her malady, then in mild type, so that when she saw her brother dead, she observed on his beauty when asleep and apprehended nothing further. In like manner, it was said by Mr. Ryle, that C. L. died of erysipelas, but induced (if induced at all) I now find by some unhappy violence he sustained in a state of reckless intemperance. I always thought such must be his end, and am surprised how it was delayed so long. The better side of the picture is, that he has left £1,200, with which and otherwise, Miss L. will be well sustained.

GEORGE DYER LAMENTS

THE LATE CHARLES LAMB

[George Dyer, in The Christian Reformer, *1835. As for his last statement, he was in a position to know; but Lamb, in his Letter to Robert Southey, Esq., had written: " I am a Dissenter."]*

I

We now announce the decease of an amiable, benevolent and ingenious man, Mr. Charles Lamb, who died at Edmonton, after a few days' illness, on Saturday 27th December last, in the 61st year of his life. . . . [Here follows a rough list of Lamb's publications.]

It is but justice to Mr. Lamb to say, that in the above

works he has in general displayed as much literary taste as he has pathos and wit; his peculiar talent was humour, and his principal delineations are taken from private and domestic life; but he is always pleasing, and his style is rather after the manner of our old English masters, of whom he was a professed admirer (although we do not consider him in the light of an imitator), rather than of those authors termed classical, on whom he was taught to put so high a value at public school; and though he continued to read and admire the latter, he chose to be considered as an English writer of the old school.

The above list will, we think, present a true picture of the late Mr. Charles Lamb; for, what he appears in his writings before the public, he was soon to be in his life and conversation among his friends. He was sociable in his manners, critical, and exact in his taste, of a rich imagination and a most sprightly wit; and as a man humane in his feelings and benevolent in his actions. His jokes, which were always kept within the bounds of decorum, never lost him a friend, nor made him an enemy. To sum up the whole, we consider him to have been a person possessed of the finest qualities, both of head and heart.

Mr. Lamb's amiable disposition eminently fitted him for domestic life, but he never was married: he lived forty years in a most tender friendship with an only sister: they were similar in their pursuits and studies, in their joys and sorrows, their affections and recreations, and may be referred to as the most perfect model of fraternal and sisterly love. Miss Lamb was the authoress of an excellent work, entitled "Mrs. Leicester's School," which was brought out under the superintendence of her brother.

It does not appear from Mr. Lamb's writings that he intermeddled much in the political or theological disputes of the times; but to the estimation in which he held our old dramatic writers and poets, we must add the admiration which he always felt for the political works of Milton, Sydney, and other standard writers of the same class. Nor was he unacquainted with many of our best Puritan authors, whom he respected for their earnestness, variety and seriousness, and above all for their sincerity; and being himself of a quiet, peaceable disposition, he was fervent in the praise

of George Fox and the other founders of the Society of Friends, called Quakers, although he never joined their society, and did not separate himself from the Church of England, to which he was trained at Christ's Hospital.

Clifford's Inn. G. D.

[*Dyer*, Gentleman's Magazine, 1835.]

II

On considering Mr. Lamb as diligently engaged in the pursuits of commercial life, it might surprise us that he could find leisure to write so much for the public; but the truth is, his faculties were extraordinary. The wit that he brought with him from school continued to flow uniformly and to increase through the whole course of his life. It was almost as natural with him to say witty things as to breathe; he could not enter a room without a joke, and he may be said to have almost conversed in extemporaneous humour. Nor did his discourse consist of merely sportive pleasantries; they had often the force of eloquence, joined with the solidity of argument, enlivened and softened by a humanity and benevolence which invariably beamed in his countenance. Perhaps, too, they were a little increased by his very infirmities; for he had a defect in his utterance, which gave a somewhat of quaintness and peculiarity of tone to his conversation. Overflowing as his spirits were, they never exceeded the bounds of propriety and decorum; and towards the fair sex, though he was never married, he never failed to evince the kindest feeling and purest respect.

Mr. Lamb has left behind him no other relation but the sister already mentioned, who is as amiable in disposition as himself, and who possesses a considerable share of literary talent. They were similar in their characters, their manners, and their studies; and there cannot be well conceived a more perfect example of fraternal and sisterly love, and untiring friendship, than that which existed between them, and which Mr. Lamb has elegantly alluded to in one of his poems, and likewise in one of his Papers entitled " Mackery End," wherein he says, " I wish that I could throw into a heap the remainder of our joint existences, that we might share them in equal division,—but that is impossible."

PROCTER'S TRIBUTE

1835

[*B. W. Procter*, Athenæum, *January-February* 1835.]

When I first became acquainted with Mr. Lamb, he lived, I think, in the Temple; but I did not visit him then, and could scarcely, therefore, be said to *know* him, until he took up his residence in Russell-street, Covent-garden. He had a first floor there, over a brazier's shop—since converted into a bookseller's,—wherein he frequently entertained his friends. On certain evenings (Thursdays) one might reckon upon encountering at his rooms from six to a dozen unaffected people, including two or three men of letters. A game at whist and a cold supper, followed by a cheerful glass (glasses!) and " good talk," were the standing dishes upon these occasions. If you came late, you encountered a perfume of the " Great Plant." The pipe, hid in smoke (the violet amongst its leaves),—a squadron of tumblers, fuming with various odours, and a score of quick intelligent glances, saluted you. There you might see Godwin, Hazlitt, Leigh Hunt, Coleridge (though rarely), Mr. Robinson, Serjeant Talfourd, Mr. Ayrton, Mr. Alsager, Mr. Manning,—sometimes Miss Kelly, or Liston,—Admiral Burney, Charles Lloyd, Mr. Alsop, and various others; and if Wordsworth was in town, you might stumble upon him also. Our friend's brother, John Lamb, was occasionally there; and his sister (his excellent sister) invariably presided.

The room in which he lived was plainly and almost carelessly furnished. Let us enter it for a moment. Its ornaments, you see, are principally several long shelves of ancient books; (those are his " ragged veterans "). Some of Hogarth's prints, two after Leonardo da Vinci and Titian, and a portrait of Pope, enrich the walls. At the table sits an elderly lady (in spectacles) reading; whilst from an old-fashioned chair by the fire springs up a little spare man in black, with a countenance pregnant with expression, deep lines in his forehead, quick luminous restless eyes, and a smile as sweet as ever threw sunshine upon the human face.

You see that you are welcome. He speaks: " Well, boys, how are you ? What's the news with you ? What will you take ? " You are comfortable in a moment. Reader! it is Charles Lamb who is before you—the critic, the essayist, the poet, the wit, the large-minded *human* being, whose apprehension could grasp, without effort, the loftiest subject and descend in gentleness upon the humblest; who sympathised with all classes and conditions of men, as readily with the sufferings of the tattered beggar and the poor chimney-sweeper's boy as with the starry contemplations of Hamlet " the Dane," or the eagle-flighted madness of Lear.

The books that I have adverted to, as filling his shelves, were mainly English books—the poets, dramatists, divines, essayists, &c.,—ranging from the commencement of the Elizabethan period down to the times of Addison and Steele. Besides these, of the earliest writers, Chaucer was there; and, amongst the moderns, Wordsworth, Coleridge, and a few others, whom he loved.

He had more real knowledge of old English literature than any man whom I ever knew. He was not an antiquarian. He neither hunted after commas, nor scribbled notes which confounded his text. The *Spirit* of the author descended upon him; and he felt it! With Burton and Fuller, Jeremy Taylor and Sir Thomas Browne he was an intimate. The ancient poets—chiefly the dramatic poets—were his especial friends. He knew every point and turn of their wit, all the beauty of their characters; loving each for some one distinguishing particular and despising none. For absolute contempt is a quality of youth and ignorance—a foppery which a wise man rejects, and *he* rejected it accordingly. If he contemned anything, it was contempt itself. He saw that every one bore some sign or mark (God's Gift) for which he ought to be valued by his fellows, and esteemed a man. He could pick out a merit from each author in this turn. He liked Heywood for his simplicity and pathos; Webster for his deep insight into the heart; Ben Jonson for his humour; Marlowe for his " mighty line "; Fletcher for his wit and flowing sweetness; and Shakspeare for his combination of wonders. He loved Donne too, and Quarles, and Marvell, and Sir Philip Sidney, and a long list besides.

No one will love the old English writers again as *he* did. Others may have a leaning towards them—a respect—an admiration—a sort of *young* man's love: but the true relishing is over; the close familiar friendship is dissolved. He who went back into dim antiquity and sought them out, and proclaimed their worth to the world—abandoning the gaudy rhetoric of popular authors for their sake, is now translated into the shadowy regions of the friends he worshipped. He who was once separated from them by a hundred lustres, hath surmounted that great interval of time and space, and is now in a manner, Their Contemporary!

* * * * *

The wit of Mr. Lamb was known to most persons conversant with existing literature. It was said that his friends bestowed more than due praise upon it. It is clear that his enemies did it injustice. Such as it was, it was at all events *his own*. He did not "get up" his conversations, nor explore the hoards of other wits, nor rake up the ashes of former fires. Right or wrong, he set to work unassisted; and by dint of his own strong capacity and fine apprehension, he struck out as many substantially new ideas, as any man of his time. The quality of his humour was essentially different from that of other men. It was not simply a tissue of jests or conceits, broad, far-fetched, or elaborate; but it was a combination of humour with pathos—a sweet stream of thought, bubbling and sparkling with witty fancies; such as I do not remember to have elsewhere met with, except in Shakespeare. There is occasionally a mingling of the serious and the comic in 'Don Juan,' and in other writers; but they differ, after all, materially from Lamb in humour:—whether they are better or worse is unimportant. His delicate and irritable genius, influenced by his early studies, and fettered by old associations, moved within a limited circle. Yet, this was not without its advantages; for, whilst it stopped him from many bold (and many idle) speculations and theories, it gave to his writings their peculiar charm, their individuality, their sincerity, their pure gentle original

character. Wit, which is "impersonal," and, for that very reason perhaps, is nine times out of ten a mere heartless matter, in him assumed a new shape and texture. It was no longer simply malicious, but was coloured by a hundred gentle feelings. It bore the rose as well as the thorn. His heart warmed the jests and conceits with which his brain was busy, and turned them into flowers.

Every one who knew Mr. Lamb, knew that his humour was not affected. It was a style,—a habit; generated by reading and loving the ancient writers, but adopted in perfect sincerity, and used towards all persons and upon all occasions. He was the same in 1810 as in 1834—when he died. A man cannot go on " affecting " for five and twenty years. He must be sometimes sincere. Now, Lamb was always the same. I never knew a man upon whom Time wrought so little.

BARRON FIELD'S TRIBUTE

CHARLES LAMB, ESQ.

1835

[Barron Field, Annual Biography for 1835.]

Everybody quotes this touching phrase, " the old familiar faces "; but very few know that they are indebted for it, among a hundred other humanities, to the most human of all writers, Charles Lamb—human in his virtues, human in his errors. Not only did he think (to use the language of Terence) nothing human alien from him, but he considered nothing interesting to him but what was human. He avowed a want of conception of anything transcendental. When his friend Coleridge was speculating, in a dream worthy of Plato, upon a future state of existence, upon man as he is, and man as he is to be, it was Lamb that said, "Give me man as he is *not* to be." How soon has he followed his school-fellow to the tomb! " Duplex nobis vinculum," said the motto to their united volume of poems, " et amicitiae et similium junctarumque camoenarum—quod utinam

neque mors solvat, neque temporis longinquitas." The wish
has been fulfilled.

. . . He was a great walker to the last, and could always
soon transport himself to town; but while he lived in London
there were few persons who enjoyed an excursion into the
country more. . . . His table and purse were only too open.
He found something to speak well of in all his friends, and
in all his friends' writings. He himself never refused to write
for anybody, not even for the albums of strangers. Task-
work disgusted him not. He even preferred the shackles of
an acrostic: those of rhyme (call them rather direction-posts
to wit and fancy) were not enough for him. Forced initial
letters suited his old-fashioned verse, with the lines flowing
into each other. . . . He was throughout life the friend of
Holcroft, Godwin, Coleridge, Lloyd, Wordsworth, Southey,
Rogers, Hazlitt, L. Hunt, Bernard Barton, Landor, Kenney,
Hood, Basil Montagu, H. C. Robinson, J. P. Collier, Allan
Cunningham, Barry Cornwall, Dyer, Cary, &c.; and
though some of these, as Mr. Arnold's butler in " The
Vicar of Wakefield " says, hated each other, he loved them
all. He never talked politics or polemics. The fancy, the
imagination, cards, wine and tobacco; Ben Jonson and
Wycherley, Hogarth and Richardson were common topics
enough for him. . . .

We consider Mr. Lamb's tact in all questions of poetry to
have been infallible. In his estimation of prints and pictures,
as well as of actors and actresses, we think that, like all near-
sighted people, he had " visions of his own," and would not
" undo them." Of music he was a still worse judge, not
because " he had no ear,"—but very few things in music
touched him: when they did, they were always beautiful
passages, and he could even hum them over; which shows
that it was not strictly true that he had no ear. Two of the
melodies which were often running in his head, were Kent's
" Oh, that I had wings like a dove," and Handel's " From
mighty kings." Mr. Wordsworth and Mr. Coleridge always
acknowledged in him an absolute judge of poetry; he loved
it for its music as well as for its sense. He could read nonsense
verses: he thought Pope's " Song by a Person of Quality "
delicious, and would read Skelton aloud by the hour,
merely for the rhymes; and yet he could relish the crabbed-

ness of Donne; nor did he tire through the weary measure of
Chapman's *Iliad*. He read few modern poets, except the
works of his friends Wordsworth and Coleridge; and although
he fed upon the old dramatists and novelists, new stories
tormented him. He did not like modern print and paper,
and manuscript still less. He was no reviewer.[1] He once
wrote an excellent critique on *The Excursion* for the *Quarterly;*
but the editor (Mr. Gifford) pared it down to nothing.

What he admired, that he imitated, or rather, he did as
good or better. His few poems and one short tragedy, have
all the terseness and simplicity of Beaumont and Fletcher,
or of Andrew Marvell or George Wither. *Rosamund Gray*
seems to have been written after reading Mackenzie's novels,
and, accordingly it is finer than any of them. *Mr. H—* is the
best dramatic jeu d'esprit in the language; it must have
delighted the green-room at the first reading, but to act it
was a mistake; of course it was damned; it wants plot and
incident, and its jokes are all intellectual; it would make an
excellent play to read to an educated audience, like the
comedies and farces of Molière, which were better read by
Le Texier, than acted even by Perlet or Maro. Lamb's
effusions are short and fragmentary. All his works, both
verse and prose, could easily have been dilated into five
times their quantity; he was therefore a poor gainer, as a
periodical writer, by the sheet. We never knew a man so
sensible of the magnanimity of suppression in writing. By a
happy word he suggested a whole triad of balanced periods,
or rather, he disdained to debase his style into such a
calculating machine. We remember, at the very last supper
we ate with him (Mr. Serjeant Talfourd will recollect it too),
he quoted a passage from Prior's " Henry and Emma," in
illustration of this doctrine and discipline; and yet he said
he loved Prior as much as any man, but that his " Henry
and Emma " was a vapid paraphrase of the old poem of
" The Nutbrowne Mayde." For example, at the dénoue-
ment of the ballad, Prior makes Henry rant out to his
devoted Emma,—

" In me behold the patent Edgar's heir,"

[1] *i.e.*, did not write for the great reviews of that day, the *Quarterly*, etc.—*B.*

P

and so on for a dozen couplets, heroic, as they are called.
And then Mr. Lamb made us mark the modest simplicity
with which the noble youth disclosed himself to his mistress
in the old poem . . . How he loved these old rhymers, and
with what justice!

We have before said that the genius of our dear friend (for
we cannot conceal our connection with him) was emphati-
cally human. The stories and characters of all his plays,
poems, and essays turn upon some weakness of humanity,
with which he had a lively sympathy, and towards which he
extended a large charity. " When a child (he says in one of
his Essays), with child-like apprehensions, . . . I read the
Parables, . . . I felt a kindliness, that almost amounted to
a *tendre*, for those five thoughtless virgins."

We have done. May such a writer as this meet, towards
all his own frailties, with the same mercy which he showed
to others, from Him who has taught us to pray that we may
be forgiven as we forgive!

BERNARD BARTON'S REFLECTIONS

(Woodbridge, 1835)

[*Letter to J. Keymer, January 4th*, 1835, *published in* Notes and
Queries, *October 18th*, 1879.]

Dear Keymer,[1]—Thy account of poor Lamb's death,
though it did not take me by surprise, for I saw it in the
Times the day before, could not but deeply interest and
painfully affect me. I had given him up as a correspondent,
after, I think, three unanswer'd letters, from a feeling that
the reluctance he had often expressed to letter writing was
so increased by indulgence, any further efforts to force him
into Epistolizing would only give him pain, without being
very likely to obtain any rejoinder, or were such extorted,
it would be compulsory, instead of *con amore*, so I had given
up all hope of hearing from him. Then came thy message
through Miss C., which induced me to make one more trial.
Yet I am glad I did make it, for although the notion may be

[1] J. Keymer, stationer, 142 Cheapside—an admirer of Lamb of whom we
should know more.—*B.*

an altogether erroneous one, I cheat myself with the thought
I might perhaps be his last correspondent, if indeed he ever
chanced to open my letter, which perhaps he might. If thou
can'st give me any further account of his few last days, pray
do! for I should like to hear all I can of him. Was he at all
aware, ere his close, that it was drawing nigh ? I should
like to know how such a man would meet death. With all his
wit and humour, unrivalled as it was, he was too good, I
would hope too rich in right feeling, to die jesting as Hume
did. Often as his sportive sallies seemed to border on what
appeared irreverent, and to some rigid people the verge of
profanity, I am disposed to acquit him of all *intentional*
offence of that kind. He was not heartless, however his
playful imagination might betray him into frequent impro-
prieties of expression. His vast and desultory reading, his
constitutional temperament, his habits of life, his eccen-
tricities of manner, all combined to render him the very
sort of character likely to be completely misunderstood by
superficial observers. A cold philosophical sceptic might
have set him down as a crack-brained enthusiast, while with
a high-flown formal professor of Orthodoxy he would have
passed for an Infidel and a Scorner. I believe him to have
been as remote from the one as from the other. But to
portray such a character were a hopeless effort; Hazlitt in
one of his better moods could perhaps have done it as well
as any one; or Leigh Hunt, if he could lay aside his jennery-
jessamy prettinesses of style and mannerism. Perhaps
Lamb's own account of himself, as given in the prefatory
paper to the *Last Essays of Elia,* is the best sketch of him we
ever shall have. I should like a copy of his tribute to
Coleridge, and pray tell me anything in thy power about
him—his close, and poor Mary, for I feel not a little inter-
ested in knowing what is to be done with and for her. At
some time or other I hope to string my own thoughts of
Lamb in verse, but I have no ability even to think of attempt-
ing it now. I can now only think and feel that I have lost
him.

We are all in the turmoil and squabble of electioneering
politics, things I never was very fond of, and now I hate
with a perfect hatred. Do write again ere long. I will
gladly pay postage to hear ought more about Lamb.

MOXON'S RECOLLECTIONS
1835

Edward Moxon, privately printed Memoir; reprinted (1835) *in*
Leigh Hunt's London Journal *and* Chambers's Edinburgh
Journal.]

Within a few months of each other we have lost two
remarkable men—Samuel Taylor Coleridge and Charles
Lamb. They were schoolfellows, read together, first pub-
lished together, and were undivided even in Death! When
we last saw the latter—sad recollection!—he said he was ever
thinking of his friend. He is now with him and for ever!
It is of Charles Lamb only that we wish to speak. No man
was ever more sincerely regretted, or will be longer remem-
bered by his friends. Happily we see the brighter after our
sorrows; and the object of our grief, in a short time, becomes
a star that we can gaze at with pleasure. Fair, fair shall be
the flowers that spring over thy tomb, dear, gentle Elia!
sweet shall be the song—sweet as thine own—that shall lure
the wanderer to the spot where thy urn receives the tears of
the stranger. Thither my feet shall repair in spring time and
in harvest; thither will I lead thy votaries, and there shall
they drink of the lucid waters that well from the memory of
thy gentle life, thou kindliest of human creatures!

Perchance, Reader, it was not thy good fortune to know
our inimitable friend. Thou hast not been with him in his
walks; and to walk with him was to converse with the
immortal dead,—with Chaucer and with Sidney,—with
Spenser and with Shakspeare,—with Burton and with Sir
Thomas Browne,—with Fuller and with Jeremy Taylor, and
with Milton, and those elder dramatists, who were to him a
first love, and, as such, cherished through life. Thou hast
not been his guest; nor sat among his books—goodly folios
in quaint bindings—in rooms scantily furnished, but rich in
the gifts of genius, walls hung around with Raphaels and
Da Vincis, with Poussins and Titians, and the works of the
incomparable Hogarth! Thou wert not a visitor in the
temple, nor an evening listener to choice—hardly choice
where all were good—passages from Milton, over the finest
of which the worshipping spirit of the reader always wept;

but his tears were those of admiration, drops that blotted out, as it were, ages of neglect! On his old favourites his eyes rested even in death! Sacred to the owner will be the volume he last bent over, with its page folded down—so ever let it remain—on thy life, all-accomplished Sidney! From thyself, if aught earthly in heaven be permitted, perchance he may learn thy story, and there walk side by side with those whom in idea he lived while on earth. Nor hast thou seen him a solitary, wandering among the cloisters of Christ's Hospital—nor in the Quadrangles at Oxford, nor at Twickenham, where he often spent his holidays—red-letter days as he called them—nor at Hampton Court, which he preferred—so truly English was his mind—to Versailles; nor in the India House, where he was loved for his goodness of heart, and for his jokes and his puns—he was a punster, and a good one;—nor in his ramblings in the neighbourhood of Cheshunt, and Southgate, and Ware, and Tottenham High Cross, and on the banks of the Lea, thinking of Walton and his plain-mindedness! nor latterly at Waltham, nor at Winchmore, nor in the green lanes about Enfield, where, on a summer's evening, he would walk with his amiable sister, his almost inseparable companion of forty years.

As, Reader, thou hast not seen the living Elia—would that thou hadst, for thou wouldst ever have remembered his sweet smile, and the gentleness of his heart—turn to his books, there thou mayst imagine him, kindlier than he was thou canst not; and he will yet guide thee to old haunts and to familiar faces, which thou wilt hereafter think of with delight. He will conduct thee to the Old South-sea House— once his own—and to Oxford, where thou wilt meet with George Dyer (George is worthy thy knowing), or he will sit with thee the old year out, and quote the old poets, and that beautiful line in his friend's ode—

"I saw the skirts of the departing year";

or he will introduce thee to Mrs. Battle, who, next to her devotions, loved a game at whist; or he will pleasantly shake his cap and bells with thee on the first of April; or accompany thee to a Quaker's meeting; or describe to thee the Old and the New Schoolmaster; or tell a delightful story—

no fiction—of Valentine's Eve, or take thee with him,
Bridget Elia by his side—thou wilt love Bridget—on a visit
to his relations,

"Through the green plains of pleasant Hertfordshire";

or he will discourse to thee on modern gallantry, or point
out to thee the old Benchers of the Inner Temple; or de-
scribe to thee his first visit to Old Drury, and introduce thee
to his old favourites—now forgotten; or thou shalt hear him
—for he loved those whom none loved—speak in the purest
strain of humanity in praise of chimney-sweepers, "innocent
blacknesses," as he calls them, and of beggars, and lament
the decay of the latter; or he will rouse thy fancy, and
make thy mouth water with his savoury dissertation on roast
pig (many were the porklings that graced his table, kind
presents from admiring and unknown correspondents); or
take thee with him in the old Margate Hoy to the sea-side,
or introduce thee to his friend Captain Jackson; or dis-
course to thee of himself—the convalescent and the super-
annuated man; or on old china, or on old books—on the
latter with what relish! or of Barbara S. (Miss Kelly), or of
Alice (his first love), or of Bridget Elia (his sister), or tell
thee the sweet story of Rosamund Gray. Let these, reader,
if thou art a lover of thy kind and of the beautiful, have a
by-place in thy mind; they will not only please thy imagina-
tion, but enlarge thy heart, its sphere of action, and its
humane capabilities. They will lead thee to new sources of
delight—springs fresh as the waters of Horeb; and thou wilt
become acquainted with men famous in their generation.
Occasionally, if thou art a reader of modern books only,
thou mayest imagine him quaint, but thou wilt find him free
from conceits, and always natural. Others may have affected
the language of an older age, but with him it was no
adoption.

He always spoke as he wrote, and did both as he felt; and
his Letters—they were unpremeditated—are in the style of
his other writings; they are in many respects equal, in some
superior, to his *Essays*; for the bloom, the freshness of the
author's mind, is still upon them. In his humour there is
much to touch the heart and to reflect upon; it is of a serious

cast, somewhat like that of Cervantes. In the jokes which
he would throw out, the offspring of the moment, there was
often more philosophy than in the premeditated sayings of
other men. He was an admirable critic, and was always
willing to exercise the art he so much excelled in for the
fame of others. We have seen him almost blind with poring
over the endless and illegible manuscripts that were sub-
mitted to him. On these occasions, how he would long to
find out something good, something that he could speak
kindly of; for to give another pain (as he writes in a letter
now before us) was to give himself greater! He lived in the
past, yet no man ever had a larger share of sympathy for
those around him. He loved his friends, and showed it
substantially by numberless tokens, and was as sincerely
loved in return. He had, like other men, his failings; but
they were such, that he was loved rather for them, than in
spite of them. Enemies he had none. For upwards of forty
years he devoted his life to the happiness of his sister, for
whom he had a most affectionate regard, and for whose
comfort he would gladly have laid down his life; and she,
not less devoted, for him would have sacrificed her own.
He preferred—we use his own words—even her occasional
wanderings to the sense and sanity of the world.

Their minds were congenial, so were their lives, and they
beautifully walked together—theirs was a blended existence
—to the hour of his dissolution. His charities, for his humble
means, surpassed those of most men. He had for some years
upon his bounty three pensioners! Generous and noble
must have been the heart of him that, out of his slender
income, could allow his old schoolmistress thirty pounds per
annum! What self-denial! What folios this sum would have
purchased for him! Well we remember the veneration with
which we used to look upon the old lady—for she remem-
bered Goldsmith! He had once lent her his poems to read.
We often lament that he did not give them to her; but the
author of the *Vicar of Wakefield* was poor. Kind surely must
have been the disposition of him who sought out the nurse
that attended the last moments of Coleridge (whom living
he adored and dead thus honoured), that on her head he
might pour out the overflowings of the irresistible goodness
of his nature. He gave her five pounds, but this we did not

learn from himself! These were but trifles; yet of such was
the life of this the most amiable of men made up.

His tastes, in many respects, were most singular. He
preferred Wardour Street and Seven Dials to fields that were
Elysian. The disappearance of the old clock from St.
Dunstan's Church drew tears from him; nor could he ever
pass without emotion the place where Exeter Change once
stood. The removal had spoiled a reality in Gay. The
passer-by, he said, no longer saw " the combs dangle in his
face." This almost broke his heart. He had no taste for
flowers or green fields; he preferred the high road. The
Garden of Eden, he used to say, must have been a dull place.
He had a strong aversion to roast beef and to fowls, and to
any wines but port or sherry. Tripe and cow-heel were to
him delicacies—rare dainties!

All his books were without portraits; nor did he ever
preserve, with two exceptions, a single letter. He had a
humorous method of testing the friendship of his visitors;
it was, whether in their walks they would taste the tap of
mine host at the Horse-Shoe, or at the Rose and Crown, or
at the Rising Sun! But a member of the Temperance
Society, on these occasions, could not have been more
abstemious. A single glass would suffice. We have seen
ladies enter with him—the fastidious Barbara S.; and great
poets—the author of the *Excursion* himself! He was no
politician, though, in his youth, he once assisted to draw
through the streets Charles James Fox! Nor was he a man of
business. He could not pack up a trunk, nor tie up a parcel.
Yet he was methodical, punctual in his appointments, and
an excellent paymaster. A debt haunted him! He could not
live in another person's books! He wished to leave a friend
a small sum of money; but " to have done with the thing,"
as he said, gave it him before-hand! If an acquaintance
dropped in of an evening before supper, he would instantly,
without saying a word, put on his hat, and go and order an
extra supply of porter. He has done this for us a hundred
times! Relics and keepsakes had no charm for him! A
traveller once brought him some acorns from an ilex that
grew over the tomb of Virgil. He threw them at the hackney-
coachmen as they passed by his window! And there is a
story, that he once sat to an artist of his acquaintance for a

whole series of the British Admirals; but for what publication we never heard!

But we are wandering from our object, which was simply to record, that, of all the men we ever knew, Charles Lamb was, in every respect, the most original, and had the kindest heart.

<div align="right">E. M.</div>

January 27th, 1835.

FORSTER'S ESTIMATE

1835

[*John Forster; his two articles in the* New Monthly Magazine *were combined as an introduction to the Galignani volume of Lamb's prose, Paris,* 1835.]

Charles Lamb was born in the Temple, in February 1775. " 'Tis my poor birth-day," says a letter of his we have lying before us, dated the 11th of February. The day will be rich hereafter to the lovers of wit and true genius. The place of his birth had greatly to do with his personal tastes in after life. Everyone who has read *John Woodvil* cannot fail to have been struck (as in that loveliest of passages on the " sports of the forest ") with its exquisite sense of rural beauty and imagery. But Mr. Lamb's affection nevertheless turned townwards. Born under the shadow of St. Dunstan's steeple, he retained his love for it, and for the neighbouring town-streets, to the last; and to the last he loved the very smoke of London, because, as he said, it had been the medium most familiar to his vision. Anything, in truth, once felt, he never wished to change. When he made any alteration in his lodgings, the thing sadly discomposed him. His household gods, as he would say, planted a terrible fixed foot.

This early habit, however, and this hatred of change, were not the only sources of his attachment to London, and to London streets. A sort of melancholy was often the source of Mr. Lamb's humour—a melancholy which, indeed,

almost insensibly dashed his merriest writings—which used
to throw out into still more delicate relief the subtleties of his
wit and fancy, and which made his very jests to " scald like
tears." In London there was some remedy for this, when it
threatened to over-master him. " Often," he said, " when
I have felt a weariness or distaste at home, have I rushed
into her crowded Strand, and fed my humour, till tears have
wetted my cheek for unutterable sympathies with the
multitudinous moving picture, which she never fails to
present at all hours, like the scenes of a shifting pantomime."
This is a great and wise example for such as may be similarly
afflicted.

Mr. Lamb's earliest associates in London were Words-
worth, Coleridge, Southey, Charles Lloyd, and others, who
" called Admiral Burney friend." They used to assemble
weekly at Burney's house, at the Queen's Gate, to chat and
play whist; or they would meet to discuss supper, and the
hopes of the world, at the old Salutation Tavern. This was
the " —— Inn," to which Mr. Lamb makes so affectionate
a reference in the dedication of his poems to Coleridge; this
was the immortal tavern, and these were the " old suppers
in delightful years," where he used to say Coleridge first
kindled in him, if not the power, yet the love of poetry, and
beauty, and kindliness;—quoting, with true enthusiasm,

> " What words have I heard
> Spoke at the Mermaid! "

Life was then, indeed, fresh to them all, and topics exhaust-
less; but yet there was one preferred before all the others,
because it included all. Mr. Lamb once reminded Southey
of it in a letter which was written in answer to a reproach the
Poet Laureate should have spared his old friend. He speaks
of Coleridge,—" the same to me still as in those old evenings,
when we used to sit and speculate (do you remember them,
Sir ?) at our old tavern, upon Pantisocracy and golden days
to come on earth."

Mr. Lamb was at this period, indeed from the time he
quitted Christ's Hospital to within nine years of his death, a
clerk in the India House. It is scarcely pleasant to think of
his constant labours there, when we think of the legacy of

nobler writing of which they may have robbed the world.
What have we to do now with all his

> " drops of labour spilt
> On those huge and figured pages
> Which will sleep unclasp'd for ages,
> Little knowing who did wield
> The quill that traversed their white field ? "

But we have the better reason, perhaps, to be grateful for
what has nevertheless been bequeathed to us. . . .

The genius of Mr. Lamb as developed in these various
writings, takes rank with the most original of the age. As a
critic, he stands *facile princeps*, in all the subjects he handled.
Search English literature through, from its first beginnings
till now, and you will find none like him. There is not a
criticism he ever wrote that does not directly tell you a
number of things that you had no previous notion of. In
criticism he was indeed, in all senses of the word, " a
discoverer—like Vasco Nunez or Magellan." In that very
domain of literature with which you fancied yourself most
variously and closely acquainted, he would show you " fresh
fields and pastures new," and these the most fruitful and
delightful. For the riches he discovered were richer that
they had lain so deep—the more valuable were they, when
found, that they had eluded the search of ordinary men.

.

But it was not as a Critic, it was not as an Essayist, it was
not as a Poet, fervently as we entertained for him in these
characters the admiration we have poorly endeavoured to
express—it is not in any of these that we felt towards him the
strongest feeling of devotion—we loved The Man. He was
the most entirely delightful person we have ever known.
He had no affectation, no assumption, no fuss, no cant,
nothing to make him otherwise than delightful. His very
foibles, as is remarked in a recent publication, were for the
most part so small, and were engrafted so curiously upon a
strong original mind, that we would scarcely have desired
them away. They were a sort of fret-work, which let in

light, and showed the form and order of his character. They had their origin in weakness of system chiefly; and that which we have heard by the unthinking condemned as wilful, in terms of severe reproach, was in the first instance nothing but a forced resort to aid that might serve to raise his spirits in society to what was no more than the ordinary pitch of all around him without it. Never should the natural temperament against which Mr. Lamb had to struggle be forgotten by those who are left to speak of his habits and character. Of all the great and peculiar sorrows he was fated to experience through life (and there were many to which even an allusion may not here be made, and for which nearly his whole existence was offered as a willing and devoted sacrifice), the sorrows with which he was born were the greatest of all. His friends, whom he delighted by his wit, and enriched by his more serious talk, never knew the whole price he paid for those hours of social conversation. . . .

No one in a conversation said such startling things as Lamb. No one was so witty or so sensible. No man ever had him at a disadvantage, except the man who did not understand him. He had a severe impediment in his speech, but this gave even an additional piquancy to the deep and eloquent things he said. After the stammering and hesitation, a half sentence would burst forth at the close, and set everybody laughing or thinking. And they would laugh about it, and think about it the next day, and the day after that. "Lamb probes a truth," said Hazlitt, "in a play upon words." "He was of the genuine line of Yorick," says the delightful writer of the *London Journal*. He was indeed;—or still more of the family of that ever-faithful and devoted "fool" in "Lear," with his sayings of wisdom and snatches of old songs—"Young Lubin was a shepherd boy." Who that was admitted to the intimacy of his acquaintance does not remember that and many others, and feel his heart sink with grief at our recent loss, though to rise again with pride in the consciousness of having been once admitted to such a friendship? We needed not to have made the restriction. Every one who knew him knew him intimately. He had no concealment, for he had nothing to conceal. He had the faculty,—as was remarked of him in *The Times* newspaper,

by an old friend of his,—of turning " even casual acquaint-
ances into friends." When you entered his little book-clad
room, he welcomed you with an affectionate greeting, set
you down to something, and made you at home at once.
His richest feasts, however, were those he served up from his
ragged-looking books, his ungainly and dirty folios, his
cobbled-up quartos, his squadrons of mean and squalid-
looking duodecimos. " So much the rather their celestial
light shone inward." How he would stutter forth their
praises! What fine things had he to say about the beautiful
obliquities of the *Religio Medici*, about Burton, and Fuller,
and Smollett, and Fielding, and Richardson, and Marvell,
and Drayton, and fifty others, ending with the thrice noble,
chaste, and virtuous, but again somewhat fantastical and
original-brained Margaret, Duchess of Newcastle! What
delightful reminiscences he had of the actors, how he used
to talk of them, and how he has written them down! How
he would startle his friends by intruding on them lists of
persons one would wish to have seen,—such odd alliances as
Pontius Pilate and Doctor Faustus, Guy Faux and Judas
Iscariot!—But the evenings passed with him are not for the
hasty mention of such articles as this.

Mr. Lamb's personal appearance was remarkable. It
quite realized the expectations of those who think that an
author and a wit should have a distinct air, a separate
costume, a particular cloth, something positive and singular
about him. Such unquestionably had Mr. Lamb. Once he
rejoiced in snuff-colour, but latterly his costume was
inveterately black—with gaiters which seemed longing for
something more substantial to close in. His legs were
remarkably slight,—so indeed was his whole body, which was
of short stature, but surmounted by a head of amazing fine-
ness. We never saw any other that approached it in its
intellectual cast and formation. Such only may be seen
occasionally in the finer portraits of Titian. His face was
deeply marked and full of noble lines—traces of sensibility,
imagination, suffering, and much thought. His wit was in
his eye, luminous, quick, and restless. The smile that played
about his mouth was ever cordial and good-humoured; and
the most cordial and delightful of its smiles were those with
which he accompanied his affectionate talk with his sister,

or his jokes against her. We have purposely refrained from
speaking of that noble-minded and noble-hearted woman,
because in describing her brother we describe her. Her
heart and her intellect have been through life the counter-
part of his own. The two have lived as one, in double
singleness together. She has been, indeed, the supplement
and completion of his existence. His obligations to her had
extended beyond the period of his memory, and they accom-
panied him to his grave. Yet he returned them not un-
fittingly! The " mighty debt of love he owed " was paid to
her in full. When he says otherwise in his charming sonnets
to her, he merely expresses the ever-unsatisfied longings of
true affection. Coleridge and she had the first and strongest
holds upon his heart. The little volume to which we referred
in the commencement illustrates this in an affecting manner.
In the pride of that first entrance into the world under the
protection of his greater friend, he had not forgotten his
sister. He dedicated all he had written to her. " The few
following poems," he says, " creatures of the fancy and the
feeling, in life's more vacant hours; produced for the most
part by love in idleness; are, with all a brother's fondness,
inscribed to Mary Ann Lamb, the author's best friend and
sister! " When, in after life, he had the power of acquitting
his debt to her more nobly, by dedicating his whole existence
to hers, he presented the offering of his poetry to Coleridge.
Well might he express that strange and most touching wish,
after the life they had led—" I wish that I could throw into
a heap the remainder of our joint existences, that we might
share them in equal division. But that is impossible! " It
was indeed, and the survivor is not the most fortunate.
Never more shall we see the picture they used to present—
worth a hundred common-places of common existence—
when they paid the occasional visits they both loved to
London!—never more see the affectionate and earnest
watchings on her side—the pleasant evasions, the charming
deference, and the little touches of gratitude on his! We
recollect being once sent by her to seek " Charles," who had
rambled away from her. We found him in the Temple,
looking up, near Crown-office-row, at the house where he
was born. Such was his ever-touching habit of seeking
alliance with the scenes of old times. They were the dearer

to him that distance had withdrawn them. He wished to
pass his life among things gone by yet not forgotten. We
shall never forget the affectionate " Yes, boy," with which he
returned our repeating his own striking lines,—

> " Ghost-like I paced round the haunts of my childhood,
> Earth seemed a desart I was bound to traverse! "

This paper, long as it has already proved, must not be
finished without the mention of one most honourable
characteristic in which Mr. Lamb has stood alone, amidst
all the political strife and personal bickerings of modern
literature. He put himself in personal opposition to no one.
He would recognize no difference of opinion as a plea
against social meeting and friendly fellowship. " It is an
error," he said, in a spirit of deep philosophy, " more
particularly incident to persons of the correctest principles
and habits, to seclude themselves from the rest of mankind,
as from another species, and form into knots and clubs. The
best people, herding thus exclusively, are in danger of
contracting a narrowness. Heat and cold, dryness and
moisture, in the natural world, do not fly asunder, to split
the globe into sectarian parts and separations; but mingling,
as they best may, correct the malignity of any single pre-
dominance. The analogy holds, I suppose, in the moral
world. If all the good people were to ship themselves on to
terra incognitas, what, in humanity's name, is to become of
the refuse? " Charles Lamb wrote in periodicals of all
opinions, and held all differing friends firmly and cordially
by the hand, as if indeed of one family of brothers. His
friendship with Southey did not shake his intimacy with the
editor of the *Examiner*, or move him one jot from the side of
Hazlitt. Lamb first met that great writer at Mr. Godwin's
house, when one of those meaning jests he used to blurt out
so often bound at once the far-sighted metaphysician to his
side. Holcroft and Coleridge happened to be there, and were
as usual engaged in a fierce dispute. The question between
them was as to which was best, " man as he was, or man as
he is to be," and it was at its highest when Lamb stammered
out, " Give me man as he is not to be! " The friendship,
however, which this saying commenced, was once inter-

rupted for some time by some wilful fancy on the part of
the irritable and world-soured philosopher. At this time
Southey happened to pay a compliment to Lamb at the
expense of some of his companions, Hazlitt among them.
The faithful and unswerving heart of the other, forsaking
not, although forsaken, refused a compliment at such a price,
and sent it back to the giver. The character of William
Hazlitt, which he wrote at the same time, may stand for
ever as one of the proudest and truest evidences of the writer's
heart and intellect. It brought back, at once, the repentant
offender to the arms of his friend, and nothing again
separated them till Death came. Charles Lamb was, we
believe, the only one of his old associates seen at the grave of
Hazlitt.

His first appearance in literature was by the side of Samuel
Taylor Coleridge. He came into his first battle, as he tells
us (literature is a sort of warfare), under cover of that greater
Ajax. The small duodecimo volume in which their poems
first appeared, and which is now exceedingly scarce, lies
before us. It was printed and published in Bristol, in the
year 1797, by "N. Biggs for T. Cottle." In the preface,
Coleridge speaks with affectionate warmth of his "friend
and old schoolfellow, Charles Lamb." "He has now com-
municated to me a complete collection of all his poems,—
quae qui non prorsus amet, illum omnes et virtutes et
veneres odere." On the title-page there are words of more
touching interest—" Duplex nobis vinculum, et amicitiae et
similium junctarumque Camœnarum; *quod utinam neque
mors solvat, neque temporis longinquitas!*" The wish has been
strikingly fulfilled. Their friendship in life survived all the
accidents of place and time; and in death it has been but a
few short months divided.

We should like to see this remarkable friendship (remark-
able in all respects and in all its circumstances) between two
of the finest and most original geniuses in an age of no com-
mon genius, worthily and lastingly recorded. It would
outvalue, in the mind of posterity, whole centuries of literary
quarrels.

Lamb never fairly recovered from the death of Coleridge.
He thought of little else (his sister was but another portion of
himself) until his own great spirit joined his friend. He had a

habit of venting his melancholy in a sort of mirth. He would, with nothing graver than a pun, " cleanse his bosom of the perilous stuff that weighed " upon it. In a jest, or a few light phrases, he would lay open the last recesses of his heart. So in respect of the death of Coleridge. Some old friends of his saw him two or three weeks ago, and remarked the constant turning and reference of his mind. He interrupted himself and them almost every instant with some play of affected wonder, or astonishment, or humorous melancholy, on the words " *Coleridge is dead.*" Nothing could divert him from that, for the thought of it never left him. About the same time, we had written to him to request a few lines for the literary album of a gentleman who entertained a fitting admiration of his genius. It was the last request we were destined to make, the last kindness we were allowed to receive! He wrote in Mr. Keymer's volume—and wrote of Coleridge. This, we believe, was the last production of his pen. A strange and not unenviable chance, which saw him, at the end of his literary pilgrimage, as he had been at the beginning,—in that immortal company!

.

Within five weeks of this date Charles Lamb died. A slight accident brought on an attack of erysipelas, which proved fatal; his system was not strong enough for resistance. It is some consolation to add, that, during his illness, which lasted four days, he suffered no pain, and that his faculties remained with him to the last. A few words spoken by him the day before he died showed with what quiet collectedness he was prepared to meet death.

These are strange words to be writing of our old friend! We can scarcely think yet that he has left us; so intimately does he seem to belong to household thoughts, and to the dear things of heart and hearth, which his writings have made yet dearer. We cannot fancy him gone from his folios, his " midnight darlings," his pictures, chit-chat, jokes, and ambiguities;—and yet it is so. Everything that was mortal of him is gone, except the tears and the love of his friends. His writings remain, to be the delight of thousands to come.

ANONYMOUS NOTICES
1835

I

[T. Barnes (unsigned) in The Times.]

. . . He was decidedly a man of genius; abounding with
original thoughts, and not less remarkable for his power of
moving the heart than of amusing the fancy. His amiable
qualities converted even casual acquaintances into friends.

II

[The Atlas, January 11th, 1835. Possibly by Charles Cowden Clarke.]

The death of Mr. Charles Lamb, the friend and worthy
co-mate in genius of Wordsworth, Coleridge, Southey, &c.,
is an event which the reading public at large must deplore,—
but to those who enjoyed the gratification of his society, is
irreparable. A casual fall in the neighbourhood of his dwell-
ing at Edmonton, which severely injured his face, was fol-
lowed by an attack of erysipelas, that carried him off in the
course of a few days. . . .

It was in the ledgers of the accomptant's office, he used to
say, with a smile of bitter sweetness, that his " works " must
be looked for. However we may regret that the hand of
genius should be employed in the systematic drudgery of an
office, it is perhaps the comfortable provision of the India
House that we have to thank for the unhacknied character
of everything that proceeded from his pen. Mr. Lamb could
not, like Hazlitt, pour forth a daily or weekly torrent of
speculative letter-press, to satisfy the appetite of a regular
devourer of newspapers—he would have made but a poor
figure in reckoning his gains per sheet with some popular
magazine contributor of the day—but if quality took pre-
cedence of quantity, if in essay, in criticising or in verse, ex-
hibiting all that was most masterly in its kind, terse and
condensed in expression, accurate in taste and polished in

style, could entitle a man to the rewards of a flourishing
author, the prosperity should have been his. He wrote, how-
ever, that which is as much admired as it is generally ill paid,
and to a mind of this order, fastidious to a fault in its refine-
ments, a clerkship with suitable leisure cannot be con-
sidered as altogether the most unfavourable condition of
life. . . .

We will remember that our first desire to know more of
Mr. Lamb was caused by the perusal of an eloquent passage,
quoted by Mr. Hazlitt in his *Characters of Shakespeare's Plays*,
upon Nahum Tate's attempted improvement of the catastrophe
of *Lear*. Circumstances afterwards threw us much into the
society which we so greatly desired, and then it became
evident to us how those who enjoyed the intercourse of the
man became the idolizers of his books. His person, his
habits of thought, and eccentricity of humour, furnished a
commentary upon his writings, and opened a shorter route
to the full appreciation of them than any other means. It
was one of the pleasant privileges of the reader of his more
sportive essays, who enjoyed the author's acquaintance, to
relish them doubly by the force of a secret sympathy with
the writer, and a consciousness of his look and air in giving
vent to certain conceits. Never, certainly, was opened a
more admirable vein of broad humour—unforced, original,
and in its wildest flights, under the control of a judgment
that never deserted him—than in Charles Lamb's first essays
in the *Reflector*—" Upon the Inconvenience Resulting from
being Hanged," "On the Melancholy of Tailors," &c.
These were our earliest favourites and our latest—the first
sprightly runnings of his genius were here exhibited
in a style which Steele and Goldsmith might have
envied.

But books never could convey an adequate idea of this
writer as a man of wit. It has been truly said by one of the
oldest and most ably-judging of his friends, that into what-
ever society he might be thrown, he was sure to say the best
thing that had been uttered on the occasion. He could
converse gravely and delightfully enough at times, but his
usual habit was to throw off as they occurred the sallies of a
sportive imagination, to which his friends had been so long
used that they could hardly have believed him present, had

he failed in the accustomed tribute. In the intervals of a rubber (for like his own *Mrs. Battle*, whose opinions on whist he has recorded, he was no talker at cards) attention was claimed by some one labouring to deliver himself of a sentence. The hesitating speech of Mr. Lamb gave poignancy to his good things and wound up expectation to the highest pitch—for his old friends well knew that the more he laboured against his impediment, the richer the burthen of his thought. A stranger would mark the exterior of the speaker upon whom the whole room hung in suspense;—the fragile and unsubstantial form—the dress of clergy black with knee breeches, in the old-fashion, from which depended legs of the slenderest structure—the hair which, in spite of years, yet preserved its raven hue, and still curled as in youth,—the lean, student face, deeply entrenched with the lines of thought and feeling, and the peculiar smile which mantled on the face as the jest rose to his lips. The witticism is fired, and the room rings with applause. Yorick was certainly a fool to him in these matters, and the best quality of his humour was its entire freedom from personality, and of everything that could give pain. It was in quips of fancy that Charles Lamb sought relief to a constitutional melancholy, and a temperament painfully alive to impressions. Who can speak the admirable fitness of time, place, and circumstance which constituted the glory of his *bon mots* at the time of their delivery, and has rendered them since for ever incommunicable ? Sayings like his must come fresh from the mouth like champagne following the cork; they would only become flat and vapid by being transferred. But what things have we not heard in the sylvan solitudes of Islington, of Dalston, of Enfield—remote districts in which, from the creation of the world, one would hardly imagine a single trace of ludicrous association to have been conjured up! Lamb, in his humorous moods, would outdo the effect of Munden and a whole troop of comedians.

It was only, however, on the surface of the man that this playful humour prevailed—his inner nature had deep tenderness and unbounded sympathy. His bachelor life seemed to have rendered the interests of friends a matter of more intimate concern to him, than it is with those who fill the absorbing duties of the husband and father. His

house, while he lived in the neighbourhood of London, was always full of visitors, and a variety of entertaining persons were always to be met there—from the gentlewoman who first taught him to read, up to the most popular poet, actor, or preacher of the day. He played the host with admirable grace, always seasoning the good things sensual with a due admixture of the better things intellectual. A supper in Colebrook-row made an era in existence. Better still was it to walk with him in the country, when such an expedition could be achieved, and to hear him talk of the old comedy— of the *Mirabels* and the *Millamants,* the *Sir Sampson Legends* and *Lord Froths* of Congreve; of Smollett, whose novels he used to read periodically, and for whose sake he would set aside St. Thomas Aquinas, Fuller, or Jeremy Taylor; or Fielding, whose *Squire Western* and *Parson Adams* were his lasting favourites.

The book which gives the truest picture of Mr. Lamb, of his foibles as a man, mixed with his strength as a writer, is the collection of essays bearing the name of *Elia.* Here we may find a handsome bundle of prejudices and peculiarities—yet the whole so free from ostentation and desire of effect, as not only to be inoffensive, but almost amiable. His greatest literary mortification, we have heard, was not to have been a successful writer of farces. Hazlitt used to smile when he said that " not content with being the finest essayist of the age, he would fain push Peake and Kenny from their stools." He was kind and encouraging to young authors; he assisted forlorn editors gratuitously, and was more anxious for the fame and worldly success of his friends than solicitous about his own. He was strongly attached to life—purely for its own sake—we have heard him say that he neither desired to be younger, handsomer, or richer than he was; if he could remain at the same point, he would gladly compound for the rest. In one of his papers on the new year, he confesses himself peculiarly haunted by thoughts of death in the winter. It is at this season that he has passed away, and it is a consolation to think that the pang of his departure must have been short. His lineaments cannot be forgotten even in the recesses of the tomb, and his memory will be embalmed in a throng of grateful, and affectionate recollections.

SAYINGS OF CHARLES LAMB
1835

[*Collected in Leigh Hunt's* London Journal, *October 17th, 1835.*]

We have been favoured by an accomplished writer, one of the most intimate and honoured friends of Mr. Lamb, with the following " quips and quillets." They are characteristic of their utterer. Those who know how Charles Lamb *hesitated* his joke, and made *feints* as it were, in order to dart it forth the next minute with ten-fold effect, will best recognize the points, and enjoy the spirit of them. Next to knowing what Lamb said, it was always desirable to know *how* he said it. . . .

Coleridge was one evening running before the wind. He had talked about everything, from Moses downwards. At last he came to his own doings at Shrewsbury, and was swinging on, nineteen knots to the hour. " At this place, at Shrewsbury, (which is not only remarkable for its celebrated cakes, and for having been the point of rendezvous for Falstaff's regiment of foot; but also, if I may presume to speak of it; for the first development of the imaginative faculty in myself, by which faculty I would be understood to mean, &c. &c.)—at Shrewsbury I was accustomed to preach—I believe, Charles Lamb, that you have heard me preach ? " pursued he, turning round to his fatigued friend, who rapidly retorted—" I—I—never heard you do anything else."

" Have you seen ——'s excellent article in the *Review* ? " asked some one of Lamb. " Yes," said he, " I saw something of it." " Did you observe what a complete theory he has built up ? " was the second inquiry. " I don't understand these things," returned Lamb, evading the question. " But did you see anything defective ? " persisted the other; " it seems to *me*, to be a perfect fabric. What is there wanting ? " " I thought," answered L., at last, " that it-it-w-wanted the—the Attic."

Somebody was telling of a merry party then in prospect. " There will be——, (*Lamb smiled*) and ——, (*another smile, but sickly*) and ——, (" *You might have done better,*" said L.,)

and D. D——." "Ugh!" shuddered Lamb, at this last name, with a face expressive of nausea, " *He*! he'd throw a—damp upon a—a—a—*funeral*! "

L. and his sister were one evening supping at Mrs. M——'s. L. (with a little unwelcome assistance from another person) had made his way to the bottom of the second bottle of porter. " You really shall not have any more, Charles," said his sister. " Pray Mrs. M——, don't give him any more." " You hear what your sister says, Mr. Lamb ? " observed Mrs. M——, pouring out the remains of the porter (which were thick) into his glass. " She is a person of mean capacity," said he; " I never listen to her. Try the next bottle, Madam; for this is thick; and——*Hospitality should run fine to the last.*"

" How obstinate M. B. is," observed a visitor. " He's an excellent fellow," said L. avoiding the point: " I like M."— " But he's so obstinate," reiterated the speaker. " Well," replied L., " I *like* a solid obstinacy. Something may come of it. Besides,—there's something to quarrel with. One's blows don't tell upon a fellow who goes whisking about like a ball of worsted, and won't stand up for his own opinion. M.'s a freeholder, and insists upon having his vote."

" What a fine style X. has! " said a poetaster. " Excellent," echoed another person; " don't you think so, Mr. L. ? "—" I'm no judge of styles," was the answer; " I only know what pleases myself."—" But surely, Mr. L. you *must* think it fine. For my part, the word *fine* doesn't half express what I think of it. It doesn't at all come up to my ideas."— " Perhaps," observed L., " the word su—su—*superfine* will do better."

COLERIDGE'S TRUE C. L.

I

[" *Minuted down from the lips of the late S. T. Coleridge.*" Monthly Repository, *October* 1835.]

Charles Lamb has more totality and individuality of character than any other man I know, or have ever known in all my life. In most men we distinguish between the different

powers of their intellect as one being predominant over the
other. The genius of Wordsworth is greater than his talent
though considerable. The talent of Southey is greater than
his genius though respectable; and so on. But in Charles
Lamb it is altogether one; his genius is talent, and his talent
is genius, and his heart is as whole and one as his head. The
wild words that come from him sometimes on religious
subjects would shock you from the mouth of any other man,
but from him they seem mere flashes of firework. If an
argument seem to his reason not fully true, he bursts out in
that odd desecrating way; yet his will, the inward man, is,
I well know, profoundly religious. Watch him when alone,
and you will find him with either a Bible, or an old divine,
or an old English poet; in such is his pleasure.

II

[*S. T. Coleridge, in* " *an eloquent and affectionate analysis of Lamb's mind
and character*," *reported in* Quarterly Review, *July* 1835.]

Believe me, no one is competent to judge of poor dear
Charles, who has not known him long and well as I have
done. His heart is as whole as his head. The wild words
which sometimes come from him on religious subjects might
startle you from the mouth of any other man; but in him
they are mere flashes of firework. If an argument seems to
him not fully true, he will burst out in that odd way; yet
his will—the inward man—is, I well know, profoundly
religious and devout. Catch him when alone, and the great
odds are, you will find him with a Bible or an old divine
before him—or may be, and that is next door in excellence,
an old English poet: in such is his pleasure.

III

[*S. T. Coleridge, in Thomas Allsop's* Letters, &c., *of S. T. C.,* 1835.]

" No, no; Lamb's scepticism has not come lightly, nor is
he a sceptic. The harsh reproof to Godwin for his contemptu-
ous allusion to Christ before a well-trained child, proves that
he is not a sceptic. His mind, never prone to analysis, seems
to have been disgusted with the hollow pretences, the false
reasonings and absurdities of the rogues and fools with which
all establishments, and all creeds seeking to become estab-

lished abound. I look upon Lamb as one hovering between earth and heaven; neither hoping much nor fearing anything.

" It is curious that he should retain many usages which he learnt or adopted in the fervour of his early religious feelings, now that his faith is in a state of suspended animation. Believe me, who know him well, that Lamb, say what he will, has more of the essentials of Christianity, than ninety-nine out of a hundred professing Christians. He has all that would still have been Christian had Christ never lived or been made manifest upon earth."

It will be interesting to compare Lamb's estimate of the belief of Coleridge—half serious, half sportive—with this defence of Lamb from the charge of scepticism. After a visit to Coleridge, during which the conversation had taken a religious turn, Leigh Hunt, after having walked a little distance, expressed his surprise that such a man as Coleridge should, when speaking of Christ, always call him our Saviour. Lamb, who had been exhilarated by one glass of that gooseberry or raisin cordial which he has so often anathematised, stammered out, " ne-ne-never mind what Coleridge says, he is full of fun."

WORDSWORTH'S

" Written After the Death of Charles Lamb "

1835

To a good man of most dear memory
This Stone is sacred. Here he lies apart
From the great city where he first drew breath,
Was reared, and taught; and humbly earned his bread,
To the strict labours of the merchant's desk
By duty chained. Not seldom did those tasks
Tease, and the thought of time so spent depress
His spirit, but the recompense was high;
Firm Independence, Bounty's rightful sire;
Affections, warm as sunshine, free as air;
And when the precious hours of leisure came,

Knowledge and wisdom, gained from converse sweet
With books, or while he ranged the crowded streets
With a keen eye, and overflowing heart:
So genius triumphed over seeming wrong,
And poured out truth in works by thoughtful love
Inspired—works potent over smiles and tears.
And as round mountain tops the lightning plays,
Thus innocently sported, breaking forth
As from a cloud of some grave sympathy,
Humour and wild instinctive wit, and all
The vivid flashes of his spoken words.

From the most gentle creature nursed in fields
Had been derived the name[1] he bore—a name,
Wherever Christian altars have been raised,
Hallowed to meekness and to innocence;
And if in him meekness at times gave way,
Provoked out of herself by troubles strange,
Many and strange, that hung about his life;
Still, at the centre of his being, lodged
A soul by resignation sanctified;
And if too often, self-reproached, he felt
That innocence belongs not to our kind,
A power that never ceased to abide in him,
Charity, 'mid the multitude of sins
That she can cover, left not his exposed
To an unforgiving judgment from just Heaven.
O, he was good, if e'er a good Man lived.

.

From a reflecting mind and sorrowing heart
Those simple lines flowed with an earnest wish,
Though but a doubting hope, that they might serve
Fitly to guard the precious dust of him
Whose virtues called them forth. That aim is missed;
For much that truth most urgently required

[1] This way of indicating the *name* of my lamented friend has been found fault
with; perhaps rightly so; but I may say in justification of the double sense
of the word, that similar allusions are not uncommon in epitaphs. . . . Nor can
I think that the objection in the present case will have much force with any one
who remembers Charles Lamb's beautiful sonnet addressed to his own name,
and ending, " No deed of mine shall shame thee, gentle name! "—W.

Had from a faltering pen been asked in vain:
Yet, haply, on the printed page received,
The imperfect record, there may stand unblamed
As long as verse of mine shall breathe the air
Of memory, or see the light of love.

Thou wert a scorner of the fields, my Friend,
But more in show than truth; and from the fields,
And from the mountains, to thy rural grave
Transported my soothed spirit, hovers o'er
Its green untrodden turf, and blowing flowers;
And taking up a voice shall speak (tho' still
Awed by the theme's peculiar sanctity
Which words less free presumed not even to touch)
Of that fraternal love, whose heaven-lit lamp
From infancy, through manhood, to the last
Of threescore years, and to thy latest hour,
Burnt on with ever-strengthening light enshrined
Within thy bosom. " Wonderful " hath been
The love established between man and man,
" Passing the love of women "; and between
Man and his help-mate in fast wedlock joined
Through God, is raised a spirit and soul of love
Without whose blissful influence Paradise
Had been no Paradise; and earth were now
A waste whose creatures bearing human form,
Direst of savage beasts, would roam in fear,
Joyless and comfortless. Our days glide on;
And let him grieve who cannot choose but grieve
That he hath been an Elm without his Vine,
And her bright dower of clustering charities,
That round his trunk and branches might have clung
Enriching and adorning. Unto thee,
Not so enriched, not so adorned, to thee
Was given (say rather thou of later birth
Wert given to her) a Sister—'tis a word
Timidly uttered, for she lives, the meek,
The self-restraining, and the ever-kind;
In whom thy reason and intelligent heart
Found—for all interests, hopes, and tender cares,

All softening, humanising, hallowing powers,
Whether withheld, or for her sake unsought,
More than sufficient recompense! Her love
(What weakness prompts the voice to tell it here?)
Was as the love of mothers; and when years,
Lifting the boy to man's estate, had called
The long-protected to assume the part
Of a protector, the first filial tie
Was undissolved; and, in or out of sight,
Remained imperishably interwoven
With life itself. Thus, 'mid a shifting world,
Did they together testify of time
And seasoned difference—a double tree
With two collateral stems sprung from one root;
Such were they—such thro' life they might have been
In union, in partition only such;
Otherwise wrought the will of the Most High;
Yet, thro' all visitations and all trials,
Still they were faithful; like two vessels launched
From the same beach one ocean to explore
With mutual help, and sailing—to their league
True, as inexorable winds, or bars
Floating or fixed of polar ice, allow.

But turn we rather, let my spirit turn
With thine, O silent and invisible Friend!
To those dear intervals, nor rare nor brief,
When reunited, and by choice withdrawn
From miscellaneous converse, ye were taught
That the remembrance of foregone distress,
And the worse fear of future ill (which oft
Doth hang around it, as a sickly child
Upon its mother) may be both alike
Disarmed of power to unsettle present good
So prized, and things inward and outward held
In such an even balance, that the heart
Acknowledges God's grace, his mercy feels,
And in its depth of gratitude is still.

O gift divine of quiet sequestration!
The hermit, exercised in prayer and praise,

And feeding daily on the hope of heaven,
Is happy in his vow, and fondly cleaves
To life-long singleness; but happier far
Was to your souls, and to the thoughts of others,
A thousand times more beautiful appeared,
Your dual loneliness. The sacred tie
Is broken; yet why grieve ? for Time but holds
His moiety in trust, till Joy shall lead
To the blest world where parting is unknown.[1]

LANDOR'S POEM
1835

[W. S. Landor to Crabb Robinson, 1835.]

The death of Charles Lamb has grieved me very bitterly.
Never did I see a human being with whom I was more
inclined to sympathize. There is something in the recollec-
tion that you took me with you to see him which affects me
greatly more than writing or speaking of him could do with
any other. When I first heard of the loss that all his friends,
and many that never were his friends, sustained in him, no
thought took possession of my mind except the anguish of
his sister. That very night, before I closed my eyes, I com-
posed this:

" TO THE SISTER OF CHARLES LAMB "

Comfort thee, O thou mourner! yet awhile
 Again shall Elia's smile
Refresh thy heart, whose heart can ache no more.
 What is it we deplore ?
He leaves behind him, freed from griefs and years,
 Far worthier things than tears:
The love of friends, without a single foe;
 Unequalled lot below!

[1] It was intended that Wordsworth should supply a few lines for Lamb's
tombstone. Those above resulted, in November 1835. They do not excel the
mention in the poem on the death of the Ettrick Shepherd:

 " And Lamb, the frolic and the gentle,
 Has vanished from our lonely hearth."—*B.*

His gentle soul, his genius, these are thine;·
 Shalt thou for these repine ?
He may have left the lowly walks of men;
 Left them he has: what then ?
Are not his footsteps followed by the eyes
 Of all the good and wise ?
Though the warm day is over, yet they seek,
 Upon the lofty peak
Of his pure mind, the roseate light, that glows
 O'er Death's perennial snows.
Behold him! From the Spirits of the Blest
 He speaks: he bids thee rest.

If you like to send these to Leigh Hunt, do it. He may be
pleased to print in his *Journal* this testimony of affection to
his friend—this attempt at consolation to the finest genius
that ever descended on the heart of woman.

A PAINTER'S RECOLLECTIONS

[*C. R. Leslie*, Autobiographical Recollections, 1860, *vol. i.*]

At Mr. Morgan's house in Berners Street, I first saw
Charles Lamb, who was intimate in a literary coterie com-
posed of persons with principles very opposite to those of
Coleridge. Somebody, wishing to give the latter a favour-
able impression of these people, spoke of Lamb's friendship
for them; and Coleridge replied, " Charles Lamb's charac-
ter is a sacred one with me; no associations that he may form
can hurt the purity of his mind, but it is not, therefore,
necessary that I should see all men with his eyes." There
can be no doubt that it was of Lamb he spoke in the follow-
ing passage from the *Table Talk*:—" Nothing ever left a
stain on that gentle creature's mind, which looked upon the
degraded men and things around him like moonshine on a
dunghill, which shines and takes no pollution. All things
are shadows to him, except those which move his affections."
No one ever more fully pictured his own mind in his writings
than Lamb has done in his delightful Essays; and every
reader of them, I think, must acknowledge that Coleridge,
in what he said, only did his friend justice. But Lamb, from

the dread of appearing affected, sometimes injured himself by his behaviour before persons who were slightly acquainted with him. With the finest and tenderest feelings ever possessed by man, he seemed carefully to avoid any display of sentimentality in his talk. The following trifling anecdote is merely given as an illustration of his playfulness. I dined with him one day at Mr. Gillman's. Returning to town in the stage-coach, which was filled with Mr. Gillman's guests, we stopped for a minute or two at Kentish Town. A woman asked the coachman, " are you full inside ? " Upon which Lamb put his head through the window and said, " I am quite full inside; that last piece of pudding at Mr. Gillman's did the business for me."

Much as I then admired the traits of his mind and feelings shown in his charming Essays, little did I comprehend the true worth of his character. I had often met his sister Mary, a quiet old lady, who was like him in face, but stouter in figure. I knew that, at times, her mind had been unhinged from an early period, but I never heard of the dreadful act with which her insanity began until long after the time of which I am writing; and I was unacquainted, therefore, with the unparalleled excellence of her brother, the strength of his love, the greatness of his courage, and that noble system of economy in which he persevered to the end of his days, so difficult to a man who had so thorough a relish for all the elegance and luxuries of life; indeed impossible, had he not had a still higher relish for the luxury of goodness. The letters published, after his death and that of his sister, by Mr. Talfourd, make up a volume of more interest to me than any book of human composition.

I have noticed that Lamb sometimes did himself injustice by his odd sayings and actions, and he now and then did the same by his writings. His *Confessions of a Drunkard* greatly exaggerate any habits of excess he may ever have indulged. The regularity of his attendance at the India House, and the liberal manner in which he was rewarded for that attendance, prove that he never could have been a drunkard. Well, indeed, would it be for the world if such extraordinary virtues as he possessed were often found in company with so very few faults.

Sir George Beaumont left £100 to Mrs. Coleridge, but

nothing to her husband, who was then, as always, very poor. Lamb was indignant at this, and said it seemed to mark Coleridge with a stigma. " If," he added, " Coleridge was a scamp, Sir George should not have continued, as he did, to invite him to dinner."

REPUBLICATIONS
1835
[*John Mitford, in* Gentleman's Magazine.]

I

Rosamund Grey. Recollections of Christ's Hospital. By C. Lamb. 1835.—Mr. Lamb in his own style hath neither peer nor follower. We hope he is now quietly seated with the company he likes, Burton, Fuller, and Ben Jonson—with perhaps old Burbage and Penkethman dropping in. We never shall forget our suppers at Islington—Miss Lamb (truly Agna Dei) opening the door, and Lamb preceding us up stairs.

" Summum properabat *Lamb*ere tectum."

II

Specimens of the Dramatic Poets. By Charles Lamb, 2 vols., second edition, 1835.—We perfectly well remember Charles Lamb, in the reading-room of the British Museum, diligently making extracts from Garrick's collections, for these well-selected and entertaining volumes:—and we remember Miss Lamb doing us the honour of showing her brother's MSS. to us, previous to publication; and we remember her incredulity, and *goodhumoured peevishness*, when we informed her, that we also possessed most of the Plays, from which her brother had made his selection: another volume, from the still rarer and older Plays would be of value. Mr. Collier, or the Rev. Mr. Dyce, could well perform the task: but the latter gentleman is brushing cobwebs from Skelton.

CPSIA information can be obtained
at www.ICGtesting.com
Printed in the USA
BVHW050010090223
658191BV00002B/144